LIBRARY
Holy Cross College
Manchester Road
Bury
BL9 9BB

Books
are available to read at

Forgotten Books

www.ForgottenBooks.com

Forgotten Books' App
Available for mobile, tablet & eReader

Download on the App Store

ANDROID APP ON Google play

WITHDRAWN

ISBN 978-1-333-06171-5
PIBN 10461190

This book is a reproduction of an important historical work. Forgotten Books uses state-of-the-art technology to digitally reconstruct the work, preserving the original format whilst repairing imperfections present in the aged copy. In rare cases, an imperfection in the original, such as a blemish or missing page, may be replicated in our edition. We do, however, repair the vast majority of imperfections successfully; any imperfections that remain are intentionally left to preserve the state of such historical works.

Forgotten Books is a registered trademark of FB &c Ltd.
Copyright © 2015 FB &c Ltd.
FB &c Ltd, Dalton House, 60 Windsor Avenue, London, SW19 2RR.
Company number 08720141. Registered in England and Wales.

For support please visit www.forgottenbooks.com

1 MONTH OF
FREE
READING

at
www.ForgottenBooks.com

By purchasing this book you are eligible for one month membership to ForgottenBooks.com, giving you unlimited access to our entire collection of over 700,000 titles via our web site and mobile apps.

To claim your free month visit: www.forgottenbooks.com/free461190

* Offer is valid for 45 days from date of purchase. Terms and conditions apply.

LIBRARY
HOLY CROSS
COLLEGE

Date: 13/01/17
Accn. No. T43987
Class No. 824 GIL

English
Français
Deutsche
Italiano
Español
Português

www.forgottenbooks.com

Mythology Photography **Fiction** Fishing Christianity **Art** Cooking Essays **Buddhism** Freemasonry Medicine **Biology** Music **Ancient Egypt** Evolution Carpentry Physics Dance Geology **Mathematics** Fitness Shakespeare **Folklore** Yoga Marketing **Confidence** Immortality Biographies Poetry **Psychology** Witchcraft Electronics Chemistry History **Law** Accounting **Philosophy** Anthropology Alchemy Drama Quantum Mechanics Atheism Sexual Health **Ancient History Entrepreneurship** Languages Sport Paleontology Needlework Islam **Metaphysics** Investment Archaeology Parenting Statistics Criminology **Motivational**

THREE ESSAYS:

ON

PICTURESQUE BEAUTY;

ON

PICTURESQUE TRAVEL;

AND ON

SKETCHING LANDSCAPE:

WITH A POEM, ON

LANDSCAPE PAINTING.

TO THESE ARE NOW ADDED

TWO ESSAYS

GIVING AN ACCOUNT OF THE PRINCIPLES AND MODE IN WHICH THE AUTHOR EXECUTED HIS OWN DRAWINGS.

By WILLIAM GILPIN, A.M.
PREBENDARY OF SALISBURY; AND VICAR OF BOLDRE IN
NEW-FOREST, NEAR LYMINGTON.

THIRD EDITION.

LONDON:
PRINTED FOR T. CADELL AND W. DAVIES, STRAND.
1808.

AN Apology may be neceſſary for preſenting a new Edition of a Work, in a more enlarged form than the one in which it was publiſhed by its author. But the two Eſſays which are added to the preſent re-publication, tho written by him for a particular purpoſe, contain ſo much general precept on the art of drawing, and are in themſelves ſo natural an appendage to the three Eſſays on *Picturesque Beauty*, &c. that the Editors conceive they are only forwarding the wiſhes of the author, and preſenting a more connected view of his valuable inſtruction, already before the public, by bringing them forward in their preſent ſhape.

In the year 1802, and in a ſubſequent one, Mr. Gilpin prepared a number of drawings for ſale, the produce of his own pencil, for the endowment of a ſchool for the benefit of the day-labouring part of the pariſhioners of Boldre, and affixed the two Eſſays to the ſale catalogues, for which they were particularly written. It is to theſe ſales that remarks in the Eſſays ſo frequently refer. It was at firſt intended to omit,

in the prefent edition, thefe feveral references, and to publifh only the general perceptive part. But the alteration was found, on trial, too extenfive and hazardous; and therefore, as a better mode, both of elucidating and exemplifying the fenfe and precepts of the author, the Editors have added impreffions of a fet of fketches, afforted by him, and referred to, as illuftrative of the principles of his drawings, and the mode of their execution.

TO

WILLIAM LOCK, Esq;

OF

NORBURY-PARK, in *SURREY.*

DEAR SIR,

The following essays, and poem, I beg leave to inscribe to you. Indeed I do little more, than return your own: for the best remarks, and observations in them, are yours. Such as may be cavilled at, I am persuaded, must be mine.

A published work is certainly a fair object of criticism: but I think, my dear sir, we admirers of the picturesque are a little misunderstood with regard to our *general intention.* I have

have several times been surprized at finding us represented, as supposing, *all beauty* to consist in *picturesque beauty*—and the face of nature to be examined *only by the rules of painting.* Whereas, in fact, we always speak a different language. We speak of the grand scenes of nature, tho uninteresting in a *picturesque light*, as having a strong effect on the imagination—often a stronger, than when they are properly disposed for the pencil. We every where make a distinction between scenes, that are *beautiful, amusing*, or otherwise pleasing; and scenes that are *picturesque.* We examine, and admire both. Even artificial objects we admire, whether in a grand, or in a humble stile, tho unconnected with picturesque beauty — the palace, and the cottage — the improved garden-scene, and the neat homestall. Works of tillage also afford us equal delight — the plough, the mower, the reaper, the hay-field, and the harvest-wane. In a word, we reverence, and admire the works of God; and look with benevolence, and pleasure, on the works of men.

In what then do we offend? At the expence of no other species of beauty, we merely endeavour to illustrate, and recommend *one* species more; which, tho among the most interesting, hath never yet, so far as I know, been made the set object of investigation. From scenes indeed of the *picturesque kind* we exclude the appendages of tillage, and in general the works of men; which too often introduce precisenefs, and formality. But excluding artificial objects from one species of beauty, is not degrading them from all. We leave then the general admirer of the beauties of nature to his own pursuits; nay we admire them with him: all we desire, is, that he would leave us as quietly in the possession of one source of amusement more.

Under this apology, my dear sir, I have ventured, in the following essays, to inlarge a little both on our theory, and practice. In the first essay (that we may be fairly understood) the *distinguishing characteristic* is marked,

of

of *such beautiful objects,* as are suited to the pencil. In the second, the mode of amusement is pointed out, that may arise from viewing the scenes of nature in a picturesque light: and in the third, a few rules are given for sketching landscape after nature. I have practised drawing as an amusement, and relaxation, for many years; and here offer the result of my experience. Some readiness in *execution* indeed, it is supposed, is necessary, before these rules can be of much service. They mean to take the young artist up, where the drawing-master leaves him. — I have only to add farther, that as several of the rules, and principles here laid down, have been touched in different picturesque works, which I have given the public, I have endeavoured not to repeat myself: and where I could not throw new light on a subject, I have hastened over it: — only in a work of this kind, it was necessary to bring them together in one view.

With

With regard to the poem, annexed to these essays, something more should be said. As that small part of the public, who personally know me; and that still smaller part, whom I have the honour to call my friends, may think me guilty of presumption in attempting a work of this kind, I beg leave to give the following history of it.

Several years ago, I amused myself with writing a few lines in verse on landscape-painting; and afterwards sent them, as a fragment (for they were not finished) to amuse a friend *. I had no other purpose. My friend told me, he could not say much for my *poetry*; but as my *rules*, he thought, were good, he wished me to finish my fragment; and if I should not like it as a *poem*, I might turn it into an *essay in prose*. — As this was only what I expected, I was not disappointed; tho not encouraged to proceed. So

* Edward Forster, Esq.; of Walthamstow.

I troubled my head no farther with my verses.

Some time after, another friend*, finding fault with my mode of describing the lakes and mountains of Cumberland, and Westmoreland, as too poetical, I told him the fate of my fragment; lamenting the hardship of my case —— when I wrote verse, one friend called it prose; and when I wrote prose, another friend called it verse. In his next letter he desired to see my verses; and being pleased with the subject, he offered, if I would finish my poem (however carelessly as to metrical exactness) he would adjust the versification. But he found, he had engaged in a more arduous task, than he expected. My rules, and technical terms were stubborn, and would not easily glide into verse; and I was as stubborn, as they, and would not relinquish the scientific part for the poetry. My friend's

* Rev. Mr. Mason.

good-

good-nature therefore generally gave way, and suffered many lines to stand, and many alterations to be made, which his own good taste could not approve *. I am afraid therefore I must appear to the world, as having spoiled a good poem: and must shelter myself, and it, under those learned reasons, which have been given for putting *Propria quæ maribus*, and *As in præsenti*, into verse. If the rules have injured the poetry; as *rules* at least, I

* Extract of a letter from Mr. Mason.

──────────────── " I have inserted conscientiously every
" word, and phrase, you have altered; except the awkward
" word *clump*, which I have uniformly discarded, whenever it
" offered itself to me in my English garden, which you may
" imagine it did frequently: in it's stead I have always
" used *tuft*. I have ventured therefore to insert it adjectively;
" and I hope, I shall be forgiven. Except in this single
" instance, I know not that I have deviated in the least from
" the alterations, you sent. —— I now quit all that relates to
" the poem, not without some self-satisfaction in thinking it is
" over: for, to own the truth, had I thought you would have
" expected such almost mathematical *exactitude of terms*, as I
" find you do; and in consequence turned lines tolerably
" poetical, into prosaic, for the sake of precision, I should
" never have ventured to give you my assistance."

hope,

hope, they will meet your approbation. I am, dear sir, with the greatest esteem, and regard,

Your sincere,

and most obedient,

humble servant

WILLIAM GILPIN.

Vicar's-hill,
October 12, 1791.

EXPLANATION

OF THE

PRINTS.

―――

Two facing page 19. It is the intention of thefe two prints to illuftrate how very adverfe the idea of *fmoothnefs* is to the *compófition* of landfcape. In the fecond of them the *great lines* of the landfcape are exactly the fame as in the firft; only they are *more broken*.

Two facing p. 75. The firft of thefe prints is meant to illuftrate the idea of *fimple illumination*. The light falls ftrongly on *various* parts; as indeed it often does in nature. But, as it is the painter's bufinefs to take nature in her moft beautiful form, he chufes to throw his light more into a *mafs*, as reprefented in the fecond print, which exhibits the *fame landfcape*, only better inlightened. When we merely take the *lines* of a landfcape from nature; and *inlighten* it (as we muft often do) from our own tafte, and judgment, the maffing of the light muft be well attended to, as one of the great fources of beauty. It muft not be

fcattered

scattered in spots; but must be brought more together, as on the rocky side of the hill in the second print: and yet it must graduate also in different parts; so as not to appear affected.

One print facing p. 77. The idea of *gradation* is here farther illustrated; according to the explanation in p. 76. —— The inscription is that admired one of Cæcilia Metella, the daughter of Metellus, and the wife of Crassus; in which, with so much elegant, and tender simplicity, her name is divided between her father, and her husband.

One facing p. 79. This print exemplifies a *simple mode* of *tinting* a drawing, as explained in the text. The colouring of this print (which is done by hand) has added a little to the expence of the book: but it was thought necessary to compleat the scheme. — It was coloured by a relation of mine; Mr. Gilpin, drawing-master at Paddington-green; who in all the copies I have seen, has illustrated my ideas very satisfactorily; and who, as far as the recommendation of a partial kinsman may go, deserves mine.

One facing p. 85. This print is an explanation of a few rules in perspective; just sufficient for the use of common landscape.

⁎ *Four Prints belonging to the* TWO ADDITIONAL ESSAYS *are sufficiently explained in the pages facing which they are respectively placed.*

ES-

ESSAY I.

ON

PICTURESQUE BEAUTY.

ESSAY I.

Disputes about beauty might perhaps be involved in less confusion, if a distinction were established, which certainly exists, between such objects as are *beautiful*, and such as are *picturesque* — between those, which please the eye in their *natural state*; and those, which please from some quality, capable of being *illustrated by painting*.

Ideas of beauty vary with objects, and with the eye of the spectator. The stone-mason sees beauties in a well-jointed wall, which escape the architect, who surveys the building under a different idea. And thus the painter, who compares his object with the rules of his art, sees it in a different light from the man of general taste, who surveys it only as simply beautiful.

As this difference therefore between the *beautiful*, and the *picturesque* appears really to exist, and must depend on some peculiar construction of the object; it may be worth while to examine, what that peculiar construction is. We inquire not into the *general sources of beauty*, either in nature, or in representation. This would lead into a nice, and scientific discussion, in which it is not our purpose to engage. The question simply is, *What is that quality in objects, which particularly marks them as picturesque?*

In examining the *real object*, we shall find, one source of beauty arises from that species of elegance, which we call *smoothness*, or *neatness*; for the terms are nearly synonymous. The higher the marble is polished, the brighter the silver is rubbed, and the more the mahogany shines, the more each is considered as an object of beauty: as if the eye delighted in gliding smoothly over a surface.

In the class of larger objects the same idea prevails. In a pile of building we wish to see neatness in every part added to the elegance of the architecture. And if we examine a piece of improved pleasure-ground, every thing rough, and slovenly offends.

<div style="text-align: right;">Mr.</div>

Mr. Burke, enumerating the properties of beauty, confiders *fmoothnefs* as one of the moft effential. " A very confiderable part of the effect of beauty, fays he, is owing to this quality: indeed the moft confiderable · for take any beautiful object, and give it a broken, and rugged furface, and however well-formed it may be in other refpects, it pleafes no longer. Whereas, let it want ever fo many of the other conftituents, if it want not this, it becomes more pleafing, than almoft all the others without it."* ———— How far Mr. Burke may be right in making fmoothnefs the *moft confiderable* fource of beauty, I rather doubt † A confiderable one it certainly is.

Thus

* Upon the fublime and beautiful, page 213.

† Mr. Burke is probably not very accurate in what he farther fays on the connection between *beauty*, and *diminutives*. —— Beauty excites love; and a loved object is generally characterifed by diminutives. But it does not follow, that all objects characterized by diminutives, tho they may be fo becaufe they are loved, are therefore beautiful. We often love them for their moral qualities; their affections; their gentlenefs; or their docility. Beauty, no doubt, awakens love; but alfo excites admiration, and refpect. This combination forms the fentiment, which prevails, when we look

Thus then, we suppose, the matter stands with regard to *beautiful objects in general*. But in *picturesque representation* it seems somewhat odd, yet perhaps we shall find it equally true, that the reverse of this is the case; and that the ideas of *neat* and *smooth*, instead of being picturesque, in reality strip the object, in which they reside, of all pretensions to *picturesque beauty*. —— Nay, farther, we do not scruple to assert, that *roughness* forms the most essential point of difference between the *beautiful*, and the *picturesque*; as it seems to be that particular quality, which makes objects chiefly pleasing in painting. — I use the general term *roughness*; but properly speaking roughness relates only to the surfaces of bodies: when we speak of their delineation, we use the word *ruggedness*. Both ideas however equally enter into the picturesque; and both are observable in the

at the Apollo of Belvidere, and the Niobe. No man of nice discernment would characterize these statues by diminutives. —— There is then a beauty, between which and diminutives there is no relation; but which, on the contrary, excludes them: and in the description of figures, possessed of that species of beauty, we seek for terms, which recommend them more to our *admiration* than our *love*.

smaller,

smaller, as well as in the larger parts of nature — in the outline, and bark of a tree, as in the rude summit, and craggy sides of a mountain.

Let us then examine our theory by an appeal to experience; and try how far these qualities enter into the idea of *picturesque beauty*; and how far they mark that difference among objects, which is the ground of our inquiry.

A piece of Palladian architecture may be elegant in the last degree. The proportion of it's parts — the propriety of it's ornaments — and the symmetry of the whole may be highly pleasing. But if we introduce it in a picture, it immediately becomes a formal object, and ceases to please. Should we wish to give it picturesque beauty, we must use the mallet instead of the chissel: we must beat down one half of it, deface the other, and throw the mutilated members around in heaps. In short, from a *smooth* building we must turn it into a *rough* ruin. No painter, who had the choice of the two objects, would hesitate which to chuse.

Again, why does an elegant piece of garden-ground make no figure on canvas? The shape

is pleasing; the combination of the objects, harmonious; and the winding of the walk in the very line of beauty. All this is true; but the *smoothness* of the whole, tho right, and as it should be in nature, offends in picture. Turn the lawn into a piece of broken ground: plant rugged oaks instead of flowering shrubs: break the edges of the walk: give it the rudeness of a road; mark it with wheel-tracks; and scatter around a few stones, and brushwood; in a word, instead of making the whole *smooth*, make it *rough*; and you make it also *picturesque*. All the other ingredients of beauty it already possessed.

You sit for your picture. The master, at your desire, paints your head combed smooth, and powdered from the barber's hand This may give it a more striking likeness, as it is more the resemblance of the real object. But is it therefore a more pleasing picture? I fear not. Leave Reynolds to himself, and he will make it picturesque by throwing the hair dishevelled about your shoulders. Virgil would have done the same. It was his usual practice in all his portraits. In his figure of Ascanius, we have the *fusos crines*; and in his portrait
of

of Venus, which is highly finished in every part, the artist has given her hair,

―――――― *diffundere ventis* *.

Modern poets also, who have any ideas of natural beauty, do the same. I introduce Milton to represent them all. In his picture of Eve, he tells us, that

―――――― to her slender waste
Her unadorned golden tresses were
Dishevelled, and in wanton ringlets waved

That lovely face of youth smiling with all it's sweet, dimpling charms, how attractive is

―――――――――――――――――

* The roughness, which Virgil gives the hair of Venus, and Ascanius, we may suppose to be of a different kind from the squalid roughness, which he attributes to Charon:

Portitor has horrendus aquas, et flumina servat
Terribili squalore Charon, cui plurima mento
Canities inculta jacet.

Charon's roughness is, in it's kind, picturesque also; but the roughness here intended, and which can only be introduced in elegant figures, is of that kind, which is merely opposed to hair in nice order. In describing Venus, Virgil probably thought hair, when *streaming in the wind*, both beautiful, and picturesque, from it's undulating form, and varied tints; and from a kind of life, which it assumes in motion; tho perhaps it's chief recommendation to him, at the moment, was, that it was a feature of the character, which Venus was then assuming.

it

it in life! how beautiful in reprefentation! It is one of thofe objects, that pleafe, as many do, both in nature, and on canvas. But would you fee the human face in it's higheſt form of *picturefque beauty*, examine that patriarchal head. What is it, which gives that dignity of character; that force of expreffion; thofe lines of wifdom and experience; that energetic meaning, fo far beyond the rofy hue, or even the bewitching fmile of youth? What is it, but the forehead furrowed with wrinkles? the prominent cheek-bone, catching the light? the mufcles of the cheek ftrongly marked, and lofing themfelves in the fhaggy beard? and, above all, the auftere brow, projecting over the eye — the feature which particularly ftruck Homer in his idea of Jupiter*, and which

he

* It is much more probable, that the poet copied *forms* from the fculptor, who muſt be fuppofed to underſtand them better, from having ſtudied them more; than that the fculptor fhould copy them from the poet. Artiſts however have taken advantage of the pre-poffeffion of the world for Homer to fecure approbation to their works by acknowledging them to be reflected images of his conception. So Phidias affured his countrymen, that he had taken his Jupiter from the defcription of that god in the firft book of Homer. The fact is, none of the features contained in that image, except the brow, can be

rendered

he had probably seen finely represented in some statue; in a word, what is it, but the *rough touches of age?*

As an object of the mixed kind, partaking both of the *beautiful*, and the *picturesque*, we admire the human figure also. The lines, and surface of a beautiful human form are so infinitely varied; the lights and shades, which it receives, are so exquisitely tender in some parts, and yet so round, and bold in others; it's proportions are so just; and it's limbs so fitted to receive all the beauties of grace, and

rendered by sculpture. But he knew what advantage such ideas, as his art could express, would receive from being connected in the mind of the spectator with those furnished by poetry; and from the just partiality of men for such a poet. He seems therefore to have been as well acquainted with the mind of man, as with his shape, and face.— If by κυανεησιν ιποφρυσι, we understand, as I think we may, *a projecting brow, which casts a broad,* and *deep shadow over the eye,* Clarke has rendered it ill by *nigris superciliis,* which most people would construe into *black eye-brows.* Nor has Pope, tho he affected a knowledge of painting, translated it more happily by *sable eye-brows.*— But if Phidias had had nothing to recommend him, except his having availed himself of the only feature in the poet, which was accommodated to his art, we should not have heard of inquirers wondering from whence he had drawn his ideas; nor of the compliment, which it gave him an opportunity of paying to Homer.

contrast·

contrast; that even the face, in which the charms of intelligence, and sensibility reside, is almost lost in the comparison. But altho the human form in a quiescent state, is thus beautiful; yet the more it's *smooth surface* is *ruffled,* if I may so speak, the more picturesque it appears. When it is agitated by passion, and it's muscles swoln by strong exertion, the whole frame is shewn to the most advantage.——But when we speak of muscles swoln by exertion, we mean only natural exertions, not an affected display of anatomy, in which the muscles, tho justly placed, may still be overcharged.

It is true, we are better pleased with the usual representations we meet with of the human form in a quiescent state, than in an agitated one; but this is merely owing to our seldom seeing it naturally represented in strong action. Even among the best masters we see little knowledge of anatomy. One will inflate the muscles violently to produce some trifling effect: another will scarce swell them in the production of a laboured one. The eye soon learns to see a defect, tho unable to amend it. But when the anatomy is perfectly just, the human body will always be more picturesque

in

in action, than at reft. The great difficulty indeed of reprefenting ftrong mufcular motion, feems to have ftruck the ancient mafters of fculpture: for it is certainly much harder to model from a figure in ftrong, momentary action, which muft, as it were, be fhot flying; than from one fitting, or ftanding, which the artift may copy at leifure. Amidft the variety of ftatues tranfmitted from their hands, we have only three, or four in very fpirited action*. Yet when we fee an effect of this kind well executed, our admiration is greatly increafed. Who does not admire the Laocoon more than the Antinous?

* Tho there are only perhaps two or three of the firft antique ftatues in *very fpirited* action — the Laocoon, the fighting gladiator, and the boxers — yet there are feveral others, which are *in action* — the Apollo Belvidere — Michael Angelo's Torfo — Arria and Pætus — the Pietas militaris, fometimes called the Ajax, of which the Pafquin at Rome is a part, and of which there is a repetition more entire, tho ftill much mutilated, at Florence — the Alexander and Bucephalus; and perhaps fome others, which occur not to my memory. The paucity however of them, even if a longer catalogue could be produced, I think, fhews that the ancient fculptors confidered the reprefentation of *fpirited action* as an atchievement. The moderns have been lefs daring in attempting it. But I believe connoiffeurs univerfally give the preference to thofe ftatues, in which the great mafters have fo fuccefsfully exhibited animated action.

Animal

Animal life, as well as human, is, in general, beautiful both in nature, and on canvas. We admire the pampered horse, as a *real object*; the elegance of his form; the stateliness of his tread; the spirit of all his motions; and the glossiness of his coat. We admire him also in *representation*. But as an object of picturesque beauty, we admire more the worn-out cart-horse, the cow, the goat, or the ass; whose harder lines, and rougher coats, exhibit more the graces of the pencil. For the truth of this we may examine Berghem's pictures: we may examine the smart touch of Rosa of Tivoli. The lion with his rough mane; the bristly boar; and the ruffled plumage of the eagle*, are all objects of this kind.

* The idea of the *ruffled plumage of the eagle* is taken from the celebrated eagle of Pindar, in his first Pythian ode; which has exercised the pens of several poets; and is equally poetical, and picturesque. He is introduced as an instance of the power of music. In Gray's ode on the progress of poesy we have the following picture of him.

> Perching on the sceptered hand
> Of Jove, thy magic lulls the feathered king
> With ruffled plumes, and flagging wing:
> Quenched in dark clouds of slumber lie
> The terror of his beak, and lightening of his eye.
> Akenside's

kind. Smooth-coated animals could not produce so picturesque an effect.

But when the painter thus prefers the cart-horse, the cow, or the ass to other objects *more beautiful in themselves*, he does not certainly recommend his art to those, whose love of beauty makes them anxiously seek, by what means it's fleeting forms may be fixed.

Akenside's picture of him, in his hymn to the Naiads, is rather a little stiffly painted.

—————————— With slackened wings,
While now the solemn concert breathes around,
Incumbent on the sceptre of his lord
Sleeps the stern eagle; by the numbered notes
Possessed; and satiate with the melting tone;
Sovereign of birds. ————————————

West's picture, especially the two last lines, is a very good one.

The bird's fierce monarch drops his vengeful ire.
Perched on the sceptre of th' Olympian king,
The thrilling power of harmony he feels
And indolently hangs his flagging wing;
While gentle sleep his closing eyelid seals,
And o'er his heaving limbs, in loose array,
To every balmy gale the ruffling feathers play.

Suggestions

Suggestions of this kind are ungrateful. The art of painting allows you all you wish. You desire to have a beautiful object painted—your horse, for instance, led out of the stable in all his pampered beauty. The art of painting is ready to accommodate you. You have the beautiful form you admired in nature exactly transferred to canvas. Be then satisfied. The art of painting has given you what you wanted. It is no injury to the beauty of your Arabian, if the painter think he could have given the graces of his art more forcibly to your cart-horse.

But does it not depreciate his art, if he give up a beautiful form, for one less beautiful, merely because he can give it *the graces of his art more forcibly* — because it's sharp lines afford him a greater facility of execution? Is the smart touch of a pencil the grand desideratum of painting? Does he discover nothing in *picturesque objects*, but qualities, which admit of being *rendered with spirit?*

I should not vindicate him, if he did. At the same time, a free execution is so very fascinating a part of painting, that we need

not wonder, if the artift lay a great ftrefs upon it.— It is not however intirely owing, as fome imagine, to the difficulty of maftering an elegant line, that he prefers a rough one. In part indeed this may be the cafe; for if an elegant line be not delicately hit off, it is the moft infipid of all lines: whereas in the defcription of a rough object, an error in delineation is not eafily feen. However this is not the whole of the matter. A free, bold touch is in itfelf pleafing*. In elegant figures indeed there muft be a delicate outline — at leaft a line true to nature: yet the furfaces even of fuch figures may be touched with freedom; and in the appendages of the compofition there muft be a mixture of rougher objects, or there will be a want of contraft. In landfcape univerfally the rougher objects are admired; which give the freeft fcope to execution. If the pencil

* A ftroke may be called *free*, when there is no appearance of conftraint. It is *bold*, when a part is given for the whole, which it cannot fail of fuggefting. This is the laconifm of genius. But fometimes it may be free, and yet fuggeft only how eafily a line, which means nothing, may be executed. Such a ftroke is not *bold*, but *impudent*.

be timid, or hesitating, little beauty results. The execution then only is pleasing, when the hand firm, and yet decisive, freely touches the characteristic parts of each object.

If indeed, either in literary, or in picturesque composition you endeavour to draw the reader, or the spectator from the *subject* to the *mode of executing* it, your affectation* disgusts. At the same time, if some care, and pains be not bestowed on the *execution*, your slovenliness disgusts as much. Tho perhaps the artist has more to say, than the man of letters, for paying attention to his *execution*. A truth is a truth, whether delivered in the language of a philosopher, or of a peasant: and the *intellect* receives it as such. But the artist, who

* Language, like light, is a medium; and the true philosophic stile, like light from a north-window, exhibits objects clearly, and distinctly, without soliciting attention to itself. In subjects of amusement indeed language may gild somewhat more, and colour with the dies of fancy: but where information is of more importance than entertainment, the you cannot throw too *strong* a light, you should carefully avoid a *coloured* one. The stile of some writers resembles a bright light placed between the eye, and the thing to be looked at. The light shews itself; and hides the object: and, it must be allowed, the execution of some painters is as impertinent, as the stile of such writers.

deals in lines, surfaces, and colours, which are an immediate address to the *eye*, conceives the *very truth itself* concerned in his *mode* of representing it. Guido's angel, and the angel on a sign-post, are very different beings; but the whole of the difference consists in an artful application of lines, surfaces, and colours.

It is not however merely for the sake of his *execution*, that the artist values a rough object. He finds it in many other respects accommodated to his art. In the first place, his *composition* requires it. If the history-painter threw all his draperies smooth over his figures; his groups, and combinations would be very awkward. And in *landscape-painting* smooth objects would produce no composition at all. In a mountain-scene what composition could arise from the corner of a smooth knoll coming forward on one side, intersected by a smooth knoll on the other; with a smooth plain perhaps in the middle, and a smooth mountain in the distance? The very idea is disgusting. Picturesque composition consists in uniting in one whole a variety of parts; and these parts can only be obtained from rough objects. If the smooth moun-

tains, and plains were broken by different objects, the compofition would be good, if we fuppofe the great lines of it were fo before.

Variety too is equally neceffary in his compofition: fo is *contraſt*. Both thefe he finds in rough objects; and neither of them in fmooth. Variety indeed, in fome degree, he may find in the outline of a fmooth object: but by no means enough to fatisfy the eye, without including the furface alfo.

From *rough* objects alfo he feeks the *effect of light and ſhade*, which they are as well difpofed to produce, as they are the beauty of compofition. One uniform light, or one uniform fhade produces no effect. It is the various furfaces of objects, fometimes turning to the light in one way, and fometimes in another, that give the painter his choice of opportunities in maffing, and graduating both his lights, and fhades.— The *richneſs* alfo of the light depends on the breaks, and little receffes, which it finds on the furfaces of bodies. What the painter calls *richneſs* on a furface, is only a variety of little parts; on which the light fhining fhews all it's fmall inequalities, and roughneffes; or in the

the painter's language, *inriches* it. —— The beauty alfo of *catching lights* arifes from the roughnefs of objects. What the painter calls a *catching light* is a ftrong touch of light on fome prominent part of a furface, while the reft is in fhadow. A fmooth furface hath no fuch prominences.

In *colouring* alfo, *rough* objects give the painter another advantage. Smooth bodies are commonly as uniform in their colour, as they are in their furface. In gloffy objects, tho fmooth, the colouring may fometimes vary. In general however it is otherwife; in the objects of landfcape, particularly. The fmooth fide of a hill is generally of one uniform colour; while the fractured rock prefents it's grey furface, adorned with patches of greenfward running down it's guttered fides; and the broken ground is every where varied with an okery tint, a grey gravel, or a leaden-coloured clay: fo that in fact the rich colours of the ground arife generally from it's broken furface.

From fuch reafoning then we infer, that it is not merely for the fake of his *execution* that the painter prefers *rough* objects to *fmooth*. The very effence of his art requires it.

As picturefque beauty therefore fo greatly depends on *rough* objects, are we to exclude every idea of *fmoothnefs* from mixing with it? Are we ftruck with no pleafing image, when the lake is fpread upon the canvas; the *marmoreum æquor*, pure, limpid, fmooth, as the polifhed mirror?

We acknowledge it to be picturefque: but we muft at the fame time recollect, that, in-fact, the fmoothnefs of the lake is more in *reality*, than in *appearance*. Were it fpread upon the canvas in one fimple hue, it would certainly be a dull, fatiguing object. But to the eye it appears broken by fhades of various kinds; or by reflections from all the rough objects in it's neighbourhood.

It is thus too in other gloffy bodies. Tho the horfe, in a *rough* ftate as we have juft obferved, or worn down with labour, is more adapted to the pencil, than when his fides fhine with brufhing, and high-feeding; yet in this latter ftate alfo he is certainly a picturefque object. But it is not his fmooth, and fhining coat, that makes him fo. It is the apparent interruption of that fmoothnefs by a variety of fhades, and colours, which produces the effect. Such a play of mufcles appears
every

every where, through the fineness of his skin, gently swelling, and sinking into each other — he is all over so *lubricus aspici*, the reflections of light are so continually shifting upon him, and playing into each other, that the eye never considers the smoothness of the surface; but is amused with gliding up, and down, among those endless transitions, which in some degree, supply the room of *roughness*.

It is thus too in the plumage of birds. Nothing can be softer, nothing smoother to the touch; and yet it is certainly picturesque. But it is not the smoothness of the surface, which produces the effect — it is not this we admire: it is the breaking of the colours: it is the bright green, or purple, changing perhaps into a rich azure, or velvet black; from thence taking a semi-tint; and so on through all the varieties of colour. Or if the colours be not changeable, it is the harmony of them, which we admire in these elegant little touches of nature's pencil. The smoothness of the surface is only the ground of the colours. In itself we admire it no more, than we do the smoothness of the canvas, which receives the colours of the picture. Even the plumage of the swan, which to the inaccurate observer ap-

pears only of one simple hue, is in fact varied with a thousand soft shadows, and brilliant touches, at once discoverable to the picturesque eye.

Thus too a piece of polished marble may be picturesque: but it is only, when the polish brings out beautiful veins, which in *appearance* break the surface by a variety of lines, and colours. Let the marble be perfectly white, and the effect vanishes. Thus also a mirror may have picturesque beauty; but it is only from it's reflections. In an unreflecting state, it is insipid.

In statuary we sometimes see an inferior artist give his marble a gloss, thinking to atone for his bad workmanship by his excellent polish. The effect shews in how small a degree smoothness enters into the idea of the picturesque When the light plays on the shining coat of a pampered horse, it plays among the lines, and muscles of nature; and is therefore founded in truth. But the polish of marble-flesh is unnatural*. The lights therefore

* On all human flesh held between the eye and the light, there is a degree of polish. I speak not here of such a polish as

therefore are false; and smoothness being here one of the chief qualities to admire, we are disgusted; and say, it makes bad, worse.

After all, we mean not to assert, that even a simple smooth surface is in no situation picturesque. In *contrast* it certainly may be: nay in contrast it is often necessary. The beauty of an old head is greatly improved by the smoothness of the bald pate; and the rougher parts of the rock must necessarily be set off with the smoother. But the point lies here: to make an object in a peculiar manner picturesque, there *must be* a proportion of *roughness*; so much at least, as to make an opposition; which, in an object simply beautiful, is unnecessary.

Some quibbling opponent may throw out, that wherever there is smoothness, there must also be roughness. The smoothest plain consists of many rougher parts; and the roughest rock of many smoother; and there is such a variety of degrees in both, that it is hard to

as this, which wrought-marble always, in a degree, possesses, as well as human flesh; but of the highest polish, which can be given to marble; and which has always a very bad effect. If I wanted an example, the bust of arch-bishop Boulter in Westminster-abbey would afford a very glaring one.

say,

say, where you have the precise ideas of *rough* and *smooth*.

To this it is enough, that the province of the picturesque eye is to *survey nature*; not to *anatomize matter*. It throws it's glances around in the broad-cast stile. It comprehends an extensive tract at each sweep. It examines *parts*, but never descends to *particles*.

Having thus from a variety of examples endeavoured to shew, that *roughness* either *real*, or *apparent*, forms an essential difference between the *beautiful*, and the *picturesque*; it may be expected, that we should point out the reason of this difference. It is obvious enough, why the painter prefers *rough* objects to *smooth**: but it is not so obvious, why the quality of *roughness* should make an *essential difference* between objects of *beauty*, and objects suited to *artificial representation*.

To this question, we might answer, that the picturesque eye abhors art; and delights solely in nature: and that as art abounds with *regularity*, which is only another name

* See page 19, &c.

for

for *smoothness*; and the images of nature with *irregularity*, which is only another name for *roughness*, we have here a solution of our question.

But is this solution satisfactory? I fear not. Tho art often abounds with regularity, it does not follow, that all art must necessarily do so. The picturesque eye, it is true, finds it's *chief* object in nature; but it delights also in the images of art, if they are marked with the characteristics, which it requires. *A painter's nature* is whatever he *imitates*; whether the object be what is commonly called natural, or artificial. Is there a greater ornament of landscape, than the ruins of a castle? What painter rejects it, because it is artificial?—— What beautiful effects does Vandervelt produce from shipping? In the hands of such a master it furnishes almost as beautiful forms, as any in the whole circle of picturesque objects?—— And what could the history-painter do, without his draperies to combine, contrast, and harmonize his figures? Uncloathed, they could never be grouped. How could he tell his story, without arms; religious utensils; and the rich furniture of banquets? Many of these con-
<div style="text-align: right">tribute</div>

tribute greatly to embellish his pictures with pleasing shapes.

Shall we then seek the solution of our question in the great foundation of picturesque beauty? in the *happy union of simplicity and variety*; to which the *rough* ideas essentially contribute? An extended plain is a simple object. It is the continuation of only one uniform idea. But the mere *simplicity* of a plain produces no beauty. Break the surface of it, as you did your pleasure-ground; add trees, rocks, and declivities; that is, give it *roughness*, and you give it also *variety*. Thus by inriching the *parts* of a united *whole* with *roughness*, you obtain the combined idea of *simplicity*, and *variety*; from whence results the picturesque. —— Is this a satisfactory answer to our question?

By no means. *Simplicity and variety* are sources of the *beautiful*, as well as of the *picturesque*. Why does the architect break the front of his pile with ornaments? Is it not to add variety to simplicity? Even the very black-smith acknowledges this principle by forming ringlets and bulbous circles on his tongs, and pokers. In nature it is the same; and your plain will just as much be

be improved *in reality* by breaking it, as *upon canvas.*—— in a garden-scene the idea is different. There every object is of the neat, and elegant kind. What is otherwise, is inharmonious; and *roughness* would be disorder.

Shall we then change our ground; and seek an answer to our question in the nature of the art of painting? As it is an art *strictly imitative*, those objects will of course appear most advantageously to the picturesque eye, which are the most easily imitated. The stronger the features are, the stronger will be the effect of imitation; and as rough objects have the strongest features, they will consequently, when represented, appear to most advantage.—— Is this answer more satisfactory?

Very little, in truth. Every painter, knows that a smooth object may be as easily, and as well imitated, as a rough one.

Shall we then take an opposite ground, and say just the reverse (as men pressed with difficulties will say any thing) that painting is *not* an art *strictly imitative*, but rather *deceptive* — that by an assemblage of colours, and a peculiar art in spreading them, the painter gives a semblance of nature at a proper distance; which at hand, is quite another thing — that

—that thofe objects, which we call picturefque, are only fuch as are more adapted to this art — and that as this art is moſt concealed in rough touches, rough objects are of courfe the moſt picturefque.—— Have we now attained a fatisfactory account of the matter?

Juſt as much fo, as before. Many painters of note did not ufe the rough ſtile of painting; and yet their pictures are as admirable, as the pictures of thofe, who did: nor are rough objects lefs picturefque on their canvas, than on the canvas of others: that is, they paint rough objects fmoothly.

Thus foiled, ſhould we in the true fpirit of inquiry, perfiſt; or honeſtly give up the caufe, and own we cannot fearch out the fource of this difference? I am afraid this is the truth, whatever airs of dogmatizing we may affume, inquiries into *principles* rarely end in fatisfaction. Could we even gain fatisfaction in our prefent queſtion, new doubts would arife. The very firſt principles of our art would be queſtioned. Difficulties would ſtart up *veſtibulum ante ipfum*. We ſhould be afked, What is beauty? What is taſte?—— Let us ſtep afide a moment, and liſten to the debates of the learned on thefe heads. They will at leaſt
ſhew

shew us, that however we may wish to fix *principles*, our inquiries are seldom satisfactory.

One philosopher will tell us, that taste is only the improvement of our own ideas. Every man has naturally his proportion of taste. The seeds of it are innate. All depends on cultivation.

Another philosopher following the analogy of nature, observes, that as all men's faces are different, we may well suppose their minds to be so likewise. He rejects the idea therefore of innate taste; and in the room of this makes *utility* the standard both of taste, and beauty.

A third philosopher thinks the idea of *utility* as absurd, as the last did that of *innate taste*. What, cries he, can I not admire the beauty of a resplendent sun-set, till I have investigated the *utility* of that peculiar radiance in the atmosphere? He then wishes we had a little less philosophy among us, and a little more common sense. *Common sense* is despised like other common things: but, in his opinion, if we made *common sense* the criterion in matters of art, as well as science, we should be nearer the truth.

A fourth

A fourth philofopher apprehends *common fenfe* to be our ftandard only in the ordinary affairs of life. The bounty of nature has furnifhed us with various other fenfes fuited to the objects, among which we converfe: and with regard to matters of tafte, it has fupplied us with what, he doubts not, we all feel within ourfelves, *a fenfe of beauty*.

Pooh! fays another learned inquirer, what is a *fenfe of beauty*? *Senfe* is a vague idea, and fo is *beauty*; and it is impoffible that any thing determined can refult from terms fo inaccurate. But if we lay afide a *fenfe of beauty*, and adopt *proportion*, we fhall all be right. *Proportion* is the great principle of tafte, and beauty. We admit it both in lines, and colours; and indeed refer all our ideas of the elegant kind to it's ftandard.

True, fays an admirer of the antique; but this proportion muft have a rule, or we gain nothing: and a *rule of proportion* there certainly is: but we may inquire after it in vain. The fecret is loft. The ancients had it. They well knew the principles of beauty; and had that unerring rule, which in all things adjufted their tafte. We fee it even in their flighteft vafes. In *their* works, proportion, tho varied through

through a thousand lines, is still the same; and if we could only discover their *principles of proportion*, we should have the arcanum of this science; and might settle all our disputes about taste with great ease.

Thus, in our inquiries into *first principles* we go on, without end, and without satisfaction. The human understanding is unequal to the search. In philosophy we inquire for them in vain—in physics—in metaphysics—in morals. Even in the polite arts, where the subject, one should imagine, is less recondite, the inquiry, we find, is equally vague. We are puzzled, and bewildered, but not informed: all is uncertainty; a strife of words; the old contest,

<blockquote>Empedocles, an Stertinii deliret acumen?</blockquote>

In a word, if *a cause be sufficiently understood*, it may suggest useful discoveries. But if it be *not so* (and where is our certainty in these disquisitions) it will unquestionably *mislead*.

END OF THE FIRST ESSAY.

D

As the subject of the foregoing essay is rather new, and I doubted, whether sufficiently founded in truth, I was desirous, before I printed it, that it should receive the *imprimatur* of sir Joshua Reynolds. I begged him therefore to look it over, and received the following answer.

<div style="text-align:right">London,
April 19, 1791.</div>

DEAR SIR,

Tho I read now but little, yet I have read with great attention the essay, which you was so good to put into my hands, on the difference between the *beautiful*, and the *picturesque*; and I may truly say, I have received from it much pleasure, and improvement.

Without opposing any of your sentiments, it has suggested an idea, that may be worth consideration — whether the epithet *picturesque* is not applicable to the excellences of the inferior schools, rather than to the higher.

The works of Michael Angelo, Raphael, &c. appear to me to have nothing of it; whereas Reubens, and the Venetian painters may almoſt be ſaid to have nothing elſe

Perhaps *picturesque* is ſomewhat ſynonymous to the word *taſte*; which we ſhould think improperly applied to Homer, or Milton, but very well to Pope, or Prior. I ſuſpect that the application of theſe words are to excellences of an inferior order; and which are incompatible with the grand ſtile.

You are certainly right in ſaying, that variety of tints and forms is picturesque; but it muſt be remembered, on the other hand, that the reverſe of this — (uniformity of colour, and a long continuation of lines,) produces grandeur.

I had an intention of pointing out the paſſages, that particularly ſtruck me; but I was afraid to uſe my eyes ſo much.

The eſſay has lain upon my table; and I think no day has paſſed without my looking at it, reading a little at a time. Whatever objections preſented themſelves at firſt view*,

were

* Sir Joſhua Reynolds had ſeen this eſſay, ſeveral years ago, through Mr. Maſon, who ſhewed it to him. He then made ſome

were done away on a closer inspection: and I am not quite sure, but that is the case in regard to the observation, which I have ventured to make on the word *picturesque*.

I am, &c.
JOSHUA REYNOLDS.

To the rev^d. Mr. Gilpin,
 Vicar's-hill.

THE ANSWER.

May 2d, 1791.

DEAR SIR,

I am much obliged to you for looking over my essay at a time, when the complaint in your eyes must have made an intrusion of this kind troublesome. But as the subject was rather novel, I wished much for your sanction; and you have given it me in as flattering a manner, as I could wish.

With regard to the term *picturesque*, I have always myself used it merely to denote *such objects, as are proper subjects for painting:*

* some objections to it: particularly he thought, that the term *picturesque*, should be applied only to the *works of nature*. His concession here is an instance of that candour, which is a very remarkable part of his character; and which is generally one of the distinguishing marks of true genius.

fo that, according to *my definition*, one of the cartoons, and a flower piece are equally picturefque.

I think however I underftand your idea of extending the term to what may be called *tafte in painting* — or the art of fafcinating the eye by fplendid colouring, and artificial combinations; which the inferior fchools valued; and the dignity of the higher perhaps defpifed. But I have feen fo little of the higher fchools, that I fhould be very ill able to carry the fubject farther by illuftrating a difquifition of this kind. Except the cartoons, I never faw a picture of Raphael's, that anfwered my idea; and of the original works of Michael Angelo I have little conception.

But tho I am unable, through ignorance, to appreciate fully the grandeur of the Roman fchool, I have at leaft the pleafure to find I have always held as a principle your idea of the production of greatnefs by *uniformity of colour, and a long continuation of line*: and when I fpeak of *variety*, I certainly do not mean to confound it's effects with thofe of *grandeur*.

I am, &c.

WILLIAM GILPIN.

To fir Jofhua Reynolds,
Leicefter-fquare.

(37)

is that, according to my definition, one of the cartoons, and a flower piece are equally picturesque.

I think, however, I understand your idea of extending the term to what may be called taste in painting,—or the art of estimating the are by splendid colouring, and artificial combinations, which the inferior [tempole] valued; and the dignity of the higher perhaps despised. But I have seen so little of the higher schools, that I should be very ill able to carry the subject farther by illustrating a disquisition of this kind. Except the cartoons, I never saw a useful Raphael; that refered my idea on the original works of Michael Angelo I have little conception.

That, tho' I am unable, through ignorance to appreciate fully the grandeur of the Roman school, I have at last the pleasure to find I have always held as a particular conducive of the production of grandeur, by majesty of colour, and a flag continuation of lines; and when I speak of beauty, I certainly do not mean to confound its effects with those of grandeur.

I am, &c.

WILLIAM GILPIN.

To Sr. Joshua Reynolds,
Leicester-square.

D 3

ESSAY II.

ON

PICTURESQUE TRAVEL.

ESSAY II.

ON

PICTURESQUE TRAVEL.

ESSAY II.

Enough has been said to shew the difficulty of *assigning causes:* let us then take another course, and amuse ourselves with *searching after effects.* This is the general intention of picturesque travel. We mean not to bring it into competition with any of the more useful ends of travelling. But as many travel without any end at all, amusing themselves without being able to give a reason why they are amused, we offer one end, which may possibly engage some vacant minds; and may indeed afford a rational amusement to such as travel for more important purposes.

In treating of picturesque travel, we may consider first it's *object*; and secondly its sources of *amusement.*

It's *object* is beauty of every kind, which either art, or nature can produce: but it is chiefly that species of *beauty*, which we have endeavoured to characterize in the preceding essay under the name of *picturesque*. This great object we pursue through the scenery of nature. We seek it among all the ingredients of landscape — trees — rocks — broken-grounds — woods — rivers — lakes — plains — vallies — mountains — and distances. These objects *in themselves* produce infinite variety. No two rocks, or trees are exactly the same. They are varied, a second time, by *combination*; and almost as much, a third time, by different *lights, and shades,* and other aerial effects. Sometimes we find among them the exhibition of *a whole*; but oftener we find only beautiful *parts**.

That we may examine picturesque objects with more ease, it may be useful to class them into the *sublime*, and the *beautiful*; tho, in fact, this distinction is rather inaccurate.

* As some of these topics have been occasionally mentioned in other picturesque works, which the author has given the public, they are here touched very slightly: only the subject required they should be brought together.

Sublimity

Sublimity alone cannot make an object *picturesque*. However grand the mountain, or the rock may be, it has no claim to this epithet, unless it's form, it's colour, or it's accompaniments have *some degree of beauty*. Nothing can be more sublime, than the ocean: but wholly unaccompanied, it has little of the picturesque. When we talk therefore of a sublime object, we always understand, that it is also beautiful: and we call it sublime, or beautiful, only as the ideas of sublimity, or of simple beauty prevail.

The *curious*, and *fantastic* forms of nature are by no means the favourite objects of the lovers of landscape. There may be beauty in a *curious* object; and so far it may be picturesque: but we cannot admire it merely for the sake of it's curiosity. The *lusus naturæ* is the naturalist's province, not the painter's. The spiry pinnacles of the mountain, and the castle-like arrangement of the rock, give no peculiar pleasure to the picturesque eye. It is fond of the simplicity of nature; and sees most beauty in her *most usual* forms. The *Giant's causeway* in Ireland may strike it as a novelty; but the lake of Killarney attracts it's attention. It would range with supreme
delight

delight among the fweet vales of Switzerland; but would view only with a tranfient glance, the Glaciers of Savoy. Scenes of this kind, as unufual, may please *once*; but the great works of nature, in her fimpleft and pureft ftile, open inexhaufted fprings of amufement.

But it is not only the *form*, and the *compofition* of the objects of landfcape, which the picturefque eye examines; it connects them with the atmofphere, and feeks for all thofe various effects, which are produced from that vaft, and wonderful ftorehoufe of nature. Nor is there in travelling a greater pleafure, than when a fcene of grandeur burfts unexpectedly upon the eye, accompanied with fome accidental circumftance of the atmofphere, which harmonizes with it, and gives it double value.

Befides the *inanimate* face of nature, it's *living forms* fall under the picturefque eye, in the courfe of travel; and are often objects of great attention. The anatomical ftudy of figures is not attended to: we regard them merely as the ornament of fcenes. In the human figure we contemplate neither *exactnefs of form*, nor *expreffion*, any farther than it is fhewn in *action*: we merely confider general fhapes, dreffes, groups, and occupations; which

we

we often find *cafually* in greater variety, and beauty, thán any feleƈtion can procure.

In the fame manner animals are the objeƈts of our attention, whether we find them in the park, the foreſt, or the field. Here too we confider little more than their general forms, aƈtions, and combinations. Nor is the picturefque eye fo faſtidious as to defpife even lefs confiderable objeƈts. A flight of birds has often a pleafing effeƈt. In ſhort, every form of life and being may have it's ufe as a piƈturefque objeƈt, till it become too fmall for attention.

But the piƈturefque eye is not merely reſtriƈted to nature. It ranges through the limits of art. The piƈture, the ſtatue, and the garden are all the objeƈts of it's attention. In the embellifhed pleafure-ground particularly, tho all is neat, and elegant—far too neat and elegant for the ufe of the pencil—yet, if it be well laid out, it exhibits the *lines*, and *principles* of landfcape; and is well worth the ſtudy of the piƈturefque traveller. Nothing is wanting, but what his imagination can fupply—a change from fmooth to rough*.

* See page 8.

But

But among all the objects of art, the picturesque eye is perhaps moſt inquiſitive after the elegant relics of ancient architecture; the ruined tower, the Gothic arch, the remains of caſtles, and abbeys. Theſe are the richeſt legacies of art. They are conſecrated by time; and almoſt deſerve the veneration we pay to the works of nature itſelf.

Thus univerſal are the objects of picturesque travel. We purſue *beauty* in every ſhape; through nature, through art; and all it's various arrangements in form, and colour; admiring it in the grandeſt objects, and not rejecting it in the humbleſt.

After the *objects* of picturesque travel, we conſider it's *ſources of amuſement*—or in what way the mind is gratified by theſe objects.

We might begin in moral ſtile; and conſider the objects of nature in a higher light, than merely as amuſement. We might obſerve, that a ſearch after beauty ſhould naturally lead the mind to the great origin of all beauty; to the

——————— firſt good, firſt perfect, and firſt fair.

But

But tho in theory this seems a natural climax, we insist the less upon it, as in fact we have scarce ground to hope, that every admirer of *picturesque beauty*, is an admirer also of the *beauty of virtue*; and that every lover of nature reflects, that

>Nature is but a name for an *effect*,
>Whose *cause* is God. ———

If however the admirer of nature can turn his amusements to a higher purpose; if it's great scenes can inspire him with religious awe; or it's tranquil scenes with that complacency of mind, which is so nearly allied to benevolence, it is certainly the better. *Apponat lucro.* It is so much into the bargain; for we dare not *promise* him more from picturesque travel, than a rational, and agreeable amusement. Yet even this may be of some use in an age teeming with licentious pleasure; and may in this light at least be considered as having a moral tendency.

The first source of amusement to the picturesque traveller, is the *pursuit* of his object—the expectation of new scenes continually opening, and arising to his view. We suppose the country to have been unexplored. Under this circumstance the mind is kept constantly in an
<div style="text-align:right">agreeable</div>

agreeable fuspence. The love of novelty is the foundation of this pleasure. Every distant horizon promises something new; and with this pleasing expectation we follow nature through all her walks. We pursue her from hill to dale; and hunt after those various beauties, with which she every where abounds.

The pleasures of the chace are universal. A hare started before dogs is enough to set a whole country in an uproar. The plough, and the spade are deserted. Care is left behind; and every human faculty is dilated with joy.—And shall we suppose it a greater pleasure to the sportsman to pursue a trivial animal, than it is to the man of taste to pursue the beauties of nature? to follow her through all her recesses? to obtain a sudden glance, as she flits past him in some airy shape? to trace her through the mazes of the cover? to wind after her along the vale? or along the reaches of the river.

After the pursuit we are gratified with the *attainment* of the object. Our amusement, on this head, arises from the employment of the mind in examining the beautiful scenes we have found. Sometimes we examine them under the idea of a *whole:* we admire the composition,

position, the colouring, and the light, in one *comprehensive view.* When we are fortunate enough to fall in with scenes of this kind, we are highly delighted. But as we have less frequent opportunities of being thus gratified, we are more commonly employed in analyzing the *parts of scenes*: which may be exquisitely beautiful, tho unable to produce a whole. We examine what would amend the composition: how little is wanting to reduce it to the rules of our art; how trifling a circumstance sometimes forms the limit between beauty, and deformity. Or we compare the objects before us with other objects of the same kind : — or perhaps we compare them with the imitations of art From all these operations of the mind results great amusement.

But it is not from this *scientifical* employment, that we derive our chief pleasure. We are most delighted, when some grand scene, tho perhaps of incorrect composition, rising before the eye, strikes us beyond the power of thought — when the *vox faucibus hæret*; and every mental operation is suspended. In this pause of intellect; this *deliquium* of the soul, an enthusiastic sensation of pleasure overspreads it,

it, previous to any examination by the rules of art. The general idea of the scene makes an impression, before any appeal is made to the judgment. We rather *feel*, than *survey* it.

This high delight is generally indeed produced by the scenes of nature; yet sometimes by artificial objects. Here and there a capital picture will raise these emotions: but oftener the rough sketch of a capital master. This has sometimes an astonishing effect on the mind; giving the imagination an opening into all those glowing ideas, which inspired the artist; and which the imagination *only* can translate. In general however the works of art affect us coolly; and allow the eye to criticize at leisure.

Having gained by a minute examination of incidents a compleat idea of an object, our next amusement arises from inlarging, and correcting our general stock of ideas. The variety of nature is such, that *new objects*, and new combinations of them, are continually adding something to our fund, and inlarging our collection: while the *same kind of object* occurring frequently, is seen under various shapes; and makes us, if I may so speak, more learned in nature. We get it more by heart.

He

He who has seen only one oak-tree, has no compleat idea of an oak in general: but he who has examined thousands of oak-trees, must have seen that beautiful plant in all it's varieties; and obtains a full, and compleat idea of it.

From this correct knowledge of objects arises another amusement; that of representing, by a few strokes in a sketch, those ideas, which have made the most impression upon us. A few scratches, like a short-hand scrawl of our own, legible at least to ourselves, will serve to raise in our minds the remembrance of the beauties they humbly represent; and recal to our memory even the splendid colouring, and force of light, which existed in the real scene. Some naturalists suppose, the act of ruminating, in animals, to be attended with more pleasure, than the act of grosser mastication. It may be so in travelling also. There may be more pleasure in recollecting, and recording, from a few transient lines, the scenes we have admired, than in the present enjoyment of them. If the scenes indeed have *peculiar greatness*, this secondary pleasure cannot be attended with those enthusiastic feelings, which accompanied the real exhibition. But, in

general, tho it may be a calmer species of pleasure, it is more uniform, and uninterrupted. It flatters us too with the idea of a sort of creation of our own; and it is unallayed with that fatigue, which is often a considerable abatement to the pleasures of traversing the wild, and savage parts of nature.—— After we have amused *ourselves* with our sketches, if we can, in any degree, contribute to the amusement of others also, the pleasure is surely so much inhanced.

There is still another amusement arising from the correct knowledge of objects; and that is the power of creating, and representing *scenes of fancy*; which is still more a work of creation, than copying from nature. The imagination becomes a camera obscura, only with this difference, that the camera represents objects as they really are: while the imagination, impressed with the most beautiful scenes, and chastened by rules of art, forms it's pictures, not only from the most admirable parts of nature; but in the best taste.

Some artists, when they give their imagination play, let it loose among uncommon scenes — such as perhaps never existed: whereas the nearer they approach the simple standard of

of nature, in it's moſt beautiful forms, the more admirable their fictions will appear. It is thus in writing romances. The correct taſte cannot bear thoſe unnatural ſituations, in which heroes, and heroines are often placed: whereas a ſtory, *naturally*, and of courſe *affectingly* told, either with a pen, or a pencil, tho known to be a fiction, is conſidered as a tranſcript from nature; and takes poſſeſſion of the heart. The *marvellous* diſguſts the ſober imagination; which is gratified only with the pure characters of nature.

——————————— Beauty beſt is taught
By thoſe, the favoured few, whom heaven has lent
The power to ſeize, ſelect, and reunite
Her lovelieſt features; and of theſe to form
One archetype compleat, of ſovereign grace.
Here nature ſees her faireſt forms more fair;
Owns them as hers, yet owns herſelf excelled
By what herſelf produced, ——————

But if we are unable to embody our ideas even in a humble ſketch, yet ſtill a ſtrong *impreſſion of nature* will enable us to judge of the *works of art*. Nature is the archetype. The ſtronger therefore the impreſſion, the better the judgment.

We are, in some degree, also amused by the very visions of fancy itself. Often, when slumber has half-closed the eye, and shut out all the objects of sense, especially after the enjoyment of some splendid scene; the imagination, active, and alert, collects it's scattered ideas, transposes, combines, and shifts them into a thousand forms, producing such exquisite scenes, such sublime arrangements, such glow, and harmony of colouring, such brilliant lights, such depth, and clearness of shadow, as equally foil description, and every attempt of artificial colouring.

It may perhaps be objected to the pleasureable circumstances, which are thus said to attend picturesque travel, that we meet as many disgusting, as pleasing objects; and the man of taste therefore will be as often offended, as amused.

But this is not the case. There are few parts of nature, which do not yield a picturesque eye some amusement.

―――――――――― Believe the muse,
She does not know that unauspicious spot,
Where beauty is thus niggard of her store.

Believe

> Believe the muse, through this terrestrial waste
> The seeds of grace are sown, profusely sown,
> Even where we least may hope. ———

It is true, when some large tract of barren country *interrupts* our expectation, wound up in quest of any particular scene of grandeur, or beauty, we are apt to be a little peevish; and to express our discontent in hasty exaggerated phrase. But when there is no disappointment in the case, even scenes the most barren of beauty, will furnish amusement.

Perhaps no part of England comes more under this description, than that tract of barren country, through which the great military road passes from Newcastle to Carlisle. It is a waste, with little interruption, through a space of forty miles. But even here, we have always something to amuse the eye. The interchangeable patches of heath, and green-sward make an agreeable variety. Often too on these vast tracts of intersecting grounds we see beautiful lights, softening off along the sides of hills: and often we see them adorned with cattle, flocks of sheep, heath-cocks, grouse, plover, and flights of other wild-fowl. A group of cattle, standing in

the shade on the edge of a dark hill, and relieved by a lighter distance beyond them, will often make a compleat picture without any other accompaniment. In many other situations also we find them wonderfully pleasing; and capable of making pictures amidst all the deficiencies of landscape. Even a winding road itself is an object of beauty; while the richness of the heath on each side, with the little hillocs, and crumbling earth give many an excellent lesson for a foreground. When we have no opportunity of examining the *grand scenery* of nature, we have every where at least the means of observing with what a *multiplicity of parts*, and yet with what *general simplicity*, she covers every surface.

But if we let the *imagination* loose, even scenes like these, administer great amusement. The imagination can plant hills; can form rivers, and lakes in vallies; can build castles, and abbeys; and if it find no other amusement, can dilate itself in vast ideas of space.

But altho the picturesque traveller is seldom disappointed with *pure nature*, however rude,
yet

yet we cannot deny, but he is often offended with the productions of art. He is difgufted with the formal feparations of property — with houfes, and towns, the haunts of men, which have much oftener a bad effect in landfcape, than a good one. He is frequently difgufted alfo, when art aims more at beauty, than fhe ought. How flat, and infipid is often the garden-fcene; how puerile, and abfurd! the banks of the river how fmooth, and par-rallel? the lawn, and it's boundaries, how unlike nature! Even in the capital collection of pictures, how feldom does he find *defign, compofition, expreffion, character,* or *harmony* either in *light,* or *colouring!* and how often does he drag through faloons, and rooms of ftate, only to hear a catalogue of the names of mafters!

The more refined our tafte grows from the *ftudy of nature,* the more infipid are the *works of art.* Few of it's efforts pleafe. The idea of the great original is fo ftrong, that the copy muft be pure, if it do not difguft. But the varieties of nature's charts are fuch, that, ftudy them as we can, new varieties will always arife: and let our tafte be ever fo refined, her works, on which it is formed,

formed, at least when we consider them as *objects*, must always go beyond it; and furnish fresh sources both of pleasure and amusement.

END OF THE SECOND ESSAY.

ESSAY III.

ON

THE ART OF SKETCHING LANDSCAPE.

ESSAY III.

ON

THE ART OF SKETCHING
LANDSCAPE.

ESSAY III.

The *art of sketching* is to the picturesque traveller, what the art of writing is to the scholar. Each is equally necessary to *fix* and *communicate* it's respective ideas.

Sketches *are* either taken from the *imagination*, or from *nature*.——When the *imaginary sketch* proceeds from the hands of a master, it is very valuable. It is his first conception: which is commonly the strongest, and the most brilliant. The imagination of a painter, really great in his profession, is a magazine abounding with all the elegant forms, and striking effects, which are to be found in nature. These, like a magician, he calls up at pleasure with a wave of his hand; bringing before the eye, sometimes a scene from history, or romance;

mance; and sometimes from the inanimate parts of nature. And in these happy moments when the enthusiasm of his art is upon him, he often produces from the glow of his imagination, with a few bold strokes, such wonderful effusions of genius, as the more sober, and correct productions of his pencil cannot equal.

It will always however be understood, that such sketches must be *examined* also by an eye *learned in the art*, and accustomed to picturesque ideas — an eye, that can take up the half-formed images, as the master leaves them; give them a new creation; and make up all that is not expressed from it's own store-house. —— I shall however dwell no longer on *imaginary sketching*, as it hath but little relation to my present subject. Let me only add, that altho this essay is meant chiefly to assist the picturesque traveller in taking *views from nature*, the method recommended, as far as it relates to *execution*, may equally be applied to *imaginary sketches*.

Your intention in taking *views from nature*, may either be to *fix them in your own memory*
—— or

—— or to *convey, in some degree, your ideas to others.*

With regard to the former, when you meet a scene you wish to sketch, your first consideration is to get it in the best point of view. A few paces to the right, or left, make a great difference. The ground, which folds awkwardly here, appears to fold more easily there: and that long black curtain of the castle, which is so unpleasing a circumstance, as you stand on one side, is agreeably broken by a buttress on another

Having thus fixed your point of view, your next consideration, is, how to reduce it properly within the compass of your paper: for the scale of *nature* being so very different from *your* scale, it is a matter of difficulty, without some experience, to make them coincide. If the landscape before you is extensive, take care you do not include too much: it may perhaps be divided more commodiously into two sketches. —— When you have fixed the portion of it, you mean to take, fix next on two or three principal points, which you may just mark on your paper. This will enable you the more easily to ascertain the relative situation of the several objects.

In

In sketching, black-lead is the first instrument commonly used. Nothing glides so volubly over paper, and executes an idea so quickly. — It has besides, another advantage; it's grey tint corresponds better with a wash, than black, or red chalk, or any other pastile. — It admits also of easy correction

The virtue of these hasty, black-lead sketches consists in catching readily the *characteristic features* of a scene. Light and shade are not attended to. It is enough if you express *general shapes*; and the relations, which the several intersections of a country bear to each other. A few lines drawn on the spot, will do this. " Half a word, says Mr. Gray, fixed on, or near the spot, is worth all our recollected ideas. When we trust to the picture, that objects draw of themselves on the mind, we deceive ourselves. Without accurate, and particular observation, it is but ill-drawn at first: the outlines are soon blurred: the colours every day grow fainter; and at last, when we would produce it to any body, we are obliged to supply it's defects

with

with a few ftrokes of our own imagination*."—What Mr. Gray fays relates chiefly to *verbal* defcription: but in *lineal* defcription it is equally true. The leading ideas muft be fixed on the fpot: if left to the memory, they foon evaporate.

The lines of black-lead, and indeed of any *one* inftrument, are fubject to the great inconvenience of *confounding diftances*. If there are two, or three diftances in the landfcape, as each of them is expreffed by the *fame kind* of line, the eye forgets the diftinction, even in half a day's travelling; and all is confufion. To remedy this, a few written references, made on the fpot, are neceffary, if the landfcape be at all complicated. The traveller fhould be accurate in this point, as the fpirit of his view depends much on the proper obfervance of diftances.—— At his firft leifure however he will review his fketch: add a few ftrokes with a pen, to mark the near grounds; and by a flight wafh of Indian ink, throw in a few general lights, and fhades, to keep all fixed, and in it's place.—— A fketch

* Letter to Mr. Palgrave, page 272, 4to.

need not be carried farther, when it is intended merely to *affift* *our own memory.*

But when a fketch is intended *to convey in fome degree, our ideas to others*, it is neceffary, that it fhould be fomewhat more adorned. To *us* the fcene, familiar to our recollection, may be fuggefted by a few rough ftrokes: but if you wifh to raife the idea, *where none exifted before*, and to do it *agreeably*, there fhould be fome *compofition* in your fketch — a degree of *correctnefs*, and *expreffion* in the out-line — and fome *effect of light*. A little *ornament* alfo from figures, and other circumftances may be introduced. In fhort, it fhould be fo far dreffed, as to give fome idea of a picture. I call this an *adorned fketch*; and fhould fketch nothing, that was not *capable* of being thus dreffed. An unpicturefque affemblage of objects; and, in general, all untractable fubjects, if it be neceffary to reprefent them, may be given as plans, rather than as pictures.

In the firft place, I fhould advife the traveller by no means to work his *adorned fketch* upon

upon his *original one*. His firſt ſketch is the ſtandard, to which, in the abſence of nature, he muſt at leaſt recur for his *general ideas*. By going over it again, the original ideas may be loſt, and the whole thrown into confuſion. Great maſters therefore always ſet a high value on their ſketches from nature. On the ſame principle the picturesque traveller preſerves his original ſketch, tho in itſelf of little value, to keep him within proper bounds.

This matter being ſettled, and the *adorned ſketch* begun anew, the firſt point is to fix the *compoſition*.

But the *compoſition*, you ſay, is already fixed by the *original ſketch*.

It is true: but ſtill it may admit many little alterations, by which the forms of objects may be aſſiſted; and yet the reſemblance not disfigured: as the ſame piece of muſic, performed by different maſters, and graced variouſly by each, may yet continue ſtill the ſame. We muſt ever recollect that nature is moſt defective in compoſition; and *muſt* be a little aſſiſted. Her ideas are too vaſt for picturesque uſe, without the reſtraint of rules. Liberties however with

truth muſt be taken with caution: tho at the ſame time a diſtinction may be made between an *object*, and a *ſcene*. If I give the ſtriking features of the *caſtle*, or *abbey*, which is my *object*, I may be allowed ſome little liberty in bringing appendages (which are not eſſential features) within the rules of my art. But in a *ſcene*, the whole view becomes the portrait; and if I flatter here, I muſt flatter with delicacy.

But whether I repreſent an *object*, or a *ſcene*, I hold myſelf at perfect liberty, in the firſt place, to diſpoſe the *foreground* as I pleaſe; reſtrained only by the analogy of the country. I take up a tree here, and plant it there. I pare a knoll, or make an addition to it. I remove a piece of paling — a cottage — a wall — or any removeable object, which I diſlike. In ſhort, I do not ſo much mean to exact a liberty of introducing what does not exiſt; as of making a few of thoſe ſimple variations, of which all ground is eaſily ſuſceptible, and which time itſelf indeed is continually making. All this my art exacts:

> She rules the foreground; ſhe can ſwell, or ſink
> It's ſurface; here her leafy ſkreen oppoſe,
> And there withdraw; here part the varying greens,

And

And croud them there in one promifcuous gloom,
As beft befits the genius of the fcene.

The foreground indeed is a mere fpot, compared with the extenfion of diftance: in itfelf it is of trivial confequence; and cannot well be called a *feature of the fcene.* And yet, tho fo little effential in *giving a likenefs*, it is more fo than any other part in *forming a compofition.* It refembles thofe deep tones in mufic, which give a value to all the lighter parts; and harmonize the whole.

As the foreground therefore is of fo much confequence, *begin* your *adorned fketch* with fixing this very material part. It is eafier to afcertain the fituation of your foreground, as it lies fo near the bottom of your paper, than any other part; and this will tend to regulate every thing elfe. In your rough fketch it has probably been inaccurately thrown in. You could not fo eafily afcertain it, till you had gotten all your landfcape together. You might have carried it too high on your paper; or have brought it too low. As you have now the general fcheme of your landfcape before you, you may adjuft it properly; and give it it's due proportion. —— I fhall add only, on the fubject of foregrounds,

grounds, that you need not be very nice in finishing them, even when you mean to *adorn* your sketches. In a finished picture the foreground is a matter of great nicety: but in a sketch little more is necessary, than to produce the effect you desire.

Having fixed your foreground, you consider in the same way, tho with more caution, the other parts of your *composition*. In a *hasty transcript* from nature, it is sufficient to take the lines of the country just as you find them: but in your *adorned sketch* you must grace them a little, where they run false. You must contrive to hide offensive parts with wood; to cover such as are too bald, with bushes; and to remove little objects, which in nature push themselves too much in sight, and serve only to introduce too many parts into your *composition*. In this happy adjustment the grand merit of your sketch consists. No beauty of light, colouring, or execution can atone for the want of *composition*. It is the foundation of all picturesque beauty. No finery of dress can set off a person, whose figure is awkward and uncouth.

Having thus *digested the composition* of your *adorned sketch*, which is done with black-lead,

you

you proceed to give a ſtronger outline to the foreground, and nearer parts. Some indeed uſe no outline, but what they freely work with a bruſh on their black-lead ſketch. This comes neareſt the idea of painting; and as it is the moſt free, it is perhaps alſo the moſt excellent method: but as a black-lead outline is but a feeble termination, it requires a greater force in the waſh to produce an effect; and of courſe more the hand of a maſter. The hand of a maſter indeed produces an effect with the rudeſt materials: but theſe precepts aim only at giving a few inſtructions to the tyroes of the art; and ſuch will perhaps make their outline the moſt effectually with a pen. As the pen is more determined than black-lead, it leaves less to the bruſh, which I think the more difficult inſtrument.—— Indian ink, (which may be heightened, or lowered to any degree of ſtrength, or weakneſs, ſo as to touch both the nearer, and more diſtant grounds,) is the beſt ink you can uſe. You may give a ſtroke with it ſo light as to confine even a remote diſtance; tho ſuch a diſtance is perhaps beſt left in black-lead.

But when we speak of an *outline*, we do not mean a *simple contour*; which, (however necessary in a correct figure,) would in landscape be formal. It is enough to mark with a few free touches of the pen, here and there, some of the breaks, and roughnesses, in which the richness of an object consists. But you must first determine the situation of your lights, that you may mark these touches on the shadowy side.

Of these free touches with a pen the chief characteristic is *expression*; or the art of giving each object, that peculiar touch, whether smooth, or rough, which best expresses it's form. The art of painting, in it's highest perfection, cannot give the richness of nature. When we examine any natural form, we find the multiplicity of it's parts beyond the highest finishing; and indeed generally an attempt at the highest finishing would end in stiffness. The painter is obliged therefore to deceive the eye by some natural tint, or expressive touch, from which the imagination takes it's cue. How often do we see in the landscapes of Claude the full effect of distance; which, when examined closely, consists of a simple dash, tinged with the hue of nature,

intermixed

intermixed with a few expreffive touches?— If then thefe expreffive touches are neceffary where the mafter carries on the deception both in form and colour; how neceffary muft they be in mere fketches, in which colour, the great vehicle of deception, is removed?— The art however of giving thofe expreffive marks with a pen, which imprefs ideas, is no common one. The inferior artift may give them by chance: but the mafter only gives them with precifion.——Yet a fketch may have it's ufe, and even it's merit, without thefe ftrokes of genius.

As the difficulty of ufing the pen is fuch, it may perhaps be objected, that it is an improper inftrument for a tyro. It lofes it's grace, if it have not a ready and off-hand execution.

It is true: but what other inftrument fhall we put into his hands, that will do better? His black-lead, his brufh, whatever he touches, will be unmafterly. But my chief reafon for putting a pen into his hands, is, that without a pen it will be difficult for him to preferve his outline, and diftances. His touches with a pen may be unmafterly, we allow: but ftill they will preferve *keeping* in his landfcape,
without

without which the whole will be a blot of confusion.——Nor is it perhaps so difficult to obtain some little freedom with the pen. I have seen assiduity, attended with but little genius, make a considerable progress in the use of this instrument; and produce an effect by no means displeasing.—If the drawing be large, I should recommend a reed-pen, which runs more freely over paper.

When the outline is thus drawn, it remains to add light, and shade. In this operation the effect of a *wash* is much better, than of lines hatched with a pen. A brush will do more in one stroke, and generally more effectually, than a pen can do in twenty*. For this purpose, we need only

* I have seldom seen any drawings etched with a pen, that pleased me. The most masterly sketches in this way I ever saw, were taken in the early part of the life of a gentleman, now very high in his profession, Mr. Mitford of Lincoln's inn. They were taken in several parts of Italy, and England; and tho they are mere memorandum-sketches, the subjects are so happily chosen — they are so characteristic of the countries they represent — and executed with so free, and expressive a touch, that I examined them with pleasure, not only as faithful portraits, (which I believe they all are) but as master-pieces, as far as they go, both in composition, and execution

Indian

Indian ink; and perhaps a little biſtre, or burnt umber. With the former we give that greyiſh tinge, which belongs to the ſky, and diſtant objects; and with the latter (mixed more, or leſs with Indian ink) thoſe warm touches, which belong to the foreground. Indian ink however alone makes a good waſh both for the foreground, and diſtance.

But mere *light and ſhade* are not ſufficient: ſomething of *effect* alſo ſhould be aimed at in the *adorned ſketch*. Mere light and ſhade propoſe only the *ſimple illumination* of objects. *Effect*, by balancing *large maſſes* of each, gives the whole a greater force.——Now tho in the exhibitions of nature, we commonly find only the *ſimple illumination* of objects; yet as we often do meet with *grand effects* alſo, we have ſufficient authority to uſe them: for under theſe circumſtances we ſee nature in her beſt attire, in which it is our buſineſs to deſcribe her.

As to giving rules for the production of effect, the ſubject admits only the *moſt general*. There muſt be a ſtrong oppoſition of light and ſhade; in which the ſky, as well as the landſcape, muſt combine. But in what way this oppoſition muſt be varied — where

the

the full tone of fhade muft prevail — where the full effufion of light — or where the various degrees of each — depends intirely on the circumftances of the *compofition*. All you can do, is to examine your drawing (yet in it's naked outline) with care; and endeavour to find out where the force of the light will have the beft effect. But this depends more on *tafte*, than on *rule*.

One thing both in light and fhade fhould be obferved, efpecially in the former — and that is *gradation*; which gives a force beyond what a glaring difplay of light can give. The effect of light, which falls on the ftone, produced as an illuftration of this idea, would not be fo great, unlefs it *graduated* into fhade.

—— In the following ftanza Mr. Gray has with great beauty and propriety, illuftrated the viciffitudes of life by the principles of picturefque effect.

> Still where rofy pleafure leads,
> See a kindred grief purfue:
> Behind the fteps, which mifery treads,
> Approaching comfort view.
> The hues of blifs more brightly glow,
> Chaftifed by fabler tints of woe;
> And, blended, form with artful ftrife,
> The ftrength, and harmony of life.

I may

I may farther add, that the production of an *effect* is particularly necessary in *drawing*. In *painting*, colour in some degree makes up the deficiency: but in simple clair-obscure there is no succedaneum. It's force depends on effect; the virtue of which is such, that it will give a value even to a barren subject. Like striking the chords of a musical instrument, it will produce harmony, without any richness of composition.

It is farther to be observed, that when objects *are in shadow*, the light, (as it is then a reflected one,) falls on the opposite side to that, on which it falls, when they are inlightened.

In *adorning your sketch*, a figure, or two may be introduced with propriety. By figures I mean moving objects, as waggons, and boats, as well as cattle, and men. But they should be introduced sparingly. In profusion they are affected. Their chief use is, to mark a road — to break a piece of foreground — to point out the horizon in a sea-view — or to carry off the distance of retiring water by the contrast of a dark sail, not quite so distant, placed before it. But in figures thus designed for the ornament of a sketch, a few slight touches

touches are sufficient. Attempts at finishing offend*.

Among trees, little distinction need be made, unless you introduce the pine, or the cypress, or some other singular form. The oak, the ash, and the elm, which bear a distant resemblance to each other may all be characterized alike. In a sketch, it is enough to mark *a tree*. One distinction indeed is often necessary even in sketches; and that is, between full-leaved trees, and those of straggling ramification. In composition we have often occasion for both, and therefore the hand should be used readily to execute either. If we have a general idea of the oak, for instance, as a light tree; and of the beech as a heavy one, it is sufficient.

It adds, I think, to the beauty of a sketch to stain the paper slightly with a reddish, or yellowish tinge; the use of which is to give a more pleasing tint to the ground of the drawing by taking off the glare of the paper. It adds also, if it be not too strong, a degree of harmony to the rawness of black and white.

* See the preceding essay.

The ſtrength, or faintneſs of this tinge depends on the ſtrength, or faintneſs of the drawing. A ſlight ſketch, ſhould be ſlightly tinged. But if the drawing be highly finiſhed, and the ſhadows ſtrong; the tinge alſo may be ſtronger. Where the ſhadows are very dark, and the lights catching, a deep tinge may ſometimes make it a good ſun-ſet. ——— This tinge may be laid on, either before, or after the drawing is made. In general, I ſhould prefer the latter method; becauſe, while the drawing is yet on white paper, you may correct it with a ſponge, dipt in water; which will, in a good degree, efface Indian ink. But if you rub out any part, *after* the drawing is ſtained, you cannot eaſily lay the ſtain again upon the rubbed part without the appearance of a patch.

Some chuſe rather to add a little colour to their ſketches. My inſtructions attempt not the art of mixing a variety of tints; and finiſhing a drawing from nature; which is generally executed in colours from the beginning, without any uſe of Indian ink; except

as

as a grey tint, uniting with other colours. This indeed, when chaftely executed, (which is not often the cafe) exceeds in beauty every other fpecies of drawing. It is however beyond my fkill to give any inftruction for this mode of drawing. All I mean is only to offer a modeft way of tinting a fketch already finifhed in Indian ink, by the addition of a little colour; which will give fome diftinction to objects; and introduce rather a gayer ftile into a landfcape.

When you have finifhed your fketch therefore with Indian ink, as far as you propofe, tinge the whole over with fome light horizon hue. It may be the rofy tint of morning; or the more ruddy one of evening; or it may incline more to a yellowifh, or a greyifh caft. The firft tint you fpread over your drawing, is compofed of light red, and oaker, which make an orange. It may incline to one, or the other, as you chufe. By wafhing this tint over your *whole drawing*, you lay a foundation for harmony. When this wafh is nearly dry, repeat it in the horizon; foftening it off into the fky, as you afcend. —— Take next a purple tint, composed of lake, and blue,

inclining

inclining rather to the former; and with this, when your firſt waſh is dry, form your clouds; and then ſpread it, as you did the firſt tint, over your *whole drawing*, except where you leave the horizon-tint. This ſtill ſtrengthens the idea of harmony. Your ſky, and diſtance are now finiſhed.

You next proceed to your *middle*, and *fore-grounds*; in both which you diſtinguiſh between the *ſoil*, and the *vegetation*. Waſh the *middle grounds* with a little umber. This will be ſufficient for the *ſoil*. The *ſoil* of the *fore-ground* you may go over with a little light red. The *vegetation* of each may be waſhed with a green, compoſed of blue, and oker; adding a little more oker as you proceed nearer the eye; and on the neareſt grounds a little burnt terra Sienna. This is ſufficient for the *middle grounds*. The *foreground* may farther want a little heightening both in the *ſoil*, and *vegetation*. In the *ſoil* it may be given in the lights with burnt terra Sienna; mixing in the ſhadows a little lake: and in the *vegetation* with gall-ſtone; touched in places, and occaſionally varied, with burnt terra Sienna.

Trees on the foreground are conſidered as a part of it; and their foliage may be co-

loured like the vegetation in their neighbourhood. Their stems may be touched with burnt terra Sienna. —— Trees, in middle distances are darker than the lawns, on which they stand. They must therefore be touched twice over with the tint, which is given only once to the lawn.

If you represent clouds with bright edges, the edges must be left in the first orange; while the tint over the other part of the horizon is repeated, as was mentioned before.

A lowering, cloudy sky is represented by, what is called, a grey tint, composed of lake, blue, and oker. As the shadow deepens, the tint should incline more to blue.

The several tints mentioned in the above process, may perhaps the most easily be mixed before you begin; especially if your drawing be large. Dilute the raw colours in saucers: keep them clean, and distinct; and from them, mix your tints in other vessels.

I shall only add, that the *strength of the colouring* you give your sketch, must depend (as in the last case, where the whole drawing is tinged,) on the height, to which you have carried the Indian ink *finishing*. If it be only a
slight

slight sketch, it will bear only a light wash of colour.

This mode however of tinting a drawing, even when you tint as high as these instructions reach, is by no means calculated to produce any effect of colouring: but it is at least sufficient to preserve harmony. *This* you may preserve: an *effect of colouring* you cannot easily attain. It is something however to avoid a disagreeable excess: and there is nothing surely so disagreeable to a correct eye, as a tinted drawing (such as we often see) in which greens, and blues, and reds, and yellows are daubed without any attention to harmony. It is to the picturesque eye, what a discord of harsh notes is to a musical ear.*

But the advocate for these glaring tints may perhaps say, he does not make his sky more

* I have been informed, that many of the purchasers of the first edition of this work, have thought the plate, which illustrates what hath been said above, was not so highly coloured, as they wished it to have been. I apprehend this was chiefly owing to the particular care I took, to have it rather *under*, than *over* tinted. The great danger, I think, is on the side of being over-loaded with colour. I have however taken care that a number of the prints in this edition shall be coloured higher, that each purchaser may have an option.

blue than nature; nor his grafs, and trees more green.

Perhaps fo: but unlefs he could work up his drawing with the *finifhing* of nature alfo, he will find the effect very unequal. Nature mixes a variety of femi-tints with her brighteft colours: and tho the eye cannot readily feparate them, they have a general chaftizing effect; and keep the feveral tints of landfcape within proper bounds, which a glare of deep colours cannot do. Befides, this chaftizing hue is produced in nature by numberlefs little fhadows, beyond the attention of art, which fhe throws on leaves, and piles of grafs, and every other minute object; all of which, tho not eafily diftinguifhed in *particulars*, tell *in the whole*, and are continually chaftening the hues of nature.

Before I conclude thefe remarks on fketching, it may be ufeful to add a few words, and but a few, on perfpective. The nicer parts of it contain many difficulties; and are of little ufe in common landfcape. Indeed in wild, irregular objects, it is hardly poffible to apply it. The eye muft regulate the winding
of

Vanishing Point

---- Nearest
Perpendicular

First vanishing line.

Vanishing

of the river; and the receding of the diftant hill. Rules of perfpective give little affiftance. But it often happens, that on the nearer grounds you wifh to place a more regular object, which requires fome little knowledge of perfpective The fubject therefore fhould not be left wholly untouched.

If a building ftand exactly in front, none of it's lines can go off in perfpective: but if it ftand with a corner towards you, (as the picturefque eye generally wifhes a building to ftand) the lines will appear to recede. In what manner they may be drawn in perfpective, the following mechanical method may explain.

Trace on your paper the *neareft perpendicular* of the building you copy. Then hold horizontally between it, and your eye, a fhred of paper, or flat ruler; raifing, or lowering it, till you fee only the edge. Where it cuts the *perpendicular* in the building, make a mark on your paper; and draw a flight line through that point, parallel with the bottom of your picture. This is called the *horizontal line*. Obferve next, with what accuracy you can (for it would require a tedious procefs to conduct it geometrically) the angle, which the *firft receding line* of the building makes with the *neareft perpendicular;*

pendicular; and in your drawing continue a similar line, till it meet the *horizontal line*, The point where it meets the *horizontal line*, is called the *vanishing point*: and regulates the whole perspective. From this point you draw a line to the *bottom* of the *nearest perpendicular*, which gives you the perspective of the base. In the same manner all the lines, which recede on both sides of the building, as well above, as below the *horizontal line*; windows, doors, and projections of every kind, if they are on the *same plane*, are regulated.

If the building consist of projections on *different planes*, it would be tedious to regulate them all by the rules of perspective; but the eye being thus master of the grand points, will easily learn to manage the smaller projections. ——— Indeed in drawing landscape, it may in general be enough to be acquainted with the principles of perspective. One of the best rules in adjusting *proportion* is, *to carry your compasses in your eye*. The same rule may be given in *perspective*. Accustom your eye to judge, how objects recede from it. Too strict an application of rules tends only to give your drawing stiffness, and formality. Indeed where the regular works of art make the *principal*

cipal part of your picture, the strictest application of rule is necessary. It is this, which gives it's chief value to the pencil of Canaletti. His truth in perspective has made subjects interesting, which are of all others the most unpromising.

Before I conclude the subject, I should wish to add, that the plate here given as an explanation, is designed merely as such; for no building can have a good effect, the base of which is so far below the horizontal line.

After all, however, from the mode of sketching here recommended (which is as far as I should wish to recommend drawing landscape to those, who draw only for amusement) no great degree of accuracy can be expected. General ideas only must be looked for: not the peculiarities of portrait. It admits the winding river — the shooting promontory — the castle — the abbey — the flat distance — and the mountain melting into the horizon. It admits too the relation, which all these parts bear to each other. But it descends not to the minutiæ of objects. The fringed

fringed bank of the river — the Gothic ornaments of the abbey — the chafms, and fractures of the rock, and caftle — and every little object along the vale, it pretends not to delineate with exactnefs. All this is the province of the finifhed drawing, and the picture; in which the artift conveys an idea of each minute feature of the country he *delineates*, or *imagines*. But *high finifhing*, as I have before obferved, belongs only to a mafter, who can give *expreffive touches*. The difciple, whom I am inftructing, and whom I inftruct only from my own experience, muft have humbler views; and can hardly expect to pleafe, if he go farther than a fketch, *adorned* as hath been here defcribed.

Many gentlemen, who draw for amufement, employ their leifure on human figures, animal life, portrait, perhaps hiftory. Here and there a man of genius makes fome proficiency in thefe difficult branches of the art: but I have rarely feen any, who do. Diftorted faces, and diflocated limbs, I have feen in abundance: and no wonder; for the fcience of anatomy, *even* as it regards painting, is with difficulty attained; and few who have

ftudied

studied it their whole lives, have acquired perfection.

Others again, who draw for amusement, go so far as to handle the pallet. But in this the success of the ill-judging artist seldom answers his hopes; unless utterly void of taste, he happen to be such an artist as may be addressed in the sarcasm of the critic,

——— Sine rivali teque, et tua solus amares.

Painting is both a science, and an art: and if so very few attain perfection, who spend a life-time on it, what can be expected from those, who spend only their leisure? The very few gentlemen-artists, who excel in *painting*, scarce afford encouragement for common practice.

But the *art of sketching landscape* is attainable by a man of business: and it is certainly more useful; and, I should imagine, more amusing, to attain *some degree* of excellence in an inferior branch, than to be a mere bungler in a superior. Even if you should not excel in *execution* (which indeed you can hardly expect) you may at least by bringing home the delineation of a fine country, dignify an indifferent

different sketch. You may please yourself by administering strongly to recollection; and you may please others by conveying your ideas more distinctly in an ordinary sketch, than in the best language.

END OF THE THIRD ESSAY.

ON

LANDSCAPE PAINTING,

A POEM.

ON

LANDSCAPE PAINTING.

A POEM.

CONTENTS

OF THE FOLLOWING

P O E M.

Line
1 INTRODUCTION, and addrefs.
26 A clofe attention to the various fcenes of nature recommended; and to the feveral circumftances, under which they appear.
78 A facility alfo in copying the different *parts* of nature fhould be attained, before the young artift attempts a *whole.*
90 This procefs will alfo be a kind of *teſt.* No one can make any progrefs, whofe imagination is not fired with the fcenes of nature.
107 On a fuppofition, that the artift is enamoured with his fubject; and is well verfed in copying the parts of nature, he begins

to

to combine, and form thofe parts into the fubjects of landfcape. He pays his firft attention to *defign*, or to the bringing together of fuch objects, as are fuited to his fubject; not mixing trivial objects with grand fcenes; but preferving the *character* of his fubject, whatever it may be.

150 The different parts of his landfcape muft next be ftudioufly arranged, and put together in a picturefque manner. This is the work of *difpofition*; or, as it is fometimes called, *compofition*. No rules can be given for this arrangement, but the experience of a nice eye: for tho nature feldom prefents a compleat compofition, yet we every where fee in her works beautiful arrangements of parts; which we ought to ftudy with great attention.

159 In general, a landfcape is compofed of three parts — a foreground — a middle ground — and a diftance.

163 Yet this is not a univerfal rule. A *balance of parts* however there fhould always be; tho fometimes thofe parts may be few.

176 It is a great error in landfcape-painters, to lofe the *fimplicity* of a whole, under the idea of giving *variety*.

182 Some

182 Some *particular scene*, therefore, or *leading subject* should always be chosen; to which the parts should be subservient.

205 In balancing a landscape, a spacious foreground will admit a small thread of distance: but the reverse is a bad proportion. In every landscape there *must* be a considerable foreground.

216 This theory is illustrated by the view of a *disproportioned distance*.

243 An objection answered, why vast distances, tho unsupported by foregrounds, may please *in nature*, and yet offend *in representation*.

266 But tho the several parts of landscape may be *well balanced*, and adjusted; yet still without *contrast in the parts*, there will be a great deficiency. At the same time this contrast must be easy, and natural.

285 Such pictures, as are painted from fancy, are the most pleasing efforts of genius. But if an untoward subject be given, the artist must endeavour to conceal, and vary the unaccommodating parts. The foreground he *must* claim as his own.

308 But if nature be the source of all beauty, it may be objected, that imaginary views can have little merit. — The objection has weight, if the imaginary view be not

formed

formed from the select parts of nature; but if it be, it is nature still.

322 The artist having thus adjusted his forms, and disposition; conceives next the best effect of light; and when he has thus laid the foundation of his picture, proceeds to colouring.

335 The author avoids giving rules for colouring, which are learned chiefly by practice.

341 He just touches on the theory of colours.

362 Artists, with equally good effect, sometimes blend them on their pallet; and sometimes spread them raw on their canvas.

383 In colouring, the sky gives the ruling tint to the landscape: and the hue of the whole, whether rich, or sober, must be harmonious.

426 A predominancy of shade has the best effect.

449 But light, tho it should not be scattered, should not be collected, as it were, into a focus.

464 The effect of *gradation* illustrated by the colouring of cattle.

483 Of the disposition of light.

508 Of the *general harmony* of the whole.

517 A method proposed of examining a picture with regard to it's *general harmony*.

531 The scientific part being closed, all that can be said with regard to *execution*, is, that, as there are various modes of it, every
artist

artift ought to adopt his own, or elfe he becomes a fervile imitator. On the whole, the bold free method recommended; which aims at giving the *character* of objects, rather than the *minute detail*.

565 Rules given with regard to figures. Hiftory in miniature, introduced in landfcape, condemned. Figures fhould be fuited to the fcene.

620 Rules to be obferved in the introduction of birds.

645 An exhibition is the trueft teft of excellence; where the picture receives it's ftamp, and value not from the airs of coxcombs; but from the judgment of men of tafte, and fcience.

still ought to obtain his own, or allow
him to mistake a slavish imitation. Of drawings
therefore the best free method recommended
supply, which aims at giving the character of
the objects, rather than the minute detail.

Draperies given with regard to figures. History
in imitation, introduced in landscape,
quaestioned. Figures should be fitted to
the laws.

On Rules to be observed in the Imitation of
skies.

On the imitation is the truest test of excellence;
with it where the picture receives it's flame, and
without it cannot not from the list of excuses; but
which alone the judgment of man of tales, and
such forms.

ON
LANDSCAPE PAINTING.
A POEM.

—————

That Art, which gives the practised pencil power
To rival Nature's graces; to combine
In one harmonious whole her scattered charms,
And o'er them fling appropriate force of light,
I sing, unskill'd in numbers; yet a Muse, 5
Led by the hand of Friendship, deigns to lend
Her aid, and give that free colloquial flow,
Which best befits the plain preceptive song.

To thee, thus aided, let me dare to sing,
Judicious Lock; who from great Nature's realms 10
Hast culled her loveliest features, and arranged
In thy rich memory's storehouse: Thou, whose glance,
Practised in truth and symmetry can trace
In every latent touch, each Master's hand;
Whether the marble by his art subdued 15
Be softened into life, or canvas smooth

Be fwell'd to animation: Thou, to whom
Each mode of landfcape, beauteous or fublime,
With every various colour, tint, and light,
It's nice gradations, and it's bold effects, 20
Are all familiar, patient hear my fong,
That to thy tafte and fcience nothing new
Prefents; yet humbly hopes from thee to gain
That plaudit, which, if Nature firft approve,
Then, and then only, thou wilt deign to yield. 25

Firft to the youthful artift I addrefs
This leading precept: Let not inborn pride,
Prefuming on thy own inventive powers,
Miflead thine eye from Nature. She muft reign
Great archetype in all. Trace then with care 30
Her varied walks. Obferve how fhe upheaves
The mountain's towering brow; on it's rough fides
How broad the fhadow falls; what different hues
Inveft it's glimmering furface. Next furvey
The diftant lake; fo feen, a fhining fpot: 35
But when approaching nearer, how it flings
It's fweeping curves around the fhooting cliffs.
Mark every fhade it's Proteus-fhape affumes
From motion and from reft; and how the forms
Of tufted woods, and beetling rocks, and towers 40
Of ruined caftles, from the fmooth expanfe,
Shade anfwering fhade, inverted meet the eye.

From mountains hie thee to the foreft-fcene.
Remark the form, the foliage of each tree,
And what it's leading feature. View the oak, 45

It's

It's maffy limbs, it's majefty of fhade;
The pendent birch; the beech of many a ftem;
The lighter afh; and all their changeful hues
In fpring or autumn, ruffet, green, or grey.
 Next wander by the river's mazy bank. 50
See where it dimpling glides; or brifkly where
It's whirling eddies fparkle round the rock;
Or where, with headlong rage, it dafhes down
Some fractured chafm, till all it's fury fpent,
It finks to fleep, a filent ftagnant pool, 55
Dark, tho tranflucent, from the mantling fhade.
 Now give thy view more ample range: explore
The vaft expanfe of ocean; fee, when calm,
What Iris-hues of purple, green, and gold,
Play on it's glaffy furface; and when vext 60
With ftorms, what depth of billowy fhade, with light
Of curling foam contrafted. View the cliffs;
The lonely beacon, and the diftant coaft,
In mifts arrayed, juft heaving into fight
Above the dim horizon; where the fail 65
Appears confpicuous in the lengthened gleam.
 With ftudious eye examine next the vaft
Etherial concave: mark each floating cloud;
It's form, it's colour; and what mafs of fhade
It gives the fcene below, pregnant with change 70
Perpetual, from the morning's purple dawn,
Till the laft glimmering ray of ruffet eve.
Mark how the fun-beam, fteeped in morning-dew,
Beneath each jutting promontory flings
A darker fhade; while brightened with the ray 75

Of fultry noon, not yet entirely quenched,
The evening-fhadow lefs opaquely falls.
 Thus ftored with fair ideas, call them forth
By practice, till thy ready pencil trace
Each form familiar: but attempt not thou 80
A *whole*, till every *part* be well conceived.
The tongue that awes a fenate with it's force,
Once lifped in fyllables, or e'er it poured
It's glowing periods, warm with patriot-fire.
 At length matured, ftand forth for honeft Fame 85
A candidate. Some nobler theme felect
From Nature's choiceft fcenes; and fketch that theme
With firm, but eafy line; then if my fong
Affift thy power, it afks no higher meed.

 Yet if, when Nature's fovereign glories meet 90
Thy fudden glance, no correfponding fpark
Of vivid flame be kindled in thy breaft;
If calmly thou canft view them; know for thee
My numbers flow not: feek fome fitter guide
To lead thee, where the low mechanic toils 95
With patient labour for his daily hire.
 But if the true genius fire thee, if thy heart
Glow, palpitate with tranfport, at the fight;
If emulation feize thee, to transfufe
Thefe fplendid vifions on thy vivid chart; 100
If the big thought feem more than Art can paint;
Hafte, fnatch thy pencil, bounteous Nature yields
To thee her choiceft ftores; and the glad Mufe
Sits by affiftant, aiming but to fan

 The

The Promethèan flame, confcious her rules 105
Can only guide, not give, the warmth divine.
 Firft learn with *objects fuited to each fcene*
Thy landfcape to adorn. If fome rude view
Thy pencil culls, of lake, or mountain-range,
Where Nature walks with proud majeftic ftep, 110
Give not her robe the formal folds of art,
But bid it flow with ample dignity.
Mix not the mean and trivial: Is the *whole*
Sublime, let each accordant *part* be grand.
 Yet if through dire neceffity (for that 115
Alone fhould force the deed) fome *polifhed* fcene
Employ thy pallet, dreffed by human art,
The lawn fo level, and the bank fo trim,
Yet ftill *preferve thy fubject*. Let the oak
Be elegant of form, that mantles o'er 120
Thy fhaven fore-ground. The rough forefter
Whofe peeled and withered boughs, and gnarled trunk,
Have ftood the rage of many a winter's blaft,
Might ill fuch cultured fcenes adorn. Not lefs
Would an old Briton, rough with martial fcars, 125
And bearing ftern defiance on his brow,
Seem fitly ftationed at a Gallic feaft.
Such apt felection of accordant forms
The mufe herfelf requires from thofe her fons
Epic, or Tragic, who afpire to fame 130
Legitimate. On them, whofe motly tafte
Unites the fock, and bufkin — who produce
Kings, and buffoons in one incongruous fcene,
She darts a frown indignant. Nor fuppofe

Thy humbler fubject lefs demands the aid 135
Of juft *Defign*, than Raphael's; tho his art
Give all but motion to fome group divine,
While thine inglorious picture woods, and ftreams.

With equal rigour Disposition claims
Thy clofe attention. Would'ft thou learn it's laws, 140
Examine Nature, when combined with art,
Or fimple; mark how various are her forms,
Mountains enormous, rugged rocks, clear lakes,
Caftles, and bridges, aqueducts and fanes.
Of these obferve, how fome, united pleafe; 145
While others, ill-combined, difguft the eye.
That principle, which rules thefe various parts,
And harmonizing *all*, produces *one*,
Is *Difpofition*. By it's plaftic pow'r
Thofe rough materials, which *Defign* felects, 150
Are nicely balanced. Thus with friendly aid
Thefe principles unite: *Defign* prefents
The general fubject; *Difpofition* culls,
And recombines, the various forms anew.

Rarely to more than three diftinguifhed parts
Extend thy landfcape: neareft to the eye 155
Prefent thy foreground; then the midway fpace;
E'er the blue diftance melt in liquid air.
But tho full oft thefe parts with blending tints
Are foftened fo, as wakes a frequent doubt
Where each begins, where ends; yet ftill preferve 160
A *general balance*. So when Europe's fons

Sound

Sound the alarm of war; some potent hand
(Now thine again my Albion) poises true
The scale of empire; curbs each rival power;
And checks each lawless tyrant's wild career. 165
 Not but there are of fewer parts who form
A pleasing picture. These a forest-glade
Suffices oft; behind which, just removed,
One tuft of foliage, WATERLO, like thine,
Gives all we wish of dear variety. 170
 For even variety itself may pall,
If to the eye, when pausing with delight
On one fair object, it presents a mass
Of many, which disturb that eye's repose.
All hail Simplicity! To thy chaste shrine, 175
Beyond all other, let the artist bow.
Oft have I seen arranged, by hands that well
Could pencil Nature's *parts*, landscapes, that knew
No *leading subject*: Here a forest rose;
A river there ran dimpling; and beyond, 180
The portion of a lake: while rocks, and towers,
And castles intermixed, spread o'er the whole
In multiform confusion. Ancient dames
Thus oft compose of various silken shreds,
Some gaudy, patched, unmeaning, tawdry thing, 185
Where bucks and cherries, ships and flowers, unite
In one rich compound of absurdity.
 Chuse then some *principal commanding theme*,
Be it lake, valley, winding stream, cascade,
Castle, or sea-port, and on *that* exhaust 190
Thy powers, and make to that all else conform.
<div align="right">Who</div>

Who paints a landscape, is confined by rules,
As fixed and rigid as the tragic bard,
To *unity of subject*. Is the scene
A forest, nothing there, save woods and lawns 195
Must rise conspicuous. Episodes of hills
And lakes be far removed; all that obtrudes
On the chief theme, how beautiful soe'er
Seen as a *part*, disgusts us in the *whole*.

 Thus in the realms of landscape, to preserve 200
Proportion just is *Disposition*'s task.
And tho a glance of distance it allow,
Even when the foreground swells upon the sight;
Yet if the distant scenery wide extend,
The foreground must be ample: Take free scope: 205
Art must have space to stand on, like the Sage,
Who boasted power to shake the solid globe.
This thou must claim; and if thy distance spread
Profuse, must claim it amply: Uncombined
With foreground, distance loses power to please. 210

 Where rising from the solid rock, appear
Those ancient battlements, their lived a knight,
Who oft surveying from his castle wall
The wide expanse before him; distance vast;
Interminable wilds; savannahs deep; 215
Dark woods; and village spires, and glittering streams,
Just twinkling in the sun-beam, wished the view
Transferred to canvas; and for that sage end,
Led to the spot some docile son of art,
Where his own taste unerring previous fixed 220
The point of amplest prospect. " Take thy stand
" Just here," he cried, " and paint me *all* thou seest,

" Omit

"Omit no single object." It was done;
And soon the live-long landscape cloaths his hall,
And spreads from base to ceiling. *All* was there; 225
As to his guest, while dinner cooled, the knight
Full oft would prove; and with uplifted cane
Point to the distant spire, where slept entombed
His ancestry; beyond, where lay the town,
Skirted with wood, that gave him place and voice 230
In Britain's senate; nor untraced the stream
That fed the goodly trout they soon should taste;
Nor every scattered seat of friend, or foe,
He calls his neighbours. Heedless he, meanwhile,
That what he deems the triumph of his taste, 235
Is but a painted survey, a mere map;
Which light and shade, and perspective misplaced,
But serve to spoil.
 Yet why (methinks I hear
Some Critic say) do ample scenes, like this,
In *picture* fail to please; when every eye 240
Confesses they transport on *Nature's chart*?
Why; but because, where *She* displays the scene,
The roving sight can pause, and swift select,
From all she offers, parts, whereon to fix,
And form distinct perceptions; each of which 245
Presents a *separate picture*. Thus as bees
Condense within their hives the varying sweets;
So does the eye a *lovely whole* collect
From *parts disjointed*; nay, perhaps, *deformed*.
Then deem not Art defective, which divides, 250
 Rejects,

Rejects, or recombines: but rather say
'Tis her chief excellence. There is, we know,
A charm unspeakable in converse free
Of lover, or of friend, when soul with soul
Mixes in social intercourse; when choice 255
Of phrase, and rules of rhetoric are disdained;
Yet say, adopted by the tragic bard,
If Jaffier thus with Belvidera talked,
So vague, so rudely; would not want of skill,
Selection, and arrangement, damn the scene? 260

 Thy forms, tho *balanced*, still perchance may want
The charm of *Contrast:* Sing we then it's power.
'Tis Beauty's surest source; it regulates
Shape, colour, light, and shade; forms every line
By *opposition just*; whate'er is *rough* 265
With skill delusive counteracts by *smooth*;
Sinuous, or *concave*, by it's opposite;
Yet ever *covertly:* should *Art* appear,
That art were *Affectation*. Then alone
We own the power of *Contrast*, when the lines 270
Unite with Nature's freedom: then alone,
When from it's careless touch each part receives
A pleasing form. The lake's contracted bounds
By contrast varied, elegantly flow;
The unweildy mountain sinks; here, to remove 275
Offensive parallels, the hill deprest
Is lifted; there the heavy beech expunged
Gives place to airy pines; if two bare knolls

 Rise

Rise to the right and left, a castle here,
And there a wood, diversify their form. 280

 Thrice happy he, who always can indulge
This pleasing feast of fancy; who, replete
With rich ideas, can arrange their charms
As his own genius prompts, creating thus
A novel whole. But tasteless wealth oft claims 285
The *faithful portrait,* and will fix the scene
Where Nature's lines run falsely, or refuse
To harmonize. Artist, if thus employed,
I pity thy mischance. Yet there are means
Even here to hide defects. The human form 290
Portrayed by Reynolds, oft abounds with grace
He saw not in his model; which nor hurts
Resemblance, nor fictitious skill betrays.
Why then, if o'er the limb uncouth he flings
The flowing vest, may not thy honest art 295
Veil with the foliage of some spreading oak,
Unpleasing objects, or remote, or near?
An ample licence for such needful change,
The foregrounds give thee. There both mend and make.
Whoe'er opposes, tell them, 'tis the spot 300
Where fancy needs must sport; where, if restrained
To close resemblance, thy best art expires.
 What if they plead, that from thy general rule,
That rests on Nature as the only source
Of beauty, thou revolt'st; tell them that rule 305
Thou hold'st still sacred: Nature *is* it's source;
Yet Nature's *parts* fail to receive alike

<div align="right">The</div>

The fair impreffion. View her varied range:
Each form that charms is there; yet her beft forms
Muft be *felected*. As the fculptured charms 310
Of the famed Venus grew, fo muft thou cull
From various fcenes fuch parts as beft create
One perfect whole. If Nature ne'er arrayed
Her moft accomplifhed work with grace compleat,
Think, will fhe wafte on defert rocks, and dells, 315
What fhe denies to Woman's charming form?

And now, if on review thy chalked *defign*,
Brought into form by *Difpofition*'s aid,
Difpleafe not, trace thy lines with pencil free;
Add lightly too that *general mafs* of fhade, 320
Which fuits the form and fafhion of it's parts.
There are who, ftudious of the beft effects
Firft fketch a flight cartoon. Such previous care
Is needful, where the Artift's fancy fails
Precifely to forefee the future whole. 325
This done, prepare thy pallet, mix thy tints,
And call on chafte Simplicity again
To fave her votary from whate'er of hue,
Difcordant or abrupt, may flaunt, or glare.

Yet here to bring materials from the mine, 330
From vegetable dies, or animal,
And fing their various properties and powers,
The mufe defcends not. To mechanic rules,
To profe, and practice, which can only teach
The ufe of pigments, fhe refigns the toil. 335

One

One truth she gives, that Nature's simple loom
Weaves but with three distinct, or mingled, hues,
The vest that cloaths Creation. These are red,
Azure, and yellow. Pure and unstained white
(If colour justly called) rejects her law, 340
And is by her rejected. Dost thou deem
The glossy surface of yon heifer's coat
A perfect white? Or yon vast heaving cloud
That climbs the distant hill? With ceruse bright
Attempt to catch it's tint, and thou wilt fail. 345
Some tinge of purple, or some yellowish brown,
Must first be blended, e'er thy toil succeed.
Pure white, great Nature wishes to expunge
From all her works; and only then admits,
When with her mantle broad of fleecy snow 350
She wraps them, to secure from chilling frost;
Conscious, mean while, that what she gives to guard,
Conceals their every charm: the stole of night
Not more eclipses: yet that sable stole
May, by the skilful mixture of these hues, 355
Be shadowed even to dark Cimmerian gloom.

 Draw then from these, as from three plenteous springs,
Thy brown, thy purple, crimson, orange, green,
Nor load thy pallet with a useless tribe
Of pigments: when commix'd with needful white, 360
As suits thy end, these native three suffice.
But if thou dost, still cautious keep in view
That harmony which these alone can give.
 Yet

Yet still there are, who scorning all the rules
Of dull mechanic art, with random hand 365
Fling their *unblended* colours, and produce
Bolder effects by opposition's aid.

 The sky, whate'er it's hue, to landscape gives
A corresponding tinge. The morning ray
Spreads it with purple light, in dew-drops steeped; 370
The evening fires it with a crimson glow
Blows the bleak north? It sheds a cold, blue tint
On all it touches. Do light mists prevail?
A soft grey hue o'erspreads the general scene,
And makes that scene, like beauty viewed through gauze,
More delicately lovely. Chuse thy sky; 376
But let that sky, whate'er the tint it takes,
O'er-rule thy pallet. Frequent have I seen,
In landscapes well composed, aerial hues
So ill-preserved, that whether cold or heat, 380
Tempest or calm, prevailed, was dubious all.
Not so thy pencil, CLAUDE, the season marks:
Thou makest us pant beneath thy summer noon;
And shiver in thy cool autumnal eve.

 Such are the powers of sky; and therefore Art 385
Selects what best is suited to the scene
It means to form: to this adapts a morn,
To that an evening ray. Light mists full oft
Give mountain-views an added dignity;
While tame impoverished scenery claims the force 390
Of splendid lights and shades; nor claims in vain.

<div style="text-align:right">Thy</div>

Thy sky adjusted, all that is *remote*
First colour faintly : leaving to the last
Thy foreground. Easier 'tis, thou know'st, to spread
Thy floating foliage o'er the sky; than mix 395
That sky amid the branches. Venture still
On warmer tints, as distances approach
Nearer the eye: Nor fear the richest hues,
If to those hues thou giv'st the meet support
Of strong opposing shade. A canvas once 400
I saw, on which the artist dared to paint
A scene in Indostan; where gold, and pearl
Barbaric, flamed on many a broidered vest
Profusely splendid; yet chaste art was there,
Opposing hue to hue; each shadow deep 405
So spread, that all with sweet accord produced
A bright, yet modest whole. Thus blend thy tints,
Be they of scarlet, orange, green, or gold,
Harmonious, till one general glow prevail
Unbroken by abrupt and hostile glare. 410

Let shade predominate. It makes each light
More lucid, yet destroys offensive glare.
Mark when in fleecy showers of snow, the clouds
Seem to descend, and whiten o'er the land,
What unsubstantial unity of tinge 415
Involves each prospect: Vision is absorbed;
Or, wandering through the void, finds not a point
To rest on. All is mockery to the eye.
Thus light diffused, debases that effect 419
Which shade improves. Behold what glorious scenes
Arise through Nature's works from shade. Yon lake

With all it's circumambient woods, far less
Would charm the eye, did not that dusky mist
Creeping along it's eastern shores, ascend
Those towering cliffs, mix with the ruddy beam 425
Of opening day, just damp it's fires, and spread
O'er all the scene a sweet obscurity.

 But would'st thou see the full effect of shade
Well massed, at eve mark that upheaving cloud,
Which charged with all th' artillery of Jove, 430
In awful darkness, marching from the east,
Ascends; see how it blots the sky, and spreads,
Darker, and darker still, it's dusky veil,
Till from the east to west, the cope of heaven
It curtains closely round. Haply thou stand'st 435
Expectant of the loud convulsive burst,
When lo! the sun, just sinking in the west,
Pours from th' horizon's verge a splendid ray,
Which tenfold grandeur to the darkness adds.
Far to the east the radiance shoots, just tips 440
Those tufted groves; but all it's splendor pours
On yonder castled cliff, which chiefly owes
It's glory, and supreme effect, to shade.

 Thus light, inforced by shadow, spreads a ray
Still brighter. Yet forbid that light to shine 445
A glittering speck; for this were to illume
Thy picture, as the convex glass collects,
All to one dazzling point, the solar rays.

 Whate'er the force of *opposition*, still
In soft *gradation* equal beauty lies. 450

<div align="right">When</div>

When the mild luftre glides from light to dark,
The eye well-pleafed purfues it. Mid the herds
Of variegated hue, that graze the lawn,
Oft may the artift trace examples juft
Of this fedate effect, and oft remark 455
It's oppofite. Behold yon lordly bull
His fable head, his lighter fhoulders tinged
With flakes of brown; at length ftill lighter tints
Prevailing, graduate o'er his flank and loins
In tawny orange. What, if on his front 460
A ftar of white appear? The general mafs
Of colour fpreads unbroken; and the mark
Gives his ftern front peculiar character.
 Ah! how degenerate from her well-cloathed fire
That heifer. See her fides with white and black 465
So ftudded, fo diftinct, each juftling each,
The groundwork-colour hardly can be known.

 Of lights, if more than two thy landfcape boaft,
It boafts too much. But if two lights be there,
Give one pre-eminence: with that be fure 470
Illume thy *foreground*, or thy *midway fpace*;
But rarely fpread it on the *diftant fcene*.
Yet there, if level plains, or fens appear,
And meet the fky, a lengthened gleam of light
Difcreetly thrown, will vary the flat fcene. 475
 But if that diftance be abruptly clofed
By mountains, caft them into general fhade:
Ill fuit gay robes their hoary majefty.
Sober be all their hues; except, perchance,

Approaching nearer in the midway space, 480
One of the giant-brethren tower sublime:
To him thy art may aptly give a gleam
Of radiance: 'twill befit his awful head,
Alike, when rising through the morning-dews
In misty dignity, the pale, wan ray, 485
Invests him; or when, beaming from the west,
A fiercer splendor opens to our view
All his terrific features, rugged cliffs,
And yawning chasms, which vapours through the day
Had veiled; dens where the lynx or pard might dwell
In noon-tide safety, meditating there 491
His next nocturnal ravage through the land.
 Are now thy lights and shades adjusted all?
Yet pause: perhaps the perspective is just;
Perhaps each local hue is duly placed; 495
Perhaps the light offends not; *harmony*
May still be wanting. That which forms a whole
From colour, shade, gradation, is not yet
Obtained. Avails it ought, in civil life,
If here and there a family unite 500
In bonds of peace, while discord rends the land,
And pale-eyed Faction, with her garment dipped
In blood, excites her guilty sons to war?
 To aid thine eye, distrustful if this end
Be fully gained, wait for the twilight hour. 505
When the grey owl, sailing on lazy wing,
Her circuit takes; when lengthened shades dissolve;
Then in some corner place thy finished piece,
Free from each garish ray: Thine eye will there

<div align="right">Be</div>

Be undisturbed by *parts*; there will the *whole* 510
Be viewed collectively; the distance there
Will from it's foreground pleasingly retire,
As distance ought, with true decreasing tone.
If not, if shade or light be out of place,
Thou feest the error, and mayest yet amend. 515

Here science ceases: but to close the theme,
One labour still, and of Herculean cast,
Remains unsung, the art to *execute*,
And what it's happiest mode. In this, alas!
What numbers fail; tho paths, as various, lead 520
To that fair end, as to thy ample walls,
Imperial London. Every artist takes
His own peculiar manner; save the hand
Coward, and cold, that dare not leave the track
It's master taught. Thou who wouldest boldly seize 525
Superior excellence, observe, with care,
The style of every artist; yet disdain
To mimic even the best. Enough for thee
To gain a knowledge from what various modes
The same effect results. Artists there are 530
Who, with exactness painful to behold,
Labour each leaf, and each minuter moss,
Till with enamelled surface all appears
Compleatly smooth. Others with bolder hand,
By Genius guided, mark the general form, 535
The leading features, which the eye of taste,
Practised in Nature, readily translates.
Here lies the point of excellence. A piece,

Thus finished, tho perhaps the playful toil
Of three short mornings, more enchants the eye, 540
Than what was laboured through as many moons.

Why then such toil mispent? We never mean,
With close and microscopic eye, to pore
On every studied *part*. The practised judge
Looks chiefly on the *whole*; and if thy hand 545
Be guided by true science, it is sure
To guide thy pencil freely. Scorn thou then
On *parts minute* to dwell. The *character*
Of objects aim at, not the *nice detail*.

Now is the scene compleat: with Nature's ease, 550
Thy woods, and lawns, and rocks, and splendid lakes,
And distant hills unite; it but remains
To people these fair regions. Some for this
Consult the sacred page; and in a nook
Obscure, present the Patriarch's test of faith, 555
The little altar, and the victim son:
Or haply, to adorn some vacant sky,
Load it with forms, that fabling bard supplies
Who sang of bodies changed; the headlong steeds,
The car upheaved of Phaeton, while he, 560
Rash boy! spreads on the plain his pallid corse,
His sisters weeping round him. Groups like these
Befit not landscape: Say, does Abraham there
Ought that some idle peasant might not do?
Is there expression, passion, character, 565
To mark the Patriarch's fortitude and faith?
The scanty space which perspective allows,
<div style="text-align:right">Forbids.</div>

Forbids. Why then degrade his dignity
By paltry miniature? Why make it thus
A mere appendage? Rather deck thy fcene 570
With figures fimply fuited to it's ftyle
The *landfcape* is thy object; and to that,
Be thefe the *under parts*. Yet ftill obferve
Propriety in all. The fpeckled pard,
Or tawny lion, ill would glare beneath 575
The Britifh oak; and Britifh flocks and herds
Would graze as ill on Afric's burning fands.
If rocky, wild, and awful be thy views,
Low arts of hufbandry exclude: The fpade,
The plough, the patient angler with his rod, 580
Be banifhed thence; far other guefts invite,
Wild as thofe fcenes themfelves, banditti fierce,
And gypfey-tribes, not merely to adorn,
But to imprefs that fentiment more ftrong,
Awaked already by the favage-fcene. 585

 Oft winding flowly up the foreft glade,
The ox-team labouring, drags the future keel
Of fome vaft admiral: no ornament
Affifts the woodland fcene like this; while far
Removed, feen by a gleam among the trees, 590
The foreft-herd in various groups repofe.

 Yet, if thy fkill fhould fail to people well
Thy landfcape, leave it defert. Think how CLAUDE
Oft crowded fcenes, which Nature's felf might own,
With forms ill-drawn, ill-chofen, ill-arranged, 595
Of man and beaft, o'er loading with falfe tafte

His sylvan glories. Seize them, Pestilence,
And sweep them far from our disgusted sight!
 If o'er thy canvas Ocean pours his tide,
The full sized vessel, with it's swelling sail, 600
Be cautious to admit; unless thy art
Can give it cordage, pennants, masts, and form
Appropriate; rather with a careless touch
Of light, or shade, just mark the distant skiff.
 Nor thou refuse that ornamental aid, 605
The feathered race afford. When fluttering near
The eye, we own absurdity results;
They seem both fixed and moving: but beheld
At proper distance, they will fill thy sky
With animation. Leave them there free scope: 610
Their *distant motion* gives us no offence.
 Far up yon river, opening to the sea,
Just where the distant coast extends a curve,
A lengthened train of sea-fowl urge their flight.
Observe their files! In what exact array 615
The dark battalion floats, distinctly seen
Before yon silver cliff! Now, now, they reach
That lonely beacon; now are lost again
In yon dark cloud. How pleasing is the sight!
The forest-glade from it's wild, timorous herd, 620
Receives not richer ornament, than here
From birds this lonely sea-view. Ruins too
Are graced by such addition: not the force
Of strong and catching lights adorn them more,
Than do the dusky tribes of rooks, and daws 625
Fluttering their broken battlements among.

 Place

Place but thefe feathered groups at diftance due,
The eye, by fancy aided, fees them move,
(Flit paft the cliff, or circle round the tower)
Tho each, a centinel, obferve his poft.

 Thy landfcape finifhed, tho it meet thy own, 630
Approving judgment, ftill requires a teft,
More general, more decifive. Thine's an eye
Too partial to be trufted. Let it hang
On the rich wall, which emulation fills;
Where rival mafters court the world's applaufe. 635
There travelled virtuofi, ftalking round,
With ftrut important, peering though the hand,
Hollowed in telefcopic form, furvey
Each lucklefs piece, and uniformly damn;
Affuming for their own, the tafte they fteal. 640
" This has not *Guido*'s air:" " That poorly apes
" *Titian*'s rich colouring·" "*Rembrant*'s forms are here,
" But not his light and fhadow " Skilful they
In every hand, fave Nature's. What if thefe
With *Gafpar* or with *Claude* thy work compare, 645
And therefore fcorn it; let the pedants prate
Unheeded. But if tafte, correct and pure,
Grounded on practice; or, what more avails
Than practice, obfervation juftly formed
On Nature's beft examples and effects, 650
Approve thy landfcape; if judicious LOCK
See not an error he would wifh removed,
Then boldly deem thyfelf the heir of Fame.

NOTES

ON THE FOREGOING

P O E M.

———

Line

34 SOME perhaps may object to the word *glimmering:* but whoever has observed the playing lights, and colours, which often invest the summits of mountains, will not think the epithet improper.

45 *What it's leading feature;* that is the *particular character* of the tree. The different shape of the leaves, and the different mode of spreading it's branches, give every tree, a *distinct form,* or *character.* At a little distance you easily distinguish the oak from the ash; and the ash from the beech. It is this *general form,* not any *particular detail,* which the artist is instructed to get by heart. The same remark holds with regard

regard to other parts of nature. These *general forms* may be called the *painter's alphabet*. By thefe he learns to read her works; and alfo to make them intelligible to others.

61 *With light of curling foam contrafted.* The progrefs of each wave is this. Beneath the frothy curl, when it rifes between the eye, and the light, the colour is pale green, which brightens from the bafe towards the fummit. When a wave fubfides, the fummit falling into the bafe, extends, and raifes it; and that part of the water which meets the fucceeding wave, fprings upward from the fhock; the top forms into foam, and rolling over falls down the fide, which has been fhocked; prefenting if the water be much agitated, the idea of a cafcade.

77 *The evening-fhadow lefs opaquely falls.* It is not often obferved by landfcape-painters, tho it certainly deferves obfervation, that the morning-fhadows are darker than thofe of the evening.

101 *If the big thought feem more than art can paint.* It is always a fign of genius to be diffatisfied with our own efforts; and to conceive more than we can exprefs.

158 *Design presents the general subject, disposition,* &c. Some writers on the art of painting have varied this division. But it seems most proper, I think, to give the selection of the elements of landscape — the assembling of rocks, mountains, cataracts, and other objects to *design:* while *disposition* is properly employed in the local arrangement of them.

159 The *general* composition of a landscape consists of three parts — the foreground — the second ground — and the distance. But no rule can be given for proportioning these parts to each other. There are ten thousand beautiful proportions; from which the eye of taste must select a good one. The foreground must always be considerable — in some cases, ample. It is the very basis, and foundation of the whole. —— Nor is it a bad rule, I think, that some part of the foreground should be the highest part of the picture. In rocky, and mountainous views this is easy, and has generally a good effect. And sometimes even when a country is more level, a tree on the foreground, carried higher than the rest of the landscape, answers the end. At the same time in many species of landscape this

rule

rule cannot eafily be obferved: nor is it by any means effential

169 *Waterlo, like thine.* The fubjects of this mafter feldom went beyond fome little foreft-view. He has etched a great number of prints in this ftile of landfcape; which for the beauty of the trees in particular, are much admired.

178 *Landfcapes, that knew no leading fubject.* There is not a rule in landfcape-painting more neglected, or that ought more to be obferved, than what relates to a *leading fubject.* By the leading fubject we mean, what *characterizes the fcene.* We often fee a landfcape, which comes under no denomination, Is it the fcenery about a ruin? Is it a lake-fcene? Is it a riverfcene? No: but it is a jumble of all together. Some leading fubject therefore is required in every landfcape, which forms it's character; and to which the painter

——————————— is confined by rules,
As fixed, and rigid as the tragic bard.

When the landfcape takes it's character from a ruin, or other object on the foreground, the *diftance* introduced, is merely an appendage; and muft plainly appear to be an under-part; not interfering with the fubject

subject of the piece. But most commonly the scene, or leading subject of the picture, occupies the middle distance. In this case, the *foreground* becomes the appendage; and without any striking object to attract the eye, must plainly shew, that it is intended only to introduce the leading-subject with more advantage.

194 Thus, in a forest-scene, the woods and lawns, are the leading subject. If the piece will allow it, a hill, or a lake, may be admitted in *remote distance:* but they must be introduced, only as the episodes in a poem, to set off the main subject. They must not interfere with it: but be *far removed.*

202 *And tho a glance.* It is certain, in fact, that a considerable foreground, with a glance of distance, will make a better picture, than a wide distance, set off only with a meagre foreground: and yet I doubt whether an adequate reason can be given; unless it be founded on what hath already been advanced, that we consider the foreground as the *basis, and foundation of the whole picture.* So that if it is not considerable in all circumstances, and extensive in some, there seems a defect.

285 *A novel whole.* The imaginary-view, formed on a judicious selection, and arrangement of the parts of nature, has a better chance to make a good picture, than a view taken in the whole from any natural scene. Not only the lines, and objects of the natural scene rarely admit a happy composition; but the *character* of it is seldom throughout preserved. Whether it be *sublime*, or *beautiful*, there is generally something mixed with it of a nature unsuitable to it. All this the exhibition of fancy rectifies, when in the hands of a master. Nor does he claim any thing, but what the poet, and he are equally allowed. Where is the story in real life, on which the poet can form either an epic, or a drama, unless heightened by his imagination? At the same time he must take care, that all his imaginary additions are founded in nature, or his work will disgust. Such also must be the painter's care. But under this restriction, he certainly may bring together a more *consistent whole,* culled from the *various parts* of nature, than nature herself exhibits in *any one scene.*

319 *Trace thy lines with pencil free.* The master is discovered even in his chalk, or black-lead lines — so free, firm, and intelligent. We

We often admire thefe firft, rude touches. The ftory of the two old mafters will be remembered; who left cards of compliments to each other, on which only the fimple outline of a figure was drawn by one, and corrected by the other; but with fuch a fuperior elegance in each, that the fignature of names could not have marked them more decifively.

323 *Firft fketch a flight cartoon.* It is the practice indeed of the generality of painters, when they have any great defign to execute, to make a flight fketch, fometimes on paper, and fometimes on canvas. And thefe fketches are often greatly fuperior to the principal picture, which has been laboured and finifhed with the exacteft care. King William on horfe-back at Hampton court, by fir Godfrey Kneller, is a ftriking example of this remark. The picture is highly finifhed; but is a tame, and unmafterly performance. At Houghton-hall I have feen the original fketch of this picture; which I fhould have valued, not only greatly beyond the picture itfelf, but beyond any thing I ever faw from the pencil of fir Godfrey.

336 *One truth fhe gives,* &c. From thefe three virgin colours, *red, blue,* and *yellow,* all the tints of nature are compofed. Greens

of various hues, are compofed of blue, and yellow: orange, of red, and yellow: purple and violet, of red, and blue. The tints of the rainbow feem to be compofed alfo of thefe colours. They lie in order thus: violet—*red*—orange—*yellow*—green—*blue*—violet—*red*: in which affortment we obferve that orange comes between *red*, and *yellow*; that is, it is compofed of thofe colours melting into each other. Green is in the fame way compofed of *yellow* and *blue*; and violet, or purple of *blue*, and *red*.—Nay even browns of all kinds may, in a degree, be effected by a mixture of thefe original colours: fo may grey; and even a kind of black, tho not a perfect one.——As all pigments however are deficient, and cannot approach the rainbow colours, which are the pureft we know, the painter muft often, even in his fplendid tints, call in different reds, blues, and yellows. Thus as vermillion, tho an excellent red on many occafions, cannot give a rofy, crimfon hue, he muft often call in lake, or carmine. Nor will he find any yellow, or blue, that will an-fwer every purpofe. In the tribe of browns he will ftill be more at a lofs; and muft have recourfe to different earths.—In oil-painting one of the fineft earths is known,

at the colour-shops, by the name of *castle-earth*, or *Vandyke's-brown*; as it is supposed to have been used by that master.

341 *And is by her rejected.* Scarce any natural object, but snow, is purely white. The chalk-cliff is generally in a degree discoloured. The petals of the snow-drop indeed, and of some other flowers, are purely white; but seldom any of the larger parts of nature.

362 *Keep in view that harmony,* &c. Tho it will be necessary to use other colours, besides *yellow, red,* and *blue,* this union should however still be kept in view, as the leading principle of harmony. A mixture indeed of these three will produce nearly the colour you want: but the more you mix your colours, the muddier you make them. It will give more clearness therefore, and brightness to your colouring, to use simple pigments, of which there are great abundance in the painter's dispensatory.

364 This mode of colouring is the most difficult to attain, as it is the most scientific. It includes a perfect knowledge of the effects of colours in all their various agreements, and oppositions. When attained, it is the most easy in practice. The artist, who blends his colours on his pallet,

depends more on his eye, than on his knowledge. He works out his effect by a more laboured procefs; and yet he may produce a good picture in the end.

392 Nobody was better acquainted with the effects of fky, nor ftudied them with more attention, than the younger Vanderveldt. Not many years ago, an old Thames-waterman was alive, who remembered him well; and had often carried him out in his boat, both up and down the river, to ftudy the appearances of the fky. The old man ufed to fay, they went out in all kinds of weather, fair, and foul; and Mr. Vanderveldt, took with him large fheets of blue paper, which he would mark all over with black, and white. The artift eafily fees the intention of this procefs. Thefe expeditions Vanderveldt called, in his Dutch manner of fpeaking, *going a fkoying*.

407 The moft remarkable inftance of ingenious colouring I ever heard of, is in Guido's St. Michael. The whole picture is compofed of blue, red, and black; by means of which colours the ideas of heaven and hell are blended together in a very extraordinary manner; and the effect exceedingly fublime; while both harmony, and chaftenefs are perferved in the higheft degree.

411 *Let*

411 *Let shade predominate.* As a *general rule*, the half-tints should have more extent than the lights; and the shadows should equal both together. —— Yet why a predominancy of shade should please the eye more than a predominancy of light, would perhaps be difficult to explain. I can easily conceive, that a *balance* of light and shade may be founded in some kind of reason; but am at a loss to give a reason for a predominancy of either. The fact however is undoubted; and we must skreen our ignorance of the principle, as well as we can.

446 This rule respects an *affected display of light.* If it be introduced as a focus, so as not to fall *naturally* on the several objects it touches, it disgusts. Rembrandt, I doubt, is sometimes chargeable with this fault. He is commonly supposed to be a master of this part of painting; and we often see very beautiful lights in his pictures, and prints: but as in many of them we see the reverse, he appears to have had no fixed principle. Indeed, few parts of painting are so much neglected, so easily transgressed, and so little understood, as the distribution of light.

449 *Opposition*, and *gradation* are the two grand means of producing effect by light. In
the

the picture just given (I. 429. &c.) of the evening-ray, the effect is produced by *oppofition.* Beautiful effects too of the same kind arise often from *catching lights.* ——— The power of producing effect by *gradation,* is not less forcible. Indeed, without a degree of *gradation oppofition* itself would be mute. In the picture just given of the evening-ray, the grand part of the effect, no doubt, arises from the *oppofition* between the gloom, and the light: but in part it arises also from the *gradation* of the light, till it reach it's point. It just tips

> The tufted groves; but all it's splendor pours
> On yonder castled cliff. ———

452 The colours of animals often strongly illustrate the idea of *gradation.* When they soften into each other, from light or dark, or from one colour into another, the mixture is very picturesque. It is as much the reverse, when white and black, or white, and red, are patched over the animal in blotches, without any intermediate tints. Domestic cattle, cows, dogs, swine, goats, and cats, are often disagreeably patched. tho we sometimes see them pleasingly coloured with a graduating tint. Wild animals, in general, are more uniformly coloured,

coloured, than tame. Except the zebra, and two or three of the spotted race, I recollect none which are not, more or less, tinted in this graduating manner. The tiger, the panther, and other variegated animals have their beauty: but the zebra, I think, is rather a curious, than a picturesque animal. It's streaked sides injure it both in point of colour, and in the delineation of it's form.

472 *But rarely spread it on the distant scene.* In general perhaps a landscape is best inlightened, when the light falls on the middle parts of the picture; and the foreground is in shadow. This throws a kind of natural retiring hue throughout the landscape: and tho the *distance be in shadow*, yet that shadow is so faint, that the retiring hue is still preserved. This however is only a general rule. In history-painting the light is properly thrown upon the figures on the foreground; which are the *capital part* of the picture. In landscape the middle grounds commonly form *the scene*, or the *capital part*; and the foreground is little more, than an appendage. Sometimes however it happens, that a ruin, or some other capital object on the foreground, makes the *principal part of the scene.* When that is the case,

cafe, it fhould be diftinguifhed by light; unlefs it be fo fituated as to receive more diftinction from fhade

487 *A fiercer fplendor opens to our view all his terrific features.* It is very amufing, in mountainous countries, to obferve the appearance, which the fame mountain often makes under different circumftances. When it is invefted with light mifts; or even when it is not illuminated, we fee it's whole fummit perhaps under one grey tint. But as it receives the fun, efpecially an evening-fun, we fee a variety of fractures, and chafms gradually opening, of which we difcovered not the leaft appearance before.

493 Tho the objects may leffen in due proportion, which is called *keeping*; tho the graduating hue of retiring objects, or the *aerial perfpective,* may be juft; and tho the light may be diftributed according to the rules of art; yet ftill there may not be that general refult of harmony, which denotes the picture *one-object:* and as the eye may be mifled, when it has the *feveral parts* before it, the beft way of examining it as a *perfect whole,* is to examine it in fuch a light, as will not admit the inveftigation of *parts.*

534 *Others,*

534 *Others*, &c. Some painters copy exactly what they see. In this there is more mechanical precision, than genius. Others take a *general, comprehensive view* of their object; and marking just the *characteristic points*, lead the spectator, if he be a man of taste, and genius likewise, into a truer knowledge of it, than the copier can do, with all his painful exactness.

568 *Why then degrade*, &c. If by bringing the figures forward on the foreground, you give room for *character*, and *expression*, you put them out of place as *appendages*, for which they were intended.

586 *Oft slowly winding*, &c. The machine itself here described is picturesque: and when it is seen in *winding motion*, or (in other words) when half of it is foreshortened, it receives additional beauty from contrast. In the same manner a cavalcade, or an army on it's march, may be considered as *one object;* and derive beauty from the same source. Mr. Gray has given us a very picturesque view of this kind, in describing the march of Edward I.;

> As down the steep of Snowdon's shaggy side
> He wound with toilsome march his long array.
> Stout Gloucester stood aghast in speechless trance:
> To arms! cried Mortimer; and couched his quivering lance.

Through

Through a paffage in the mountain we fee the troops winding round at a great diftance. Among thofe nearer the eye, we diftinguifh the horfe and foot; and on the foreground, the action, and expreffion of the principal commanders.

The ancients feem to have known very little of that fource of the picturefque, which arifes from prefpective: every thing is introduced in front before the eye: and among the early painters we hardly fee more attention paid to it. Raphael is far from making a full ufe of the knowledge of it: and I believe Julio Romano makes ftill lefs.

I do not remember meeting any where with a more picturefque defcription of a line of march, than in Vaillant's travels into the interior parts of Africa. He was paffing with a numerous caravan, along the borders of Caffraria. I firft, fays he, made the people of the hord, which accompanied me, fet out with their cattle. Soon after my cattle followed cows, fheep, and goats: with all the women of the hord, mounted on oxen with their children. My waggons, with the reft of my people, clofed the rear. I myfelf, mounted on horfeback, rode backwards, and forewards. This caravan

on

on it's march, exhibited often a singular, and amusing spectacle. The turns it was obliged to make in following the windings of the woods, and rocks, continually gave it new forms. Sometimes it intirely disappeared: then suddenly, at a distance, from the summit of a hill, I again discovered my vanguard slowly advancing perhaps towards a distant mountain: while the main body, following the track, were just below me.

600 This rule indeed applies to all other objects: but as the ship is so large a machine, and at the same time so complicated a one, it's *character* is less obvious, than that of most other objects. It is much better therefore, where a vessel is necessary, to put in a few touches for a skiff; than to insert some disagreeable form for a ship, to which it has no resemblance. At the same time, it is not at all necessary to make your ship so accurate, that a seaman could find no fault with it. It is the same in figures: as appendages of landscape there is no necessity to have them exactly accurate; but if they have not the *general form*, and *character* of what they represent, the landscape is better without them.

608 *They*

608 *They seem,* &c. *Rapid motion alone, and that near the eye,* is here censured. We should be careful however not to narrow too much the circumscribed sphere of art. There is an art of seeing, as well as of painting. The eye must in part enter into the deception. The art of painting must, in some degree, be considered as an act of convention. General forms only are imitated, and much is to be supplied by the imagination of the spectator.—— It is thus in the drama. How absurdly would the spectator act, if instead of assisting the illusion of the stage, he should insist on being deceived, without being a party in the deception?—if he refused to believe, that the light he saw, was the sun; or the scene before him, the Roman capital, because he knew the one was a candle-light, and the other, a painted cloth? The painter therefore must in *many things* suppose deception; and only avoid it, where it is too *palpably gross* for the eye to suffer.

641 Guido's air, no doubt, is often very pleasing. He is thought to have excelled in imagining the angelic character; and, as if aware of this superiority, was fond of painting angels. After all, however, they, whose taste is formed on the simplicity

of

of the antique, think *Guido's air*, in general somewhat theatrical.

643 *Skilful they*, &c. The greatest obstruction to the progress of art arises from the prejudices of conceited judges; who, in fact, know less about the matter, than they who know nothing: inasmuch as truth is less obvious to error, than it is to ignorance. Till they can be prevailed on to return upon their steps, and look for that criterion in nature, which they seek in the half-perished works of great names, the painter will be discouraged from pursuing knowledge in those paths, where Raphael, and Titian found it.—We have the same idea well inforced in Hogarth's analysis of beauty. (Introduc. p. 4.) " The reason why gentlemen, inquisitive
" after knowledge in pictures, have their
" eyes less qualified to judge, than others,
" is because their thoughts have been con-
" tinually employed in considering, and
" retaining the various *manners*, in which
" pictures are painted — the histories, names,
" and characters of the masters, together
" with many other little circumstances be-
" longing to the *mechanical* part of the
" art; and little or no time has been given
" to perfect the ideas they ought to have
" in

" in their minds, of the objects themselves
" in nature. For having adopted their
" firſt notions merely from *imitations ;* and
" becoming too often as bigotted to their
" faults, as to their beauties, they totally
" diſregard the works of nature, merely
" becauſe they do not tally with what their
" minds are ſo ſtrongly prepoſſeſſed with.
" Were it not for this, many a reputed
" capital picture, which now adorns the
" cabinet of the curious, would long ago
" have been committed to the flames."

644 *What if theſe compare,* &c. Bruyere obſerves, that the inferior critic judges only by *compariſon.* In one ſenſe all judgment muſt be formed by compariſon. But Bruyere, who is ſpeaking of poetry, means, that the inferior critic has no ſcale of judgment of a work of art, but by comparing it with ſome other work of the ſame kind. He judges of Virgil by a compariſon with Homer; and of Spencer by comparing him with Taſſo. By ſuch criticiſm he may indeed arrive at certain truths; but he will never form that maſterly judgment, which he might do by comparing the work before him with the great archetypes of nature, and the ſolid rules of his art.——What Bruyere ſays of the critic in poetry, is
very

very applicable to the critic in painting. The inferior critic, who has travelled, and feen the works of many great mafters, fuppofes he has treafured up from them the ideas of perfection; and inftead of judging of a picture by the rules of painting, and it's agreement with nature, he judges of it by the arbitrary ideas he has conceived; and thefe too very probably much injured in the conception. From this comparative mode of criticizing, the art receives no advancement. All we gain, is, that one artift paints better than another.

END OF THE NOTES.

(46)

colour very applicable to the coffin in painting
pictures of the interior catacombs like Trevelloe
and one, the ochres of some place rather
different. He has reached up three them
time. Class of gentleman, and behind to
judging of a picture by the rules of
painting, and its agreement with nature,
be judges of it by the settled rules he
has received; and this is very evi-
dently in this infernal priestly conception.
From this comparative want of culti-
vation, the recluses are no movement.
All we gain is, that one self minor
terror than another.

TOP OF THE HOUSE.

TWO ESSAYS:

ON THE

PRINCIPLES ON WHICH THE AUTHOR MADE
HIS DRAWINGS;

AND

THE MODE OF EXECUTING THEM.

TWO ESSAYS:

ON THE

PRINCIPLES ON WHICH THE AUTHOR MADE
HIS DRAWINGS,

THE MODE OF EXECUTION THEM

ESSAY I.

ON THE MODE IN WHICH THE AUTHOR EXECUTES THESE ROUGH SKETCHES.

These sketches are in the same style as most of those which were offered before. They are *roughly finished*, pretending only to exhibit a little composition and effect. They are taken, indeed, from the same rough scenes of nature; and consist chiefly of mountains, rocks, rivers, and lakes These ingredients, however, though few, afford such variety, and may be so infinitely combined, that the same objects may recur in various scenes, and yet none of those scenes may resemble each other: as in the human face there are only four features, yet they are capable of receiving so many variations, that no two faces are exactly alike.

The *pen* I use is made of a reed, which gives a much freer and easier stroke than a pen made of a quill, which never runs fluently on paper, but scratches it, and often sputters the ink. The reed pen may be cut to a fine point, where a slight touch is required, as sometimes in distant foliage; and when it grows blunt with a little use, it becomes something between a brush and a pen, and

gives a bold ſtroke, which has a good effect on the boles of trees, or on a foreground. But care ſhould be taken to leave the ſtrongeſt marks of the pen on the ſide oppoſite to that on which you mean the light to enter.

In *highly finiſhed* drawings the pen is not generally uſed. The black lead lines are commonly wrought up into effect by the bruſh; but, in a rough ſketch, the pen I think, is the beſt inſtrument, it gives a termination to an object at once, and marks it with freedom and ſpirit, which are the grand characteriſtics of a ſketch.

The ink which is uſed with the pen in theſe drawings is what the callico-printers, I believe, call *iron-water*, and uſe in fixing their colours. It has a browniſh tint, which is more pleaſing to the eye, and unites better with the ſhade of Indian ink than common ink. Both Indian ink and common ink, lowered by water, want ſtrength, and the latter retains always an unpleaſant hue. I could never find any ink that was indelible but this iron-water. You may eaſily make an ink of the colour you wiſh, but when you waſh a ſhade over it, it blurs, and runs. Sometimes, indeed, you find in old ink-ſtands a

yellowiſh

yellowish ink, which is very good. But this is a precarious supply. I remember once being much disappointed in an attempt to procure some of this picturesque ink. I had money to pay to an old lady, who gave me a receipt, written out of a leaden stand full of it. It was before I had heard of the iron-water, and thinking I had met with a great treasure, I cast about how to get possession of it. I told the old lady, therefore, that I thought her ink was bad, and if she would trust her leaden pot with me, I would fill it with better. She courteously told me, if I did not like her receipt, she would draw me out another. It would have been in vain to have told her, as she was half deaf, and of confused intellect, that her bad ink was to me better than any other, and for what use I wanted it.

No instrument is more useful in drawing than a piece of moistened spunge. When the shade is too strong, it easily rubs it down, and the paper, when dry, as easily admits it again.

The tint, which is thrown over these drawings, after they are finished, is composed of gamboge and any brownish colour. It gives

harmony

harmony to the whole, and takes off the rawness of white paper. It should be stronger or slighter, according to the depth of shadow in the drawings. The harmonizing effect of it is such, that I well remember, (if I may be allowed to mention so trifling a circumstance,) when a boy I used to make little drawings, I was never pleased with them till I had given them a brownish tint. And, as I knew no other method, I used to hold them over smoke till they had assumed such a tint as satisfied my eye.

For the use of those who may perhaps like my mode of drawing, I have separated a few parcels, each parcel consisting of three drawings, two of which may be called skeletons. They will easily shew my process. The first drawing is only in its black-lead state, and points out merely the composition. — The next drawing goes a step farther. The distance is still left in black lead; but the objects on the foreground are roughly touched with a pen. This introduces some idea of *keeping*. — The third drawing adds light and shade, and carries the idea as far as my drawings commonly go. — The composition of these three drawings shews the great advantage of

light

light and shade, and gives some idea of the disposition of light, and of its great utility in combining the several *parts* of a landscape into one *whole*.

I am very far from calling this mode of drawing the *best*, or even a *good* one, if finishing is required: but it is a very quick method of conveying picturesque ideas, and very capable of producing an effect.—Nor let the professional man laugh at these little instructions; I mean them not for him; but only for the use of those who wish for an easy mode of expressing their ideas; who draw only for amusement, and are satisfied, without colouring and high finishing, with an endeavour, by a rough sketch, to produce a little *composition* and *effect*.

Under this idea I have sometimes presumed to recommend my own drawings to those who are fond of neater work than mine, and even to young ladies. I offer them, however, only as useful in pointing out the *form* and *component parts* of a landscape, marking where the light may fall to most advantage. In all these points the drawings of young artists are most deficient. They chiefly depend on the beauty and neatness of the several objects.
But

But if thefe objects are not well united, and formed into fome compofition, the moft valuable part of the drawing is ftill wanting; and, what fhould be a landfcape, becomes only a beautiful piece of patch-work.

Under many of thefe drawings, alfo, are defcriptions, as if they were real fcenes. Indeed, if artificial landfcape cannot be thus analized as a *whole*, it muft confift of *unconnected parts*; and can be only indifferently compofed.

The *fkeleton drawings* relate more to the firft Effay; thefe *defcriptive* drawings rather to the fecond. The former relate to the *mode of executing the parts*; the latter to the *management of a whole*.

When I fold my laft drawings, I advertized a *catalogue*, and *added* to it an Effay upon the *Principles on which the Drawings were executed*. But, as the *catalogue* feemed the principal thing intended, it took the eye, and the *Effay*, which had not been advertized, was overlooked: thus three or four hundred copies of this effay were left upon my hands. I thought it a pity, therefore, that fo much of my time had been taken up in vain, in writing the Effay; and fo much lofs fhould accrue to

my

my endowment for want of its fale. In the following little work, therefore, I have endeavoured to make the inftruction of the Effay more complete. I have taken away the catalogue-part as now ufelefs, and have added another little effay, which feems to be a proper appendage to the firft. In the firft Effay, printed with the catalogue, an account is given of the *principles* on which the drawings offered in fale were made. In this additional effay, the *mode of executing* them is explained.

ESSAY

my endowment for want of its title. In the following little work, therefore, I have endeavoured to make the instruction of the Bibly more complete. I have taken away the catalogue-part as now useful, and have added another little essay, which seems to be a proper appendage to the first. In the first essay, printed with the catalogue, an account is given of the principles on which the drawings offered in his were made. In this additional essay, the mode of executing them is explained.

ESSAY II.

ON THE PRINCIPLES ON WHICH THE AUTHOR'S SKETCHES ARE COMPOSED.

―――― Contented with a humble theme,
He pours the ſtream of imitation down
The vale of nature, where it creeps and winds
Among her wild and lovely works.

ESSAY II.

ON THE PRINCIPLES ON WHICH THE AUTHOR'S METHODS ARE COMPOSED.

———— Cemented with a humbler theme,
He posts the fhoem of imitation down
The side of nature, where it creeps and winds
Among her wild and lovely works.

Most of the sketches here offered to the public, are *imaginary* views. But as many people take offence at *imaginary* views; and will admit such landscape only as is immediately taken from nature, I must explain what we mean by an *imaginary* view.

We acknowledge nature to be the grand storehouse of *all picturesque beauty*. The nearer we copy her, the nearer we approach perfection. But this does not affect the *imaginary view*. When we speak of *copying nature*, we speak only of particular *objects*, and particular *passages* — not of *putting the whole together* in a picturesque manner; which we seldom seek in nature, because it is seldom found. Nature gives us the materials of landscape; woods, rivers, lakes, trees, ground, and mountains: but leaves us to work them up into pictures, as our fancy leads. It is thus she sheds her bounty on other occasions. She gives us grass; but leaves us to make hay. She gives us corn; but leaves us to make bread.

Yet

Yet still in copying the several *objects, ana passages of nature,* we should not copy with that painful exactness, with which Quintin Matsis, for instance, painted a face. This is a sort of plagiarism below the dignity of painting. Nature should be copied, as an author should be translated. If, like Horace's translator, you give word for word*, your work will necessarily be insipid. But if you catch the meaning of your author, and give it freely, in the idiom of the language into which you translate, your translation may have both the *spirit,* and *truth* of the original. *Translate nature* in the same way. Nature has its idiom, as well as language; and so has painting.

Every part of nature exhibits itself in, what may be called, *prominent features.* At the first glance, without a minute examination, the difference is apparent between the bole of a beech, for instance, and that of an oak; between the foliage of an ash, and the foliage of a fir These *discriminating* features the painter seizes; and the more faithfully he transfuses them into his work, the more ex-

* ―― Verbum verbo curabis reddere, fidus Interpres ――

cellent

cellent will be his reprefentation. And when thefe *prominent features* are naturally expreffed, and judicioufly combined in a *fictitious* view, that view may not only be a *natural* one, but a *more beautiful exhibition of nature,* than can eafily be found in real landfcape. It may even be called more *natural*, than nature itfelf: inafmuch as it feizes, and makes ufe, not only of nature's *own* materials, but of the beft of each kind.

The painter of *fictitious* views goes ftill farther. There are few forms, either in animate, or inanimate nature, which are completely perfect. We feldom fee a man, or a horfe, without fome perfonal blemifh: and as feldom a mountain, or tree, in its moft beautiful form. The painter of *fictitious* fcenes therefore not only takes his forms from the moft compleat individuals, but from the moft beautiful parts of each individual; as the fculptor gave a purer figure by felecting beautiful parts, than he could have done by taking his model from the moft beautiful fingle form.

Befides, pleafing circumftances in *nature* will not always pleafe in *painting*. We often fee effects of light, and deceptions in compofition, which delight us, when we can ex

amine, and develope them *in nature*. But when they are *reprefented*, like a text without its context, they may miflead; and the painter had better reject fuch fcenery, though ftrictly natural. *Obfcurity* in painting fhould be as much avoided, as in writing; unlefs in diftances, or in fome particular incidents, where obfcurity is intended.

The painter of a *fictitious view* claims no greater liberty, than is willingly allowed to the hiftory-painter; who in all fubjects, taken from remote times, is neceffarily obliged to his imagination, formed as it ought to be, upon nature. If he give fuch a character to the hero he exhibits, as does not belye the truth of hiftory; and make fuch a reprefentation of the ftory, as agrees with the times he reprefents, and with the rules of his art, his hiftory-piece is admired, though widely different, in many circumftances, from the real fact. Le Brun's picture of Alexander entering the tent of Darius, is undoubtedly very different from any thing, that really happened: but it conveys fo much the appearance of nature, and of truth, that it gives us full fatisfaction.

The

The painter of *imaginary* landscape desires no other indulgence. If from an accurate observation of the most beautiful objects of nature, he can by the force of his imagination characterize, and dispose them naturally, he thinks he may be said to paint from nature.

"The poet's art," says the abbé Du Bos, "consists in making a good representation of things, that *might have* happened, and in embellishing it with proper images."

Du Bos speaks after Aristotle, whose principle it is, that the poet is not required to relate what has *really happened*, but what *probably might happen*; which Horace translates, when he tells us, the poet,

———— ita mentitur; sic veris falsa remiscet,
Primo ne medium, medio ne discrepet imum.

All this as exactly regulates the art of managing *fiction* in landscape, as it does in poetry. And indeed the general rules of the best critics for the direction of the drama, direct us with great propriety in picturesque composition.——It is true indeed we may, for the sake of curiosity, wish to have a *particular scene exactly represented:* but, the indulgence of curiosity does not make the picture better.

Besides the advantage in point of *composition*, the *imaginary* scene preserves more the *character* of landscape, than the *real* one. A landscape may be rural, or sublime — inhabited, or desolate — cultivated, or wild. Its *character*, of whatever kind, should be observed throughout. Circumstances, which suit one species, contradict another. Now in nature we rarely see this attention. Seldom does she produce a scene *perfect in character*. In her best works she often throws in some feature at variance with the rest — some trivial circumstance mixed often with sublime scenery: and injudicious painters have been fond of affecting such inconsistencies. I have seen a view of the Colosseum, for instance, adorned with a woman hanging linen to dry under its walls. Contrasts of this kind may suit the moralist, the historian, or the poet, who may take occasion to descant on the instability of human affairs. But the *eye*, which has nothing to do with *moral sentiments*, and is conversant only with *visible forms*, is disgusted by such unnatural union.

There is still a *higher character* in landscape, than what arises from the *uniformity of objects* — and that is the power of furnishing images

images *analagous to the various feelings, and sensations of the mind.* If the landscape-painter can call up such representations, (which seems not beyond his art) where would be the harm of saying, that landscape, like history-paintings, hath its ethics!

<div style="text-align: center;">——— ——— Such thy pencil, Claude!
It makes us pant beneath thy summer-sun,
And shiver in thy cool autumnal eve.</div>

To convey however ideas of this kind is the perfection of the art: it requires the splendour, and variety of colours; and is not to be attempted in such trivial sketches as these. In the mean time, the *painter of imaginary scenes* pursues the best mode of forming these *ethical* compositions, as all nature lies before him, and he has her whole storehouse at command.

To what hath been said in favour of *imaginary views*, nothing more pertinent, can be added than a few remarks from a gentleman* well known for his superior taste in painting.

" You ask me, whether I have ever seen a
" *correct* view of any *natural scene*, which quite
" satisfied me? and you confess you rarely
" have. I am perfectly of your opinion. There is
" a servile individuality in the *mere* portrait of

* Sir George Beaumont, Bart.

" a view

"a view which always difpleafes me; and is
"even lefs interefting than a map. It muft be full
"of awkward lines; and the artift, cramped
"by given fhapes, gives his work always the
"air of a copy. The old mafters rarely
"painted views from nature. I believe never,
"but when commiffioned. Like poets they
"did not confine themfelves to matter of fact;
"they chofe rather to exhibit what a country
"fuggefted, than what it really comprized;
"and took, as it were, the effence of things.
"The fervile imitator feems to me to miftake
"the *body* for the *foul*; and will never touch
"the heart. Befides, every thing looks well
"in nature. Lumpifh forms, and counter-
"acting lines, touched by her exquifite hand,
"are hardly noticed. But in art they are
"truly difgufting; and the artift muft avail
"himfelf of every advantage, if he wifhes to
"cope with her. If he attack her on equal
"terms, he is fure of being difgracefully van-
"quifhed."

Having faid thus much in favour of *imaginary compofition*, we are compelled however by truth to add, on the other fide, that a conftant application to his own refources is apt to lead the artift without great care, into the difagree-
able

able bufinefs of repeating himfelf. If he would avoid this, he muft frequently refrefh his memory with nature; which, however flovenly in her compofition, is the only fchool where he muft ftudy forms: or, if he cannot always have recourfe to nature for the object he wants, he muft turn over his common-place-book. This, it may be hoped, abounds with forms and paffages, which may furnifh a fufficient variety for his choice.

The hints, from which moft of thefe fketches offered to the public are taken, were collected from mountainous, and lake fcenery, where the author chiefly fought his picturefque ideas.

Such fcenery affords two great fources of picturefque compofition — *fublimity*, or *fimple grandeur*; and *grandeur united with beauty*. The former arifes from a *uniformity of large parts*, without *ornament*, without *contraft*, and without *variety*. The latter arifes from the introduction of *thefe appendages*, which forms fcenery of a *mixed kind*.

Some of thefe fketches are attempts at *fublimity* or *fimple grandeur*. But as this is an idea, which is neither eafily caught, nor generally

nerally admired, moſt of them aim at mixing *grandeur* and *beauty* together.

But whether the artiſt paint from *nature* or from his *imagination*, certain general rules, which belong to his art, ſhould never be tranſgreſſed.

In the firſt place, he ſhould always remember, that the excellence of landſcape-painting conſiſts in bringing before the *ſpectator's eye*, or rather in raiſing to *his imagination* ſuch ſcenes as are moſt *pleaſing*, or moſt *ſtriking*. Every painter therefore ſhould have this idea always in view; and ſhould paint ſuch ſcenes only. In the choice of theſe intereſting ſubjects he chiefly diſcovers his taſte. The full effect indeed of ſuch ſcenes can only be given by the *pallet*; yet it ſhould be aimed at, as far as poſſible, even in the *ſketch*.

Again, a landſcape, as well as a hiſtory-piece, ſhould have ſome *maſter-ſubject*. We often indeed ſee landſcape compoſed without much idea of this kind. One piece of ground is tacked to another, with little meaning or connection. We ſhould attend more to the ſimplicity of a *whole*. Some uniform, diſtinct

tinct plan should always be presented; and the several parts should have relation to each other. The scenery about a castle, a ruin, a bridge, a lake, a winding river, or some remarkable disposition of ground, may make the leading part of a landscape; and if it be set off with a suitable distance, if necessary, and a proper fore-ground, we have subject enough for a picture. In short, there should be some idea of *unity* in the *design*, as well as in the *composition*; and every part should concur in shewing it to advantage. The parts being thus few and simple, the eye at once conceives the *general idea*. If the landscape be a finished piece, all these parts should be enriched with a variety of *detail*, which, at the same time, must unite in embellishing the *general effect*.

Still farther, the *probability* of every part should appear. A castle should never be placed where a castle cannot be supposed to stand. A lake should generally have the appendage of a mountainous country; and the course of a winding river should be made intelligible by the folding of the hills. In some of the drawings now offered to the public, it is endeavoured to explain this idea by a few remarks on the back of each. These
explanatory

explanatory drawings are particularly mentioned in the catalogue. Indeed, a landscape, which cannot bear to be analized in this way, must be faulty. Sometimes, it is true, we find in nature itself improbable circumstances. The artist for that reason rejects them. But he is inexcusable, if he purposely introduce them.

The *general effect* of a picture is produced by a unity of *light*, as well as of *composition*. When we have gotten the several parts of a landscape together, — that is, when we are satisfied with the *composition*, still we cannot judge of the *effect*; nor appreciate the picture, till we have *introduced the light*, which makes a complete change in a landscape, either for the better or the worse. It is thus in nature. The appearance of the same country, under different effects of light, is totally different. These effects therefore cannot be too much studied; and should be studied when the artist *finishes a picture*, by making different sketches of the same subject, so as to ascertain the best. This is not always perhaps enough attended to. In *painting* indeed, a bad distribution of light is less discernable. The variety of colour-
ing

ing impofes on the fight; but in a collection of *prints* or *drawings*, the defects in light are obvious.

Gradation is another principle with regard to light, which is very effential in point of beauty. Neither lights, nor fhades, fhould *uniformly* fpread over one furface; but fhould *graduate* from more to lefs. *Gradation* in light and fhade, though not always feen in nature, is however frequently enough feen to be acknowledged among its beft fources of beauty. It removes that difgufting effect, which in found is called *monotony*; and produces, in its room, a pleafing variety on the furfaces of objects.

The illuftration of thefe few principles (as far as a fketch, or rough drawing can illuftrate them) is all that is aimed at in the drawings now offered to fale. Few of them will afford more than the *rude conception* of a landfcape. They pretend to fome degree of *compofition* and *effect*; but to little farther. Hard lines muft be excufed, and an inaccurate detail. They may perhaps have fomewhat more of *fcience* in them, than of *art*. What merit they have, is readily allowed without affectation.

Though

Though they cannot well claim the title of landscapes, they may furnish a few general hints; and some of them might be made pictures perhaps in the hands of a good master, who could furnish the *detail*. At the same time, thus much may be said, that we always conceive the *detail* to be the inferior part of a picture. We look with more pleasure at a landscape well designed, composed, and enlightened, though the parts are inaccurately, or roughly executed, than at one, in which the *parts* are well made out, but the *whole* ill-conceived. These ideas were once paradoxically, but well explained by a gentleman, who thought himself a better artist, after his hand began to shake, and his eyes to fail. By the shaking of my hand, he would say, my stroke, which was before formal, becomes more free: and when my eyes were good, I entered more into the *detail* of objects: now I am more impressed with the *whole*.

In *teaching* to draw, the stress is laid at first, as it ought to be, on the *parts*. If a scholar can touch a tree, or a building with accuracy, he has so far attained perfection. But it is the perfection only of a scholar. The great principles

ciples of his art are still behind. Often, however, our *riper* judgment is swayed by the excellence of the *parts,* in preference to a *whole.* The merit of a picture is fixed perhaps by the *master's touch;* or by the beauty of his *colouring;* or some other inferior excellence. But a great critic in arts, formed a different opinion;

> Æmilium circa ludum faber imus, & ungues
> Exprimet, & molles imitabitur ære capillos,
> Infelix operis *summâ,* quia ponere *totum*
> Nesciet.

A few of the drawings here exhibited, may be called *studies;* that is, the same subject hath been attempted in different ways, both with regard to *composition,* and *effect.*

In a few of them, the more redundant designs of Claude are simplified. A very numerous collection of prints were taken from the drawings of that master. Claude's originals are in the hands of the Duke of Devonshire. They exhibit many *beautiful parts,* but rarely a *simple whole;* though the collection, for what reason is not obvious, is styled *the book of truth.*

A few of the drawings here offered to sale, are slightly tinted; not as finished drawings; but

but juſt enough to give a diſtinction among objects. Yet even in theſe ſlight ſketches, unleſs there is ſome appearance of *harmony*, a very little degree of colouring glares. When therefore you have put in your light and ſhade, with Indian ink, ſpread over the *whole* a ſlight waſh of red and yellow mixed, which make an orange. It may incline either to one or the other, as may beſt ſuit your compoſition A cold bluiſh tint may ſometimes have effect. This general waſh will produce a degree of *harmony*. While the ſky is yet moiſt, tint the upper part of it, if it be orange, with blue, blending them together. Or if a little part only of the ſky appear, it may be all blue, or all orange, as may have the beſt effect. When the ſky is dry, throw a little blue, or what Reeves calls a *neutral tint**, into the diſtances; and over any water, that may be in the landſcape. Then introduce your browns, which are of various kinds, into the foreground; but let them be introduced ſlightly; and when all is dry, you may touch ſome of the brighteſt parts with dead green, or a little gall-ſtone. Burnt terra-de-Sienna, mixed with a little gall-ſtone, make a good tint for foliage.

* See his box of colours.

Some apology may perhaps be neceffary for the uniformity of one principle, which runs through moft of the defigns here exhibited; and that is the practice of *throwing the foreground into fhade*. Many artifts throw their *lights* on the *foreground*; and often, no doubt, with good effect. But, in general, we are perhaps better pleafed with a *dark* foreground. It makes a kind of graduating fhade, from the eye through the removed parts of the picture; and carries off the diftance better than any other contrivance. By throwing the *light* on the *foreground*, this *gradation* is *inverted*. In many of thefe fketches the lights were at firft left on the foreground; but on examining them with a frefh eye, they glared fo difagreeably, that they were afterwards put out.— Befides, the foreground is commonly but an *appendage*. The middle diftance generally makes the fcene, and requires the moft diftinction. In hiftory-painting it is the reverfe. The *principal* part of the fubject occupies the *foreground*; and the *removed* parts of the picture form the *appendages*. In a landfcape too, when a building, or other object of confequence, appears on the foreground, and the diftance is of little value, the light, on the fame principle,

may

may then fall on the *foreground:* though a building is sometimes thrown, even in that case, with more effect into shadow.—In most of these sketches it may be added, that the foreground is only just *washed in.* If the drawings had been *finished,* the foregrounds should have been broken into parts. But the author sues for candour on the head of *finishing.*

An apology may perhaps be due, on the other side also, for preserving too strong a light on some of the removed parts of the composition. In general, no part of the surface of a country (except, here and there, the reflected parts of water) should be so light, as the lightest parts of the sky. But this rule is not always observed in these sketches; partly because in work so slight, it might induce heaviness; and partly, because a little colour might easily supply the want of shade, if these sketches should ever be honoured with painting from them.

With regard to *figures* introduced in landscape, there is often great deformity. Bad appendages of this sort are very disgusting: and yet we often see views enlivened, (if it can be called

called enlivening) with ill-drawn figures of men, horses, cows, sheep, waggons, and other objects, which have not even the *air* of the things they represent. Or perhaps if the figures of a landscape are tolerably touched, too great a *number* of them are introduced; or they are *ill put together*; or perhaps *ill-suited* to the scene. Some of these circumstances are too often found in the best landscapes — as often in those of Claude, as of any other master. And yet I have heard, that Claude had a higher opinion of his own excellence in figures, than in any other part of his profession. Sir Peter Lely, we are told, wished for one of Claude's best landscapes; but delicately hinted to him, that he should rather chuse it without figures. Claude felt himself hurt at Sir Peter's depreciating that excellence, which he himself valued. He filled his landscape therefore with more figures, than he commonly introduced; and desired Sir Peter, if he did not like it, to leave it for those who understood the composition of landscape better.—— This picture, is at present, I am told, in the hands of Mr. Agar in London; and the history of it affords good instruction to such conceited artists as value them-

themselves on what nobody else values. Many landscape painters however might be named, who knew how to touch a small figure, and could people their landscapes with great beauty. Among these the late Mr. Wilson, one of the best landscape-painters, that hath appeared in our days, might be mentioned. Other painters, who could not paint figures themselves, have borrowed assistance from those who could. The late ingenious Mr. Barret, who painted every part of inanimate nature with singular beauty, had the discretion to get his landscapes generally peopled by a better hand than his own.

It cannot be supposed, the figures in these sketches are set up as models. So far from it, that they do not even pretend to the name of *figures*. They are meant only as substitutes to shew, where two or three figures might be placed to advantage. And yet even such figures are better than those, in which *finishing* is attempted and legs and arms set on without either life, air, or proportion. Indeed the figures here introduced, are commonly dressed in cloaks, which conceal their deformities. If legs and arms be not well set on, they are certainly better concealed.

As

As I can say nothing myself therefore on the subject of figures, I have gotten a few hints, and examples from my brother, Mr. Sawrey Gilpin; who, if my prejudices do not mislead me, is well skilled in this part of his art.

These hints respect the *size*, the *relative proportion of the parts, the balance of figures at rest, or in motion*; and what appears to him the easiest mode of sketching figures*: to which are added a few of such groups as may be introduced in landscape.

In the first place, with regard to the *size* of figures, as the known dimensions of the human body give a scale to the objects around, exactness in this point is a matter of no little consequence. If the figure be too large, it diminishes the landscape—if too small, it makes it enormous: and yet it seems no very

* Mr. S. G. had once thoughts of giving the public a few remarks on landscape-figures, both human and animal; and illustrating his remarks by a variety of etched examples. It would be a work (in my opinion at least) highly useful to all, who draw or paint landscape. But I fear his engagements will prevent his ever bringing this work to such perfection, as would satisfy himself; and this little extract from it is probably the only part of it that will ever appear.

difficult

difficult matter to adjuſt the proportion, by comparing the figure with ſome object on the ſame ground.

Though in figures, meant only to adorn landſcape, the exactneſs of *anatomy* is not required, yet a ſmall degree of *diſproportion* ſtrikes the eye with diſguſt, even in a ſketch — in the *head* and *limbs* eſpecially. The body naturally forms itſelf into two parts of equal length. From the crown of the head to the point where the limbs divide, is one half. This may be ſubdivided into four parts. The head and neck to the top of the ſhoulder make one of theſe ſub-diviſions: from the top of the ſhoulder to the lower line of the muſcle of the breaſt we meaſure another: from thence to the hips a third; and from the hips to the point where the limbs divide, a fourth. The *legs* and *arms* admit each of a diviſion into two parts. In the former, the upper part of the knee is the point of diviſion; as the elbow is in the latter, when the hand is cloſed. When the arm hangs down, and the fingers are extended, their points will reach the middle of the thigh. But though we have no occaſion to obſerve this diviſion accurately in ornamental figures,

it

N°. 2.

it may be useful to have a *general idea* of it.

The *balance*, however, of a figure, even in landscape, is matter of great consequence. If every thing else were right but this, the effect of the figure would be destroyed. A figure intended to be in *motion*, from an unhappy poise of its limbs, would appear to *stand still*. And from the same cause, a *standing* figure would appear to be a *falling* one. The balance of *standing* figures may be regulated by a supposed perpendicular dividing the body, from the crown of the head, into two parts. If the legs bear equal weight, this line will fall exactly between them. If the weight is borne unequally, the line will fall nearer that leg which bears the greatest proportion: and if the whole burden be thrown on one leg, the line will pass through the centre of its heel. When the weight is thus unequally distributed, the shoulder on one side forms a counterpoise to the hip on the other: and when the shoulder is not a sufficient counterpoise, as in the case of bearing a weight in one hand, the contrary arm is thrown out to restore the balance.— *Stooping* figures come under the same rule; only

only the perpendicular will arise from the centre of gravity, at the feet of the figure, and divide it into equal parts. The *progressive* motion of figures may also be adjusted by a perpendicular, drawn from the foot, that bears the weight; the figure being projected beyond it in proportion to the velocity, with which it is represented to move*.

A few words may be added with regard to the *easiest manner of sketching slight figures in landscape*. To attempt finishing the limbs at first, would lead to stiffness. If the figures are placed near the eye, a little attention to *drawing* is requisite: and the simplest, and perhaps the best method will be, to sketch them in lines nearly straight, under the regulations above given. A little swelling of the muscles, and a few touches to mark the extremities, the articulation of the joints, and the sharp folds of the drapery, may afterwards be given, and will be sufficient †.

After gaining a knowledge in the *form* of figures, the next point is to *group* them. The form depends on *rule*; the group more on

* To illustrate these remarks, see plate 1.
† To illustrate these remarks, see plate 2.

taste.

N.3.

taste. A few landscape-groups are here specified, which may assist the young artist in combining his figures*

With regard to his own *drawings*, the author hath only to observe farther, that they will appear to most advantage, if they are examined by candle-light; or, if in day-light, by intercepting a strong light. This mode of viewing them will best shew the *effect*, in which chiefly consists the little merit they have; and will likewise conceal the faultiness of the *execution* in the several details. Such of these drawings however as are tinted, cannot be examined by candle-light.

* See plate 3.

THE END.

Strahan and Preston,
Printers-Street, London.

A Catalogue *of*
Mr. Gilpin's Picturesque Works, *sold by*
Meſſrs. Cadell *and* Davies *in the* Strand.

OBSERVATIONS on the River Wye, and ſeveral Parts of South Wales, &c. relative chiefly to picturefque Beauty, made in the Summer of the year 1770. Illuſtrated with Plates. Fifth Edition. 17s. in boards.
⁎ Another Edition, elegantly printed in a Pocket Volume, without Plates. 4s. in Boards.

OBSERVATIONS on ſeveral Parts of England, particularly the Mountains and Lakes of Cumberland and Weſtmoreland, relative chiefly to picturefque Beauty, made in the Year 1772. With Plates. 2 Vols. Fourth Edition. 1l. 16s. in Boards.

OBSERVATIONS on the Coaſts of Hampſhire, Suſſex, and Kent, relative to Picturefque Beauty, made in the Summer of the Year 1774. With Engravings. 8vo. 7s. in Boards.

OBSERVATIONS on ſeveral Parts of Great Britain, particularly the Highlands of Scotland, relative chiefly to picturefque Beauty, made in the Year 1776. 2 Vols. with Plates. Third Edition. 1l. 16s. in Boards.

OBSERVATIONS on the Weſtern Parts of England, relative chiefly to picturefque Beauty. To which are added, a few Remarks on the picturefque Beauties of the Iſle of Wight. With Plates. Second Edition. 1l. 5s. in Boards.

REMARKS on Foreſt Scenery, and other Woodland Views, relative chiefly to picturefque Beauty, illuſtrated by the Scenes of New Foreſt in Hampſhire. 2 vols. with Plates. Third Edition. 1l. 16s. in Boards.

AN ESSAY on PRINTS. Fourth Edition. 4s. in Boards.

TWO ESSAYS—one on the Author's Mode of executing rough Sketches—the other, on the Principles on which they are compoſed, Price 3s.

AN
ESSAY
ON
PRINTS.

A Catalogue of
Mr. Gilpin's Picturesque Works, sold by
Messrs. Cadell and Davies in the Strand.

OBSERVATIONS on the River Wye, and several Parts of South Wales, &c. relative chiefly to picturesque Beauty, made in the Summer of the Year 1770. Illustrated with Plates. Vol. Edition, 17s. in boards.

*** Another Edition, elegantly printed in a Pocket Volume, without Plates, 4s. in Boards.

OBSERVATIONS on several Parts of England, particularly the Mountains and Lakes of Cumberland and Westmoreland, relative chiefly to picturesque Beauty, made in the Year 1772. With Plates. 2 Vols. Fourth Edition. 1l. 1s. in Boards.

OBSERVATIONS on the Highlands, Scotland, and parts relative to Picturesque Beauty, made in the Summer of the Year 1776. With Engravings. 2l. 2s. in Boards.

OBSERVATIONS on the ... Parts of Great Britain, particularly the Highlands of Scotland, relative chiefly to picturesque Beauty, made in the Year 1776. 2 Vols. with Plates. Third Edition, 1l. 11s. 6d. in Boards.

OBSERVATIONS on the Western Parts of England, relative chiefly to picturesque Beauty. To which is annexed a few Remarks on the picturesque Beauties of the Isle of Wight. With Plates. Second Edition. 1l. 1s. in Boards.

REMARKS on Forest Scenery, and other Woodland Views relative chiefly to picturesque Beauty, illustrated by the Scenes of the New Forest in Hampshire. 2 vols. with Plates. Third Edition. 1l. 4s. in Boards.

AN ESSAY on PRINTS. Fourth Edition. 4s. in Boards.

THREE ESSAYS — on the Author's Mode of executing rough Sketches; the other, on the Principles on which they are designed. Price 5s.

AN

ESSAY

ON

PRINTS.

By WILLIAM GILPIN, M.A.
PREBENDARY OF SALISBURY;
AND VICAR OF BOLDRE IN NEW-FOREST,
NEAR LYMINGTON.

THE FIFTH EDITION.

LONDON:
PRINTED BY A. STRAHAN, PRINTERS-STREET;
FOR T. CADELL, JUN. AND W. DAVIES, IN THE STRAND.
1802.

AN

ESSAY

ON

PRINTS.

By WILLIAM GILPIN, M.A.
PREBENDARY OF SALISBURY;
AND VICAR OF BOLDRE IN NEW-FOREST,
NEAR LYMINGTON.

THE FIFTH EDITION.

LONDON:
PRINTED BY A. STRAHAN, PRINTERS-STREET;
FOR T. CADELL, JUN. AND W. DAVIES, IN THE STRAND.
1802.

TO THE HONORABLE

HORACE WALPOLE,

IN DEFERENCE TO HIS TASTE
IN THE POLITE ARTS;
AND THE
VALUABLE RESEARCHES HE HAS MADE
TO IMPROVE THEM;

THE FOLLOWING WORK

IS INSCRIBED

BY HIS MOST OBEDIENT

AND VERY HUMBLE SERVANT,

WILLIAM GILPIN.

TO THE HONORABLE

HORACE WALPOLE,

IN DEFERENCE TO HIS TASTE
IN THE POLITE ARTS;
AND THE
VALUABLE RESEARCHES HE HAS MADE
TO IMPROVE THEM;

THE FOLLOWING WORK

IS INSCRIBED

BY HIS MOST OBEDIENT

AND VERY HUMBLE SERVANT,

WILLIAM GILPIN.

PREFACE.

THE chief intention of the following work, was to put the elegant amusement of collecting prints on a more rational footing; by giving the *unexperienced* collector a few principles, and cautions to assist him.

With this view the author thought it necessary to apply the principles of painting to prints: and as his observations are not always new, he hath at least made them concise.

His account of artifts might eafily have been enlarged, by having recourfe to books : particularly he could have availed himfelf much of the ingenious refearches of Mr. Walpole. He did not however choofe to fwell his volume with what others had faid ; but wifhed rather to reft on fuch obfervations, as he had himfelf made. He had many opportunities of feeing fome of the beft collections of prints in England ; and occafionally availed himfelf of them by minuting down remarks.

Of the works of living artifts the author hath purpofely faid little.
He

He thought himself not at liberty to find fault; and when he mentions a modern print, he means not, by praising one, to imply inferiority in another; but merely to illustrate his subject, when he had occasion, with such prints, as occurred to his memory.

The author wishes to add, that when he speaks *positively* in any part of the following work, he means not to speak *arbitrarily:* but only to avoid the tedious repetition of qualifying phrases.

> N. B. When the figures on the *right hand* are spoken of, those are meant, which are opposite to the spectator's right hand: and so of the left.

his subject, when he had occasion, with such prints, as occupied to his memory.

The author wishes to add, that when he speaks positively in any part of the following work, he means not to speak arbitrarily, but only to avoid the tedious repetition of qualifying phrases.

N. B. When the figures on the right hand are spoken of, those are meant, which are opposite to the spectator's right hand:

EXPLANATION

OF

TERMS.

Composition, in its *large* fenfe means, a picture in general: in its *limited* one, the art of grouping figures, and combining the parts of a picture. In this latter fenfe it is fynonymous with *difpofition*.

Defign, in its ftrict fenfe, applied chiefly to *drawing:* in its more inlarged one, defined page 2. In its moft inlarged one, fometimes taken for a picture in general.

A whole: The idea of *one* object, which a picture fhould give in its comprehenfive view.

Expreffion: its ftrict meaning defined page 16: but it often means the force, by which objects of *any* kind are reprefented.

Effect arises chiefly from the management of light; but the word is sometimes applied to the general view of a picture.

Spirit, in its strict sense, defined page 21: but it is sometimes taken in a more inlarged one, and means the *general* effect of a masterly performance.

Manner, synonymous with *execution.*

Picturesque: a term expressive of that peculiar kind of beauty, which is agreeable in a picture.

Picturesque grace: an agreeable form which may be given even to a clownish figure.

Repose, or *quietness* applied to a picture, when the *whole* is harmonious; when nothing glares either in the light, shade, or colouring.

To *keep down, take down,* or *bring down,* signify throwing a degree of shade upon a glaring light.

A middle tint, is a medium between a strong light, and strong shade: the phrase is not at all expressive of colour.

Catching

Catching lights are strong lights, which strike on some particular parts of an object, the rest of which is in shadow.

Studies are the sketched ideas of a painter, not wrought into a whole.

Freedom is the result of quick execution.

Extremities are the hands and feet.

Air, expresses chiefly the graceful action of the head; but often means a graceful attitude.

Contrast, is the opposition of one part to another.

Needle is the instrument used in etching.

Catching lights are strong lights, which strike on some particular parts of an object, the rest of which is in shadow.

Studies are the sketched ideas of a painter, not wrought into a whole.

Freedom is the result of quick execution.

Extremities are the hands and feet.

Air expresses chiefly the graceful action of the head; but often means a graceful attitude.

Contrast is the opposition of one part to another.

Needle is the instrument used in etching.

Glaring ... signify ... degree of ... glaring light.

A ... between a strong light ... the plural is use of colour.

Catching

CONTENTS.

CHAPTER I.

The principles of painting confidered, as far as they relate to prints *Page* 1

CHAP. II.

Obfervations on the different kinds of prints 2

CHAP. III.

Characters of the moft noted mafters 43

CHAP. IV.

Remarks on particular prints - 127

CHAP. V.

Cautions in collecting prints - 165

CHAP. I.

HE principles of painting confidered, as far as they relate to prints - Page 1

CHAP. II.

fervations on the different kinds of prints 2

CHAP. III.

aracters of the moft noted mafters - 43

CHAP. IV.

marks on particular prints - - 127

CHAP. V

utions in collecting prints - - 165

CHAP. I.

The principles of Painting confidered, fo far as they relate to Prints.

A PAINTING, or picture, is diftinguifhed from a print only by colouring, and the manner of execution. In other refpects, the foundation of beauty is the fame in both; and we confider a print, as we do a picture, in a double light, with regard to the *whole*, and with regard to its *parts*. It may have an agreeable effect as a *whole*, and yet be very culpable in its *parts*. It may be likewife the reverfe. A man may make a good appearance on the *whole*; though his *limbs*, examined feparately, may be wanting in exact proportion. His *limbs* on the other hand, may be exactly formed, and yet his perfon, on the *whole*, may be awkward, and difpleafing.

To make a print agreeable as a *whole*, a juft obfervance of thofe rules is neceffary,

which relate to *defign, difpofition, keeping*, and the *diftribution of light:* to make it agreeable in its *parts*—of thofe which relate to *drawing, expreffion, grace,* and *perfpective*.

We confider the *whole* before its *parts*, as it naturally precedes in practice. The painter firft forms his general ideas; and difpofes them, yet crude, in fuch a manner, as to receive the moft beautiful form, and the moft beautiful effect of light. His laft work is to finifh the feveral parts: as the ftatuary fhapes his block, before he attempts to give delicacy to the limbs.

By *defign*, (a term which painters fometimes ufe in a more limited fenfe) we mean the general conduct of the piece, as a reprefentation of fuch a particular ftory. It anfwers, in the hiftorical relation of a fact, to a judicious choice of circumftances; and includes a *proper time, proper characters,* the *moft affecting manner of introducing thofe characters,* and *proper appendages.*

With regard to a *proper time*, the painter is affifted by good old dramatic rules; which inform him, that *one* point of time only fhould be taken—the moft affecting in the action; and that no other part of the ftory fhould
interfere

interfere with it. Thus *in the death of* ANANIAS, if the inſtant of his falling down be choſen; no anachroniſm ſhould be introduced; every part of the piece ſhould correſpond; each character ſhould be under the ſtrongeſt impreſſion of aſtoniſhment, and horror: thoſe paſſions being yet unallayed by any cooler paſſions ſucceeding.

With regard to *characters*, the painter muſt ſuit them to his piece, by attending to hiſtorical truth, if his ſubject be hiſtory; or to heathen mythology, if it be fabulous.

He muſt alſo *introduce them properly*. They ſhould be ordered in ſo advantageous a manner, that the principal figures, thoſe which are moſt concerned in the action, ſhould catch the eye *firſt*, and engage it *moſt*. This is very eſſential in a well-told ſtory. In the firſt place, they ſhould be the leaſt embarraſſed of the group. This alone gives them diſtinction. But they may be farther diſtinguiſhed, ſometimes by a *broad light*; ſometimes by a *ſtrong ſhadow*, in the midſt of a light; ſometimes by a remarkable *action*, or *expreſſion*; and ſometimes by a combination of two or three of theſe modes of diſtinction.

The laſt thing included in *deſign* is the uſe of *proper appendages*. By *appendages* are meant animals, landſcape, buildings, and in general, whatever is introduced into the piece by way of ornament. Every thing of this kind ſhould correſpond with the ſubject, and rank in a proper ſubordination to it. BASSAN would ſometimes paint a ſcripture-ſtory : and his method was, to croud his foreground with cattle; while you ſeek for his ſtory, and at length with difficulty find it in ſome remote corner of his picture. Indeed neither the *landſcape*, nor the *ſtory* is principal; but his cattle. A *ſtory* therefore is an abſurd appendage.

When all theſe rules are obſerved, when a proper point of time is choſen; when characters correſponding with the ſubject are introduced, and theſe ordered ſo judiciouſly as to point out the ſtory in the ſtrongeſt manner ; and laſtly when all the appendages, and under-parts of the piece are ſuitable, and ſubſervient to the ſubject; then the ſtory is well told, and of courſe the *deſign* is perfect.

The second thing to be considered with regard to a *whole*, is *disposition*. By this word is meant the art of grouping figures, and of combining the several parts of a picture. *Design* considers the several parts as producing a *whole*;—but a *whole*, arising from the *unity of the subject*, not the *effect of the object*. For the figures in a piece may be so ordered, as to tell a story in an affecting manner, which is as far as *design* goes; and yet may want that agreeable *combination*, which is necessary to please the eye. To produce such a combination is the business of *disposition*. In the cartoon of St. PAUL *preaching at Athens*, the *design* is perfect; and the characters in particular, are so ordered, as to tell the story in a very affecting manner: yet the several parts of the picture are far from being agreeably combined. If RUBENS had had the *disposition* of the materials of this picture, its effect as a *whole* had been very different.

Having thus distinguished between *design* and *disposition*, I shall explain the latter a little farther.

It is an obvious principle, that one object at a time is enough to engage either the senses, or the intellect. Hence the necessity of *unity*, or a *whole*, in painting. The eye, on a complex view, must be able to comprehend the picture as *one object*, or it cannot be satisfied. It may be pleased indeed by feeding on the parts separately: but a picture, which can please no otherwise, is as poor a production as a machine, whose springs and wheels are finished with nicety, but are unable to act in concert, and effect the intended movement.

Now *disposition*, or the art of grouping and combining the figures, and several parts of a picture, contributes greatly to make the picture appear as *one object*. When the parts are scattered, they have no dependence on each other; they are still only parts: but when, by an agreeable grouping, they are massed together, they become a *whole*.

In disposing figures, great artifice is necessary to make each group open itself in such a manner, as to set off advantageously the several figures,

figures, of which it is compofed. The *action* at leaft of each figure fhould appear.

No group can be agreeable without *contraſt*. By *contraſt* is meant the oppofition of one part to another. A famenefs in attitude, action, or expreffion, among figures in the fame group, will always difguft the eye. In the cartoon of St. PAUL *preaching at Athens*, the contraft among the figures is pleafing; and the want of it, *in the death of* ANANIAS, makes the group of the apoftles rather difagreeable.

Nor indeed is *contraſt* required only among the *figures* of the *fame* group, but alfo among the *groups themfelves*, and among *all the parts*, of which the piece is compofed. In the *beautiful gate of the temple*, the figures of the principal group are well contrafted; but the adjoining group is difpofed almoft in the fame manner; which, together with the formal pillars, introduce a difagreeable regularity into the picture.

The judicious painter, however, whether he group, combine, or contraft, will always avoid the *appearance of artifice*. The feveral

parts of his picture will be so suited to each other, that his art will seem the result of chance. In the *sacrifice at Lystra*, the head of the ox is bowed down, with a design, no doubt, to group the figures around it more harmoniously: but their action is so well suited to the posture of the ox, and the whole is managed with so much judgment, that, although the figures are disposed with the utmost art, they appear with all the ease of nature. The remaining part of the group is an instance of the reverse; in which a number of heads appear manifestly stuck in to fill up vacuities.

But farther, as a *whole*, or *unity*, is an essential of beauty, *that disposition* is certainly the most perfect, which admits but of *one* group. All subjects, however, will not allow this *close* observance of unity. When this is the case, the several groups must again be combined; chiefly by a proper distribution of light, so as to constitute a *whole*.

But as the *whole* will soon be lost, if the constituent *parts* become *numerous*, it follows, that *many* groups must not be admitted.

Judicious

Judicious painters have thought *three* the utmost number, that can be allowed. Some subjects indeed, as battles, and triumphs, necessarily require a great number of figures, and of course various combinations of groups. In the management of *such* subjects, the greatest art is necessary to preserve a *whole*. Confusion in the figures must be expressed without confusion in the picture. A writer should treat his subject *clearly*, though he write upon *obscurity*.

With regard to *disposition*, I shall only add, that the *shape* or *form* of the group should also be considered. The *triangular* form Michael Angelo thought the most beautiful. And indeed there is a lightness in it, which no other form can receive. The group of the apostles, in the cartoon of *giving the keys*, and the same group, in the *death of* Ananias, are both heavy; and this heaviness arises from nothing more than from the form of a parallelogram, within the lines of which these groups are contained. The triangular form too is capable of the most variety: for the vertical angle of a group so disposed may either be acute, or obtuse, in any degree. Or a *segment* only of

a tri-

a triangle may be taken, which still increases the variety.

I know well, that many of these remarks (on the cartoons especially) oppose the opinions of very great masters. The sublimity of the Roman school, they say, totally disregarded the mechanical construction of a group. And without doubt, simplicity, and a sameness of figure, are ingredients of the sublime. But perhaps this theory, like other theories, may be carried too far. I cannot conceive, that the group of the apostles in the cartoon of ANANIAS, for instance, would be less sublime in the form of a triangle, than in that of a parallelogram. The triangle is certainly the more simple figure, as it consists of three sides only, while the parallelogram occupies four. Besides, Raphael himself by no means adopted the square form as a *ruling principle.*——But I speak with diffidence on this subject; nor indeed is this a place to discuss it.

A third thing to be considered in a picture, with regard to a *whole*, is *keeping*. This word implies the different degrees of strength and faintness,

faintnefs, which objects receive from nearnefs, and diftance. A nice obfervance of the gradual fading of light and fhade contributes greatly towards the production of a *whole*. Without it, the diftant parts, inftead of being connected with the objects at hand, appear like foreign objects, without meaning. Diminifhed in *fize* only, they unite Lilliput and Brobdignag in one fcene. *Keeping* is generally found in great perfection in DELLA BELLA's prints; and the want of it, as confpicuoufly in TEMPESTA's.

Nearly allied to *keeping* is the doctrine of *harmony,* which equally contributes towards the production of a *whole*. In *painting,* it has great force. A judicious arrangement of according tints will ftrike even the unpractifed eye. The *effect* of every picture, in a great meafure, depends on one principal and mafter-tint; which, like the key-tone in mufic, prevails over the whole piece. Of this ruling tint, whatever it is, every object in the picture fhould in a degree participate. This theory is founded on principles of truth; and produces a fine effect from the *harmony,*

in

in which it unites every object. Harmony is oppofed to glaring and gaudy colouring. Yet the fkilful painter fears not, when his fubject allows it, to employ the greateft variety of rich tints; and though he may depreciate their value in fhadow, he will not fcruple in his lights, to give each its utmoft glow. His art lies deeper. He takes the glare from one vivid tint by introducing another; and from a nice affemblage of the brighteft colours, each of which alone would ftare, he creates a glow in the higheft degree harmonious. But thefe great effects are only to be produced by the magic of colours. The harmony of a print is a more fimple production: and yet unlefs a print poffefs the fame *tone of fhadow*, if I may fo exprefs myfelf, there will always appear great harfhnefs in it. We often meet with hard touches in a print; which, ftanding alone, are unharmonious; but if every contiguous part fhould be touched-up to that *tone*, the effect would be harmony.—*Keeping* then proportions a proper degree of ftrength to the near and diftant parts, in refpect to *each other*. *Harmony* goes a ftep farther, and keeps each part quiet, with refpect to the *whole*. I fhall only add, that in fketches,

and

and rough etchings, no *harmony* is expected: it is enough, if *keeping* be obferved. *Harmony* is looked for only in finifhed prints. If you would fee the want of it in the ftrongeft light, examine a worn-print, harfhly touched by fome bungler.

The laft thing, which contributes to produce a *whole*, is a proper *diftribution of light*. This, in a print efpecially, is moft effential. Harmony in colouring may, in fome meafure, fupply its place in painting: but a print has no fuccedaneum. Were the *defign*, *difpofition*, and *keeping* ever fo perfect, beautiful, and juft; without this effential, inftead of a whole, we fhould have only a piece of patch-work. Nay, fuch is the power of *light*, that by an artificial management of it we may even harmonize a bad difpofition.

The general rule which regards the diftribution of *light*, is, that it fhould be fpread in *large maffes*. This gives the idea of a *whole*. Every grand object catches the light only on one large furface. Where the light is fpotted, we have the idea of feveral objects; or at leaft of an incoherent one, if

the

the object be single; which the eye surveys with difficulty. It is thus in painting. When we see, on a *comprehensive* view, *large masses* of light and shade, we have, of course, the idea of a *whole*—of *unity* in that picture. But where the light is scattered, we have the idea of several objects; or at least of one broken and confused. TITIAN's known illustration of this point by a bunch of grapes is beautiful, and explanatory. When the light falls upon the *whole bunch* together (one side being illumined, and the other dark) we have the representation of those large masses, which constitute a *whole*. But when the grapes are stripped from the bunch, and scattered upon a table (the light shining upon each separately) a *whole* is no longer preserved.

Having thus considered those essentials of a print, which produce a *whole*, it remains to consider those, which relate to the *parts* —*drawing*, *expression*, *grace*, and *perspective*. With regard to these, let it be first observed, that in order, they are inferior to the other. The production of a *whole* is the great effect, that should be aimed at in a picture. A

picture without a *whole* is properly only a study: and thofe things, which produce a *whole*, are of courfe the *principal* foundation of beauty. So thought a great mafter of compofition. With him no man was entitled to the name of artift, who could not produce a *whole*. However exquifitely he might finifh, he would ftill be defective.

> Infelix operis fummâ, quia ponere totum
> Nefciet.———————————

By *drawing* we mean the exactnefs of the out-line. Without a competent knowledge of this there can be no juft reprefentation of nature. Every thing will be diftorted and offenfive to the eye. *Bad* drawing therefore is that difgufting object which no practifed eye can bear.

Drawing, however, may be very tolerable, though it fall fhort, in a *certain degree*, of abfolute perfection. The defect will only be obferved by the moft critical, and anatomical eye: and we may venture to fay, that drawing is ranked too high, when the *niceties* of it are confidered

in preference to thofe effentials, which conſtitute a *whole*.

Expreſſion is the life and foul of painting. It implies a juſt reprefentation of *paſſion*, and of *character*: of *paſſion*, by exhibiting every emotion of the mind, as outwardly difcovered by any peculiarity of geſture; or the extenfion, and contraction of the features: of *character*, by reprefenting the different manners of men, as arifing from their particular tempers, or profeſſions. The cartoons are full of examples of the firſt kind of *expreſſion*; and with regard to the fecond, commonly called *manners-painting*, it would be invidious not to mention our countryman HOGARTH; whofe works contain a variety of characters, *reprefented* with more force, than moſt men can *conceive* them.

Grace confiſts in fuch a difpofition of the parts of a figure, as forms it into an agreeable attitude. It depends on *contraſt* and *eafe*. *Contraſt*, when applied to a fingle figure, means the fame, as when applied to a group; the
oppofition

opposition of one part to another. It may be considered with reference to the *body*, the *limbs*, and the *head*; the graceful attitude arising sometimes from a contrast in one, sometimes in another, and sometimes in all. With reference to the *body*, contrast consists in giving it an easy turn, opposing concave parts to convex. Of this St. PAUL in *the sacrifice at Lystra* is an instance.——With reference to the *limbs*, it consists in the opposition between extention and contraction. MICHAEL ANGELO's illustration by a triangle, or pyramid, may here likewise again be introduced; this form giving grace and beauty to a *single figure*, as well as to a *group*. Only here a greater liberty may be allowed. In *grouping*, the triangle should, I think, always rest upon its base; but in a single figure, it may be inverted, and stand upon its apex. Thus if the lower parts of the figure be extended, the upper parts should be contracted; but the same beautiful form is given by extending the arms, and drawing the feet to a point.—Lastly, contrast often arises from the air of the head; which is given by a turn of the neck from the line of the body. The cartoons abound with ex-

amples of this fpecies of *grace.* It is very remarkable in the figure of St· JOHN healing the cripple: and the fame cartoon affords eight, or nine more inftances. I fay the lefs on this fubject, as it hath been fo well exp´ ined by the ingenious author of the *Analyfis of Beauty.*

Thus *contraft* is the foundation of *grace*; but it muft ever be remembered, that *contraft* fhould be accompanied with *eafe.* The body fhould be *turned* not *twifted;* every *confrained* pofture avoided; and every motion fuch, as nature, which loves eafe, would dictate.

What hath been faid on this head relates equally to *all* figures; thofe drawn from *low,* as well as thofe from *high* life. And here we may diftinguifh between *picturefque* grace, and that grace which arifes from *dignity of character.* Of the *former* kind, which is the kind here treated of, *all* figures fhould partake: you find it in BERGHEM's clowns, and in CALLOT's beggars: but it belongs to *expreffion* to mark thofe characteriftics, which diftinguifh the *latter.*

I fhall

I shall only observe farther, that when the piece consists of many figures, the contrast of *each single* figure should be subordinate to the contrast of the *whole*. It will be improper therefore, in many cases, to practise the rules, which have been just laid down. They ought, however, to be a general direction to the painter; and at least to be observed in the *principal* figures.

Perspective is that proportion, with regard to *size*, which near and distant objects, with their parts, bear to each other. It is an attendant on *keeping:* one gives the out-line; and the other fills it up. Without a competent knowledge of *perspective* very absurd things would be introduced: and yet to make a vain shew of it, is pedantic.——Under this head may be mentioned *fore-shortening*. But unless this be done with the utmost art, it were better omitted: it will otherwise occasion great awkwardness. RUBENS is famous for *fore-shortening;* but the effect is chiefly seen in his *paintings;* seldom in his *prints*.

To this fummary of the rules, which relate to the *whole* of the picture, and to its *parts*, I fhall juft add a few obfervations on *execution*; which relates equally to both.

By *execution* is meant that manner of working, by which each artift produces his effect. Artifts may differ in their *execution* or *manner*, and yet all excel. CALLOT, for inftance, ufes a ftrong, firm ftroke; SALVATOR, a flight, and loofe one; while REMBRANDT executes in a manner different from both, by fcratches feemingly at random.

Every artift is in fome degree a *mannerift*: that is, he executes in a *manner* peculiar to himfelf. But the word *mannerift* has generally a clofer fenfe. Nature fhould be the ftandard of imitation: and every object fhould be executed, as nearly as poffible, in *her manner*. Thus WARTERLO's trees are all ftrongly impreffed with the character of nature. Other mafters again, deviating from this ftandard, execute in fome manner of their own. They have a particular touch for a figure, or a tree

tree; and this they apply on all occafions. Inftead therefore of reprefenting that endlefs variety which nature exhibits on every fubject, a famenefs runs through all their performances. Every figure, and every tree bears the fame ftamp. Such artifts are *properly* called *mannerifts*. TEMPEST, CALLOT, and TESTA are all *mannerifts* of this kind

By the *fpirit* and *freedom* of *execution*, we mean fomething, which is difficult to explain. A certain heavinefs always follows, when the artift is not fure of his ftroke, and cannot execute his idea with precifion. The reverfe is the cafe, when he is certain of it, and gives it boldly. I know not how to explain better what is meant by *fpirit*. Mere *freedom* a quick execution will give; but unlefs that *freedom* be attended with precifion, the ftroke, however free, will be fo unmeaning as to lofe its effect.

To thefe obfervations, it may not be improper to add a fhort comparative view of the *peculiar* excellences of pictures, and prints, which will fhew us, in what points the picture has the advantage

In *defign* and *compofition* the effect of each is equal. The print exhibits them with as much force and meaning, as the picture.

In *keeping* the picture has the advantage. The *hazinefs* of diftance cannot well be expreffed by any thing but the *hue of nature*, which the pencil is very able to give. The print *endeavours* to preferve this hazinefs; and to give the idea; but does it imperfectly. It does little more than aid the memory. We know the appearance exifts in nature; and the print furnifhes a hint to recollect it.

In the *diftribution of light* the comparifon runs very wide. Here the painter avails himfelf of a thoufand varied tints, which affift him in this bufinefs; and by which he can harmonize his gradations from light to fhade with an almoft infinite variety. Harmonious colouring has in itfelf the effect of a proper diftribution of light. The engraver, in the mean time, is left to work out his effect with two materials only, plain white and

and black.—In the print, however, you can more easily trace the *principles* of light and shade. The pencil is the implement of deception; and it requires the eye of a master to distinguish between the effect of light, and the effect of colour: but in the print, even the unpractised eye can readily catch the mass; and follow the distribution of it through all its variety of middle tints.—One thing more may be added: If the picture has no harmony in its colouring, the tints being all at discord among themselves, which is often the case in the works even of reputable painters, a good print, from such a picture, is more beautiful than the picture itself. It preserves what is valuable (upon a supposition there is any thing valuable in it), and removes what is offensive.

Thus the comparison runs with regard to those essentials, which relate to a *whole:* with regard to *drawing, expression, grace,* and *perspective,* we can pursue it only in the two former: in the latter, the picture and print have equal advantages.—With regard to *perspective* indeed, the lines of the print verging

more conspicuously to one point, mark the *principles* of it more strongly.

Drawing, in a *picture*, is effected by the contiguity of two different colours: in a *print* by a positive line. In the *picture*, therefore, *drawing*, has more of nature in it, and more of effect · but the student in anatomy finds more precision in the print; and can more easily trace the line, and follow it in all its windings through light and shade.—In mezzotinto the comparison fails · in which, drawing is effected nearly as it is in painting.

With regard to *expression*, the painter glories in his many advantages. The passions receive their force almost as much from *colour*, as from the emotion of feature. Nay lines, without colour, have frequently an effect very opposite to what is intended. Violent expressions, when lineal only, are often grotesque. The complexion should support the distortion. The bloated eyes of immoderate grief degenerate into coarse features, unless the pencil add those high-blown touches, which mark
the

the paffion. Afk the engraver, why he could not give the dying faint of Dominichino his true expreffion *? Why he gave him that ghaftly horror, inftead of the ferene languor of the original? The engraver may with juftice fay, he went as far as lines could go; but he wanted Dominichino's pencil to give thofe pallid touches, which alone could make his lines expreffive.—Age alfo, and fex, the bloom of youth, and the wan cheek of ficknefs, are equally indebted for their moft characteriftic marks, to the pencil.—In *portrait*, the different hues of hair, and complexion;—in *animal-life* the various dies of furs, and plumage;—in *landfcape*, the peculiar tints of feafons; of morning, and evening; the light azure of a fummer-fky; the fultry glow of noon; the bluifh, or purple tinge, which the mountain affumes, as it recedes, or approaches; the grey mofs upon the ruin; the variegated greens, and mellow browns of foliage, and broken ground: in fhort, the colours of every part of nature, have a wonderful force in ftrengthening the expreffion

* Jac Frey's copy of Dominichino's St. *Jerome*.

of objects.—In the room of all this, the deficient print has only to offer mere form, and the gradations of fimple light. Hence the fweet touches of the pencil of CLAUDE, mark his pictures with the ftrongeft expreffions of nature, and render them invaluable; while his prints are generally the dirty fhapes of fomething, which he could not exprefs.

The idea alfo of *diftant magnitude*, the print gives very imperfectly. It is expreffed chiefly by colour. Air, which is naturally blue, is the medium through which we fee; and every object participates of this bluenefs. When the diftance is fmall, the tinge is imperceptible: as it increafes, the tinge grows ftronger; and when the object is very remote, it intirely lofes its natural colour, and becomes blue. And indeed this is fo familiar a criterion of diftance, at leaft with thofe who live in mountainous countries, that if the object be vifible at all, after it has received the full *ether-tinge*, if I may fo fpeak, the fight immediately judges it to be very large. The eye ranging over the plains of Egypt, and catching the blue point of a pyramid, from the colour

concludes

concludes the diftance; and is ftruck with the magnitude of an object, which, through fuch a fpace, can exhibit form.—Here the print fails: this criterion of diftant magnitude, it is unable to give.

I cannot forbear inferting here a fhort criticifm on a paffage in VIRGIL. The poet defcribing a tower retiring from a veffel in full fail, fays,

<blockquote>Protinus aërias Phæacum abfcondimus arces.</blockquote>

RUÆUS, and other commentators, explain *aëreas* by *altas*, or fome equivalent word; which is magnifying an idea which in nature fhould be diminifhed. The idea of magnitude is certainly not the ftriking idea that arifes from a retiring object: I fhould rather imagine that VIRGIL, who was of all poets perhaps the moft picturefque, meant to give us an idea of colour, rather than of fhape; the tower, from its diftance, having now affumed the *aërial* tinge.

The print equally fails, when the medium itfelf receives a foreign tinge from a ftrength

of colour behind it. The idea of horror, impreffed by an expanfe of air glowing, in the night, with diftant fire, cannot be raifed by black and white. VANDERVELDE has often given us a good idea of the dreadful glare of a fleet in flames: but it were ridiculous for an engraver to attempt fuch a fubject; becaufe he cannot exprefs that idea, which principally illuftrates his ftory.

Tranfparency, again, the print is unable to exprefs. Tranfparency is the united tinge of two colours, one behind the other; each of which, in part, difcovers itfelf fingly. If you employ one colour only, you have the idea of opaquenefs. A fine carnation is a white tranfparent fkin, fpread over a mulitude of fmall blood veffels, which blufh through it. When the breath departs, thefe little fountains of life ceafe to flow: the bloom fades; and livid palenefs, the colour of death, fucceeds. —The happy pencil marks both thefe effects. It fpreads the glow of health over the cheek of beauty; and with equal facility it expreffes the cold, wan, tint of human clay. The print can exprefs neither; reprefenting, in
the

the fame dry manner, the bright tranfparency of the one, and the inert opaquenefs of the other.

Laftly, the print fails in the expreffion of *polifhed bodies;* which are indebted for their chief luftre to *reflected colours.* The print indeed goes farther here, than in the cafe of tranfparency. In this it can do very little; in *polifhed bodies,* it can at leaft give *reflected fhapes.* It can fhew the *forms* of hanging woods upon the edges of the lake; though unable to give the kindred tinge. But in many cafes the *polifhed* body receives the *tinge,* without the *fhape.* Here the engraver is wholly deficient: he knows not how to ftain the gleaming filver with the purple liquor it contains; nor is he able to give the hero's armour its higheft polifh from the tinge of the crimfon veft, which covers it.

A fingle word upon the fubject of *execution,* fhall conclude thefe remarks. Here the advantage lies wholly on the fide of painting. *That* manner which can beft give the idea of
the

the furface of an object, is the beft; and the lines of the fineft engraving are harfh in comparifon of the fmooth flow of the pencil. *Mezzotinto*, though deficient in fome refpects, is certainly in this the happieft mode of execution; and the ancient *wooden print*, in which the middle tint is ufed, has a foftnefs, when well executed, which neither etching, nor engraving can give.

CHAP. II.

Observations on the different Kinds of Prints.

THERE are three kinds of Prints, *engravings*, *etchings*, and *mezzotintos*. The characteriſtic of the firſt is *ſtrength*; of the ſecond, *freedom*; and of the third, *ſoftneſs*. All theſe, however, may in ſome degree be found in each.

From the ſhape of the engraver's tool, each ſtroke is an angular inciſion; which muſt of courſe give the line ſtrength, and firmneſs; if it be not very tender. From ſuch a line alſo, as it is a deliberate one, correctneſs may be expected; but no great freedom: for it is a laboured line, ploughed through the metal; and muſt neceſſarily, in a degree, want eaſe.

Unlimited *freedom*, on the other hand, is the characteriſtic of *etching*. The needle, gliding along

along the furface of the copper, meets no refiftance; and eafily takes any turn the hand pleafes to give it. Etching indeed is mere drawing: and may be practifed with the fame facility.—But as *aqua-fortis* bites in an *equable* manner, it cannot give the lines that ftrength, which they receive from a pointed graver cutting into the copper. Befides, it is difficult to prevent its biting the plate *all over* alike. The *diftant parts* indeed may eafily be covered with wax, or varnifh, and the *general effect* of the *keeping* preferved; but to give each *fmaller* part its proper relief, and to *harmonize* the *whole*, requires fo many different degrees of ftrength, fuch eafy tranfitions from one into another, that aqua-fortis alone is not equal to it. Here, therefore, engraving hath the advantage; which by a ftroke, deep or tender, at the artift's pleafure, can vary ftrength and faintnefs in any degree.

As engraving, therefore, and etching have their refpective advantages, and deficiencies, artifts have endeavoured to unite their powers; and to correct the faults of each, by joining the *freedom* of the one, with the *ftrength* of
the

the other. In moſt of our modern prints, the plate is firſt etched, and afterwards ſtrengthened, and finiſhed by the graver. And when this is *well* done, it has a happy effect. The flatneſs, which is the conſequence of an equable ſtrength of ſhade, is taken off; and the print gains a new effect, by the relief given to thoſe parts which *hang* (in the painter's language) on the parts behind them.—But great art is neceſſary in this buſineſs. We ſee many a print, which wanted only a *few* touches, receive afterwards ſo *many*, as to become laboured, heavy, and difguſting.

In *etching*, we have the greateſt variety of excellent prints. The caſe is, it is ſo much the ſame as *drawing*, that we have the very works themſelves of the moſt celebrated maſters: many of whom have left behind them prints in this way; which, however ſlight and incorrect, will always have ſomething *maſterly*, and of courſe *beautiful* in them.

In the muſcling of human figures, of any conſiderable ſize, *engraving* hath undoubtedly

the advantage of *etching*. The soft and delicate tranfitions, from light to fhade, which are there required, cannot be fo well expreffed by the needle: and, in general, *large prints* require a ftrength which *etching* cannot give; and are therefore fit fubjects for *engraving*.

Etching, on the other hand, is more particularly adapted to fketches, and flight defigns; which, if executed by an engraver, would entirely lofe their freedom; and with it their beauty. Landfcape too, in general, is the object of *etching*. The foliage of trees, ruins, fky, and indeed every part of landfcape, requires the utmoft freedom. In finifhing an *etched* landfcape with the *tool* (as it is called), too much care cannot be taken to prevent heavinefs. We remarked before the nicety of touching upon an etched plate; but in landfcape the bufinefs is peculiarly delicate. The foregrounds, and the boles of fuch trees as are placed upon them, may require a few ftrong touches; and here and there a few harmonizing ftrokes will add to the effect: but if the engraver venture much farther, he has good luck if he do no mifchief.

An

An *engraved* plate, unlefs it be cut very flightly, will caft off feven or eight hundred good impreffions; and yet this depends, in fome degree, on the hardnefs of the copper. An *etched* plate will not give above two hundred; unlefs it be eaten very deep, and then it may perhaps give three hundred. After that, the plate muft be retouched, or the impreffions will be faint.

Before I conclude the fubject of etching, I fhould mention an excellent mode of practifing it on a *foft ground*; which has been lately brought into ufe, and approaches ftill nearer to drawing, than the common mode. On a thin paper, fomewhat larger than the plate, you trace a correct outline of the drawing you intend to etch. You then fold the paper, thus traced, over the plate; and laying the original drawing before you, finifh the outline on the traced one with a black lead pencil. Every ftroke of the pencil, which you make on one fide, licks up the foft ground on the other. So that when you have finifhed your drawing with

black-

black-lead, and take the paper off the plate, you will find a complete, and very beautiful drawing on the reverſe of the paper; and the etching likewiſe as complete on the copper. You then proceed to bite it with aqua-fortis, in the common mode of etching: only as your ground is ſofter, the aqua-fortis muſt be weaker.

Beſides theſe ſeveral methods of engraving on *copper*, we have prints engraven on pewter, and on wood. The pewter plate gives a coarſeneſs and dirtineſs to the print, which is often diſagreeable. But engraving upon wood is capable of great beauty. Of this ſpecies of engraving more ſhall elſewhere be ſaid.

Mezzotinto is very different from either *engraving* or *etching*. In theſe you cut out the *ſhades* on a ſmooth plate. In *mezzotinto*, the plate is covered with a rough ground; and you ſcrape the lights. The plate would otherwiſe give an impreſſion entirely black.

Since the time of its invention by Prince RUPERT, as is commonly ſuppoſed, the art
of

of scraping *mezzotintos* is greatly more improved than either of its sister arts. Some of the earliest *etchings* are perhaps the best; and *engraving*, since the times of GOLTZIUS and MULLER, hath not perhaps made any great advances. But *mezzotinto*, compared with its original state, is, at this day, almost a new art. If we examine some of the modern pieces of workmanship in this way by our best mezzotinto-scrapers, they as much exceed the works of WHITE and SMITH, as those masters did BECKET and SIMONS. It must be owned, at the same time, they have better originals to copy. KNELLER's portraits are very paltry, compared with those of our modern artists; and are scarce susceptible of any effects of light and shade. As to Prince RUPERT's works, I never saw any, which were *certainly* known to be his: but those I have seen for his, were executed in the same black, harsh, disagreeable manner, which appears so strong in the masters who succeeded him. The invention however was noble; and the early masters have the credit of it: but the truth is, the ingenious mechanic hath been called in to the painter's aid; and hath invented a manner of

laying

laying ground, wholly unknown to the earlier masters: and they who are acquainted with *mezzotinto*, know the *ground* to be a very capital confideration.

The characteriſtic of *mezzotinto* is *ſoftneſs*; which adapts it chiefly to portrait, or hiſtory, with a few figures, and theſe not too ſmall. Nothing, except paint, can expreſs fleſh more naturally, or the flowing of hair, or the folds of drapery, or the catching lights of armour. In engraving and etching we muſt get over the prejudices of croſs lines, which exiſt on no natural bodies: but *mezzotinto* gives us the ſtrongeſt repreſentation of the real *ſurface*. If however, the figures are too crowded, it wants ſtrength to detach the ſeveral parts with a proper relief: and if they are very ſmall, it wants preciſion, which can only be given by an outline; or, as in painting, by a different tint. In miniature-works alſo, the unevenneſs of the ground will occaſion bad drawing, and awkwardneſs—in the extremities eſpecially. Some inferior artiſts have endeavoured to remedy this, by terminating their figures with an engraved, or etched line: but they have tried the experiment with bad ſucceſs. The ſtrength of the line, and the ſoftneſs of the ground,

accord

accord ill together. I speak not here of that judicious mixture of *etching* and *mezzotinto*, which was formerly used by WHITE; and which our best mezzotinto-scrapers at present use, to give a strength to particular parts; I speak only of a harsh, and injudicious lineal termination.

Mezzotinto excels each of the other species of prints, in its capacity of receiving the most beautiful effects of light and shade: as it can the most happily unite them, by blending them insensibly together.—Of this REMBRANDT seems to have been aware. He had probably seen some of the first mezzotintos; and admiring the effect, endeavoured to produce it in etching, by a variety of interfecting scratches.

You cannot well cast off more than an hundred good impressions from a mezzotinto plate. The rubbing of the hand soon wears it smooth: And yet by constantly repairing it, it may be made to give four or five hundred, with tolerable strength. The first impressions are not always the best. They are too black and harsh. You will commonly have the best impressions from the fortieth to the sixtieth: the harsh edges will be softened down; and yet there will be spirit and strength enough left.

I ſhould not conclude theſe obſervations without mentioning the manner of working with the *dry needle*, as it is called; a manner between etching and engraving. It is performed by cutting the copper with a ſteel point, held like a pencil; and differs from etching only in the force with which you work. This method is uſed by all engravers in their ſkies, and other tender parts; and ſome of them carry it into ſtill more general uſe.

Since the laſt edition of this work was publiſhed, a new mode of etching hath come much into uſe, called aquatinta. It is ſo far ſimilar to the common mode of etching, that the ſhadows are bitten into copper by aquafortis, from which the lights are defended by a prepared, *granulated* ground. Through the minute interſtices of this ground the aquafortis is admitted, and forms a kind of waſh. In the compoſition of this *granulation*, the great ſecret of the art, I underſtand, conſiſts; and different artiſts have their different modes of preparing their ground. Some alſo ſtrengthen the aquatinta waſh by the uſe of the

the needle, as in common etching; which, in landfcape efpecially, has a good effect. The fecret of the art however, does not entirely confift in preparing, and laying on the ground. Much experience is neceffary in the management of it.

The great advantage of this mode of etching is, that it comes nearer the idea of drawing, than any other fpecies of working on copper: the fhades are thrown in by a wafh, as if with a brufh. It is alfo, when perfectly underftood, well calculated for difpatch. In general indeed, it feems better adapted to a rough fketch, than a finifhed work; yet in fkilful hands, when affifted by the needle, or the engraver's tool, it may be carried to a gıeat height of elegant finifhing.

On the other hand, the great difadvantage of this mode of etching arifes from the difficulty of making the fhades graduate foftly into the lights. When the artift has made too harfh an edge, and wifhes to burnifh it off, there is often a middle tint below it: in burnifhing off the one, he difturbs the other; and inftead of leaving a foft graduating edge, he introduces, in its room, an edging of light.

The

The aquatinta mode of etching was firſt introduced into England, though but little known, about thirty, or forty years ago, by a Frenchman of the name of La Prince: but whether he was the inventor of it, I never heard. It has ſince been improved by ſeveral artiſts. Mr. Sandby has uſed it very happily in ſeveral of his prints. Mr. Jukes alſo, and Mr. Malton have done ſome good things in this way: but, as far as I can judge, Mr. Alken has carried it to the higheſt degree of perfection; and has ſome ſecret in preparing, and managing his ground, which gives his prints a ſuperior effect.

CHAP.

CHAP. III.

Characters of the most noted Masters.

MASTERS IN HISTORY.

ALBERT DURER, though not the inventor, was one of the first improvers of the art of engraving. He was a German painter, and at the same time a man of letters, and a philosopher. It may be added in his praise, that he was the intimate friend of Erasmus; who revised, it is supposed, some of the pieces which he published. He was a man of business also; and was, during many years, the leading magistrate of Nuremburg.—His prints, considered as the first efforts of a new art, have great merit. Nay, we may add, that it is astonishing to see a new art, in its earliest essays, carried to such a length. In some of those prints, which he executed on copper, the engraving is elegant to a great degree. His *Hell-scene* particularly, which was engraved in the year 1513, is as highly finished

finifhed a print as ever was engraved, and as happily finifhed. The labour he has beftowed upon it, has its full effect. In his wooden prints too we are furprifed to fee fo much meaning, in fo early a mafter; the heads fo well marked; and every part fo well executed. —This artift feems to have underftood the principles of defign. His compofition too is often pleafing; and his drawing generally good: but he knows very little of the management of light; and ftill lefs of grace: and yet his ideas are purer, and more elegant, than we could have fuppofed from the awkward archetypes, which his country and education afforded. He was certainly a man of a very extenfive genius; and, as *Vafari* remarks, would have been an extraordinary artift, if he had had an Italian, inftead of a German education. His prints are numerous. They were much admired in his own life-time, and eagerly bought up: which put his wife, who was a teafing woman, on urging him to fpend more time upon engraving, than he was inclined to do. He was rich, and chofe rather to practife his art as an amufement, than as a bufinefs. He died in the year 1527.

The

The immediate fucceffors, and imitators of ALBERT DURER were LUCAS VAN LEIDEN, ALDGRAVE, PENS, HISBEN, and fome others of lefs note. Their works are very much in their mafter's ftyle; and were the admiration of an age which had feen nothing better. The beft of ALDGRAVE's works are two or three fmall pieces of the ftory of Lot.

GOLTZIUS flourifhed a little after the death of thefe mafters; and carried engraving to a great height. He was a native of Germany, where he learned his art: but travelling afterwards into Italy, he improved his ideas. We plainly difcover in him a mixture of the Flemifh and Italian fchools. His forms have fometimes a degree of elegance in them; but, in general, the Dutch mafter prevails. GOLTZIUS is often happy in *defign* and *difpofition;* and fails moft in the *diftribution of light.* But his chief excellence lies in *execution.* He engraves in a noble, firm, expreffive manner; which hath fcarce been excelled by any fuc-

ceeding .mafters. There is a variety too in his mode of execution, which is very pleafing. His print of the *circumcifion* is one of the beft of his works. The ftory is well told; the groups agreeably difpofed; and the execution admirable: but the figures are Dutch; and the whole, through the want of a proper diftribution of fhade, is only a glaring mafs.

MULLER engraved very much in the ftyle of GOLTZIUS—I think in a ftill bolder and firmer manner. We have no where greater mafter-pieces in execution, than the works of this artift exhibit. The *baptifm of* JOHN is perhaps the moft beautiful fpecimen of bold engraving, that is extant.

ABRAHAM BLOEMART was a Dutch mafter alfo, and contemporary with GOLTZIUS. We are not informed what particular means of improvement he had; but it is certain he defigned in a more elegant tafte, than any of his countrymen. His figures are often graceful; excepting only, that he gives them fometimes an affected twift; which
is

is still more conspicuous in the fingers; an affectation which we sometimes also find in the prints of GOLTZIUS.—The *resurrection of* LAZARUS is one of BLOEMART's masterpieces; in which are many faults, and many beauties; both very characteristic.

While the Dutch masters were thus carrying the art of engraving to so great a height, it was introduced into Italy by ANDREA MANTEGNA; to whom the Italians ascribe the invention of it. The paintings of this master abound in noble passages, but are formal and disagreeable We have a specimen of them at Hampton Court, in the triumph of JULIUS CÆSAR.—His prints, which are said to have been engraved on tin plates, are transcripts from the same ideas. We see in them the chaste, correct out-line, and noble simplicity of the Roman school; but we are to expect nothing more; not the least attempt towards an agreeable *whole*.——And indeed, we shall perhaps find, in general, that the masters of the Roman school were more studious of those essentials of painting, which regard the *parts*; and the Flemish masters,

masters, of those, which regard the *whole*. The former therefore drew better *figures*; the latter made better *pictures*.

MANTEGNA was succeeded by PARMIGIANO and PALMA, both masters of great reputation. PARMIGIANO having formed the most accurate taste on a thorough study of the works of RAPHAEL, and MICHAEL ANGELO, published many single figures, and some designs engraven on wood, which abounded with every kind of beauty; if we may form a judgment of them from the few which we sometimes meet with. Whether PARMIGIANO invented the art of engraving on wood, does not certainly appear. His pretensions to the invention of etching are less disputable. In this way he published many flight pieces, which do him great credit. In the midst of his labours, he was interrupted by a knavish engraver, who pillaged him of all his plates. Unable to bear the loss, he forswore his art, and abandoned himself to chemistry.

PALMA

PALMA was too much employed as a painter to have much leifure for etching. He hath left feveral prints, however, behind him; which are remarkable for the delicacy of the drawing, and the freedom of the execution. He etches in a loofe, but mafterly manner. His prints are fcarce; and indeed we feldom meet with any that deferve more than the name of fketches.

FRANCIS PARIA feems to have copied the manner of PALMA with great fuccefs. But his prints are ftill fcarcer than his mafter's; nor have we a fufficient number of them, to enable us to form much judgment of his merit.

But the great improver of the art of engraving on wood, and who at once carried it to a degree of perfection, which hath not fince been exceeded, was ANDREA ANDREANI, of Mantua. The works of this mafter are remarkable for the freedom, ftrength, and fpirit

of the execution; the elegant correctnefs of the drawing; and in general for their effect. Few prints come fo near the idea of painting. They have a force, which a pointed tool on copper cannot reach: and the wafh, of which the middle tint is compofed, adds often the foftnefs of drawing. But the works of this mafter are feldom feen in perfection. They are fcarce; and when we do meet with them, it is a chance if the impreffions be good: and very much of the beauty of thefe prints depends on the goodnefs of the impreffion. For often the outline is left hard, the middle tint being loft; and fometimes the middle tint is left without its proper termination. So that on the whole, I fhould not judge this to be the happieft mode of engraving.

Among the ancient Italian mafters, we cannot omit MARK ANTONIO; and AUGUSTIN of Venice. They are both celebrated; and have handed down to us many engravings from the works of RAPHAEL: but their *antiquity*, not their *merit*, feems to have recommended them. Their execution is harfh, and formal to the laft degree: and if their prints give

give us any idea of the works of RAPHAEL, we may well wonder, as PICART obferves, how that mafter got his reputation.—But we cannot, perhaps, in England, form an adequate idea of thefe mafters. I have been told, their beft works are fo much valued in Italy, that they are engroffed there by the curious: that very few of them find their way into other countries; and that what we have, are, in general, but the refufe.

FREDERIC BAROCCHI was born at Urbin; where the genius of RAPHAEL infpired him. In his early youth he travelled to Rome: and giving himfelf up to intenfe ftudy, he acquired a great name in painting. At his leifure hours he etched a few prints from his own defigns; which are highly finifhed, and executed with great foftnefs and delicacy. The *Salutation* is his capital performance: of which we feldom meet with any impreffions, but thofe taken from the retouched plate, which are very harfh.

ANTHONY TEMPESTA was a native of Florence, but refided chiefly at Rome; where he was employed in painting by GREGORY XIII. ——His prints are very numerous: all from his own defigns. Battles and huntings are the fubjects in which he moft delighted. His merit lies in expreffion, both in feature and in action; in the grandeur of his ideas; and in the fertility of his invention. His figures are often elegant, and graceful; and his heads marked with great fpirit, and correctnefs. His horfes, though flefhy and ill drawn, and evidently never copied from nature, are, however, noble animals, and difplay an endlefs variety of beautiful actions.—His imperfections at the fame time, are glaring. His compofition is generally bad. Here and there you have a good group; feldom an agreeable whole. He had not the art of preferving his back-grounds tender; fo that we are not to expect any effect of keeping. His execution is harfh; and he is totally ignorant of the diftribution of light.— But notwithftanding all his faults, fuch is his merit, that, as ftudies at leaft, his prints deferve a much higher rank in the cabinets of

con-

connoiffeurs, than they generally find; you can fcarce pick out one of them, which does not furnifh materials for an excellent compofition.

AUGUSTIN CARACCI has left a few etchings; which are admired for the delicacy of the drawing, and the freedom of the execution. But there is great flatnefs in them, and want of ftrength. Etchings, indeed, in this ftyle are rather meant as fketches, than as finifhed prints.—I have heard his print of St. Jerome much commended; but I find no remarks upon it in my own notes.

GUIDO's etchings, moft of which are fmall, are efteemed for the fimplicity of the defign; the elegance and correctnefs of the outline; and that grace, for which this mafter is generally—perhaps too generally efteemed. The extremities of his figures are particularly touched with great accuracy. But we have the fame flatnefs in the works of GUIDO, which we find in thofe of his mafter CARACCI; accompanied, at the fame time, with lefs freedom.

dom. The *parts* are finished; but the *whole* neglected.

CANTARINI copied the manner of GUIDO, as PARIA did that of PALMA; and so happily, that it is often difficult to distinguish the works of these two masters.

CALLOT was little acquainted with any of the grand principles of painting: of composition, and the management of light he was totally ignorant. But though he could not make a picture, he was admirably skilled in drawing a figure. His attitudes are generally graceful, when they are not affected; his expression strong; his drawing correct; and his execution masterly, though rather laboured. His *Fair* is a good epitome of his works. Considered as a *whole*, it is a confused jumble of ideas; but the *parts*, separately examined, appear the work of a master. The same character may be given of his most famous work, the *Miseries of War:* in which there is more expression, both in action and feature, than was ever perhaps shewn in so small a compass. And yet I know not whether

whether his *Beggars* be not the more capital performance. In the *Miseries of War*, he aims at compofition, in which he rarely fucceeds: his *Beggars* are detached figures, in which lay his ftrength. Though the works of this mafter are generally fmall, I have feen one of a large fize. It confifts of two prints; each of them near four feet fquare, reprefenting the fiege of Toulon. They are rather indeed perfpective plans, than pictures. The pains employed on them, is aftonifhing. They contain multitudes of figures; and, in miniature, reprefent all the humour, and all the employment of a camp.——I fhall only add, that a vein of drollery runs through all the defigns of this mafter: which fometimes, when he chufes to indulge it freely, as in the *Temptation of St.* ANTHONY, difplays itfelf in a very facetious manner.

Count GAUDE contracted a friendfhip at Rome with ADAM ELSHAMAR; from whofe defigns he engraved a few prints. GAUDE was a young nobleman on his travels; and never practifed engraving as a profeffion. This would call for indulgence, if his prints wanted it: but in their way, they are beautiful; though

on the whole, formal, and unpleafant. They are highly finifhed; and this correctnefs has deprived them of freedom. Moon-lights, and torch-lights are the fubjects he generally chufes; and he often preferves the effects of thefe different lights. His prints are generally fmall. I know only one, the *Flight into Egypt*, of a larger fize.

SALVATOR ROSA *painted* landfcape more than hiftory; but his *prints* are chiefly hiftorical. He was bred a painter; and underftood his art; if we except the *management of light*, of which he feems to have been ignorant. The capital landfcape of this mafter at Chifwick, is a noble picture. The contrivance, the compofition, the diftances, the figures, and all the parts and appendages of it are fine: but in point of light it might perhaps have been improved, if the middle ground, where the figures of the fecond diftance ftand, had been thrown into fun-fhine. —In *defign*, and generally in *compofition*, SALVATOR is often happy. His figures, which he drew in good tafte, are graceful, and expreffive, well grouped, and varied in agreeable attitudes. In the legs, it muft be owned, he

is

is a *mannerist:* they are well drawn; but all cast in one mould. There is a stiffness too in the backs of his extended hands: the palms are beautiful. But these are trivial criticisms. —His *manner* is slight; so as not to admit either softness or effect: yet the simplicity and elegance of it are pleasing; and bear that strong characteristic of a master's hand, *sibi quivis speret idem.*——One thing in his manner of shading, is disagreeable. He will often shade a *face* half over with long lines; which, in so small and delicate an object, gives an unpleasant abruptness. It is treating a face like an egg: no distinction of feature is observed.——
SALVATOR was a man of genius, and of learning: both which he has found frequent opportunities of displaying in his works. His style is grand; every object that he introduces is of the heroic kind; and his subjects in general shew an intimacy with ancient history, and mythology.——A roving disposition, to which he is said to have given a full scope, seems to have added a wildness to all his thoughts. We are told, he spent the early part of his life in a troop of banditti: and that the rocky and desolate scenes, in which he was accustomed to take refuge, furnished him with those romantic

ideas

ideas in landfcape, of which he is fo exceedingly fond; and in the defcription of which he fo much excels. His *Robbers*, as his detached figures are commonly called, are fuppofed to have been taken from the life.

REMBRANDT's excellency, as a painter, lay in colouring; which he poffeffed in fuch perfection, that it almoft fcreens every fault in his pictures. His prints, deprived of this palliative, have only his inferior qualifications to recommend them. Thefe are expreffion, and fkill in the management of light, execution, and fometimes compofition. I mention them in the order in which he feems to have poffeffed them. His expreffion has the moft force in the character of age. He marks as ftrongly as the hand of time. He poffeffes too, in a great degree, that inferior kind of expreffion, which gives its proper, and characteriftic touch to drapery, fur, metal, and every object he reprefents.—His management of light confifts chiefly in making a very ftrong contraft; which has often a good effect: and yet in many of his prints, there is no effect at all; which gives us reafon to think, he either

ther had no principles, or publifhed fuch prints before his principles were afcertained.—His execution is peculiar to himfelf. It is rough, or neat, as he meant a fketch, or a finifhed piece; but always free and mafterly. It produces its effect by ftrokes interfected in every direction; and comes nearer the idea of painting than the execution of any other mafter in etching—Never painter was more at a lofs than REMBRANDT, for that fpecies of grace, which is neceffary to fupport an elevated character. While he keeps within the fphere of his genius, and contents himfelf with low fubjects, he deferves any praife. But when he attempts beauty, or dignity, it were goodnatured to fuppofe, he means only burlefque and caricature. He is a ftrong contraft to SALVATOR. The one drew all his ideas from nature, as fhe appears with grace and elegance: The other caught her in her meaneft images; and transferred thofe images into the higheft characters. Hence SALVATOR exalts banditti into heroes: REMBRANDT degrades patriarchs into beggars. REMBRANDT, indeed, feems to have affected awkwardnefs. He was a man of humour; and would laugh at thofe artifts who ftudied the antique. " I'll

fhew

shew you my antiques," he would cry; and then he would carry his friends into a room furnished with head-dresses, draperies, household-stuff, and instruments of all kinds: " These," he would add, " are worth all your antiques."—His best etching is that, which goes by the name of the *hundred-guilders-print*; which is in such esteem, that I have known thirty guineas given for a good impression of it. In this all his excellencies are united: and I might add, his imperfections also. Age and wretchedness are admirably described; but the principal figure is ridiculously mean.—REMBRANDT is said to have left behind him near three hundred prints; none of which are dated before 1628; none after 1659. They were in such esteem, even in his own life time, that he is said to have retouched some of them four or five times.

PETER TESTA studied upon a plan very different from that, either of SALVATOR, or REMBRANDT. Those masters drew their ideas from nature: TESTA, from what he esteemed a superior model—the antique. Smitten with the love of painting, this artist travelled

velled to Rome in the habit of a pilgrim; deftitute of every mean of improvement, but what mere genius furnifhed. He had not even intereft to procure a recommendation; nor had he any addrefs to fubftitute in its room. The works of fculpture fell moft obvioufly in his way; and to thefe he applied himfelf with fo much induftry, copying them over, and over, that he is faid to have gotten them all by heart. Thus qualified, he took up the pencil. But he foon found the fchool, in which he had ftudied, an infufficient one to form a painter. He had neglected colouring; and his pictures were in no efteem. I have heard it faid, that fome of his pictures were excellent: and that if the houfe of Medici had continued to direct the tafte of Italy, his works would have taken the lead among the firft productions of the age. But it was TESTA's misfortune to live when the arts were under a lefs difcerning patronage. and P. DA CORTONA, who was TESTA's rival, though far inferior to him in genius, carried the palm. Difappointed and mortified, he threw afide his pallet, and applied himfelf to etching; in which he became a thorough proficient.— His prints have great merit; though they are little efteemed. We are feldom, indeed to ex-
pect

pect a coherency of defign in any of them. An enthufiaftic vein runs through moft of his compofitions; and it is not an improbable conjecture, that his head was a little difturbed. He generally crouds into his pieces fuch a jumble of inconfiftent ideas; that it is difficult fometimes only to guefs at what he aims. He was as little acquainted with the diftribution of light, as with the rules of defign: and yet, notwithftanding all this, his works contain an infinite fund of entertainment. There is an exuberance of fancy in him, which, with all its wildnefs, is agreeable: his ideas are fublime and noble; his drawing is elegantly correct; his heads exhibit a wonderful variety of characters; and are touched with uncommon fpirit, and expreffion; his figures are graceful, rather too nearly allied to the antique; his groups often beautiful; and his execution, in his beft etchings, (for he is fometimes unequal to himfelf,) very mafterly.* Perhaps, no prints afford more ufeful ftudies for a painter.——The *Proceffion of* SILENUS, if we may guefs at fo confufed a defign, may illuftrate all that hath been faid. The *whole* is as inco-

* Some of his works are etched by Cæs. Testa.

herent,

herent, as the *parts* are beautiful.——This unfortunate artift was drowned in the Tyber; and it is left uncertain, whether by accident or defign.

SPANIOLET etched a few prints in a very fpirited manner. No mafter underftood better the force of every touch. SILENUS *and* BACCHUS, and the *Martyrdom of St.* BARTHOLOMEW, are the beft of his hiftorical prints: and yet thefe are inferior to fome of his caricatures, which are admirably executed.

MICHAEL DORIGNY, or OLD DORIGNY, as he is often called, to diftinguifh him from NICHOLAS, had the misfortune to be the fon-in-law of SIMON VOUET; whofe works he engraved, and whofe imperfections he copied. His execution is free, and he preferves the lights extremely well on fingle figures: his drapery too is natural, and eafy: but his drawing is below criticifm; in the extremities efpecially. In this his mafter mifled him. VOUET excelled in compofition; of which we have many beautiful inftances in DORIGNY's prints.

VILLAMENA was inferior to few engravers. If he be deficient in ſtrength and effect, there is a delicacy in his manner, which is inimitable. One of his beſt prints is, the *Deſcent from the Croſs.*——But his works are ſo rare, that we can ſcarce form an adequate idea of his merit.

STEPHEN DE LA BELLA was a minute genius. His manner wants ſtrength for any larger work; but in ſmall objects it appears to advantage: there is great freedom in it, and uncommon neatneſs. His figures are touched with ſpirit; and ſometimes his compoſition is good: but he ſeldom diſcovers any ſkill in the management of light; though the defect is leſs ſtriking, becauſe of the ſmallneſs of his pieces. His *Pont Neuf* will give us an idea of his works. Through the bad management of the light, it makes no appearance as a *whole*; though the compoſition, if we except the modern architecture, is tolerable. But the figures are marked with great beauty; and the diſtances extremely fine. —Some of his ſingle heads are very elegant.

LA

LA FAGE's works confift chiefly of fketches. The great excellency of this mafter lay in drawing; in which he was perfectly fkilled. However unfinifhed his pieces are, they difcover him to have been well acquainted with anatomy and proportion. There is very little in him befides, that is valuable; grace, and expreffion fometimes; feldom compofition: his figures are generally too much crouded, or too diffufe. As for light and fhade, he feems to have been totally ignorant of their effect; or he could never have fhewn fo bad a tafte, as to publifh his defigns without, at leaft, a bare expreffion of the maffes of each. Indeed, we have pofitive proof, as well as negative. Where he has attempted an effect of light, he has only fhewn how little he knew of it.——— His genius chiefly difplays itfelf in the gambols of nymphs and fatyrs; in routs and revels: but there is fo much obfcenity in his works of this kind, that, although otherwife fine, they fcarce afford an innocent amufement.——In fome of his prints, in which he has attempted the fublimeft characters, he has given them a wonderful dignity. Some of his figures of Chrift

are not inferior to the ideas of RAPHAEL: and in a flight sketch, intitled, *Vocation de Moyse*, the Deity is introduced with surprising majesty. —His best works are slightly etched from his drawings by ERTINGER; who has done justice to them.

BOLSWERT engraved the works of RUBENS, and in a style worthy of his master. You see the same free, and animated manner in both. It is said that RUBENS touched his proofs: and it is probable; the ideas of the painter are so exactly transfused into the works of the engraver.

PONTIUS too engraved the works of RUBENS; and would have appeared a greater master, if he had not had such a rival as BOLSWERT.

SCIAMINOSSI etched a few small plates, of the *Mysteries of the Rosary*, in a masterly style. There is no great beauty in the composition; but the drawing is good; the figures are generally

rally graceful; and the heads touched with spirit.

Roman le Hooghe is inimitable in execution. Perhaps, no mafter etches in a freer and more fpirited manner: there is a richnefs in it likewife, which we feldom meet with. His figures too are often good; but his compofition is generally faulty: it is crouded, and confufed. He knows little of the effect of light. There is a flutter in him too, which hurts an eye pleafed with fimplicity. His prints are generally hiftorical. The *deluge at Coeverden* is finely defcribed.—Le Hooghe was much employed, by the authors of his time, in compofing frontifpieces; fome of which are very beautiful.

Luiken etches in the manner of Le Hooghe, but it is a lefs mafterly manner. His *Hiftory of the Bible* is a great work; in which there are many good figures, and great freedom of execution: but poor compofition, much confufion, and little fkill in the diftribution of light. This mafter hath alfo etched a

book

book of various kinds of capital punifhment; amongft which, though the fubject is difgufting, there are many good prints.

GERRARD LAIRESSE etches in a loofe, and unfinifhed; but free, and mafterly manner. His light is often well diftributed; but his fhades have not fufficient ftrength to give his pieces effect. Though he was a Dutch painter, you fee nothing of the Dutchman in his works. His compofition is generally elegant and beautiful; efpecially where he has only a few figures to manage. His figures themfelves are graceful, and his expreffion ftrong.—It may be added, that his draperies are particularly excellent. The fimple and fublime ideas, which appear every where in his works, acquired him the title of the *Dutch* RAPHAEL; a title which he well deferves LAIRESSE may be called an ethic painter. He commonly inculcates fome truth either in morals, or religion; which he illuftrates by a Latin fentence at the bottom of his print.

CASTIGLIONE was an Italian painter of eminence. He drew human figures with grace and correctnefs: yet he generally chofe fuch fubjects as would admit the introduction of animal life, which often makes the more diftinguifhed part.——There is a fimplicity in the defigns of this mafter, which is beautiful. In compofition he excels. Of his elegant groups we have many inftances, in a fet of prints, etched from his paintings, in a flight, free manner, by C. MACEE; particularly in thofe of the *patriarchal journeyings*. He hath left us feveral of his *own* etchings, which are very valuable. The fubjects, indeed, of fome of them, are odd and fantaftic; and the compofition not equal to fome prints we have from his paintings, by other hands; but the execution is greatly fuperior. Freedom, ftrength, and fpirit, are eminent in them; and delicacy likewife, where he chufes to finifh highly; of which we have fome inftances.—One of his beft prints is, the *entering of* NOAH *into the ark*. The compofition; the diftribution of light; the fpirit and expreffion, with which

the animals are touched; and the freedom of the execution, are all admirable.

TIEPOLO was a diftinguifhed mafter: but by his merit; rather than the number of his etchings. He was chiefly employed, I have heard, as a painter, in the Efcurial, and other palaces in Spain. The work, on which his reputation as an etcher is founded, is a feries of twenty plates, about nine inches long, and feven broad. The fubject of them is emblematical; but of difficult interpretation. They contain, however, a great variety of rich, and elegant compofition; of excellent figures; and of fine old heads and characters. They are fcarce; at leaft, they have rarely fallen in my way.——— I have feen a few other prints by this mafter: but none, except thefe, which I have thought excellent. He was a ftrange, whimfical man; and, perhaps, his beft pieces were thofe, in which he gave a loofe to the wildnefs of his imagination.

VANDER MUILEN has given us hiftorical reprefentations of feveral modern battles.
Lewis

Lewis XIV. is his great hero. His prints are generally large, and contain many good figures, and agreeable groups: but they have no effect, and seldom produce a *whole*. A disagreeable monotony (as the musical people speak) runs through them all.

OTHO VENIUS has entirely the air of an Italian, though of Dutch parentage. He had the honour of being master to RUBENS; who chiefly learned from him his knowledge of light and shade. This artist published a book of love-emblems; in which the Cupids are engraved with great elegance. His pieces of fabulous history have less merit.

GALESTRUZZI was an excellent artist. There is great firmness in his stroke; great precision; and, at the same time, great freedom. His drawing is good; his heads are well touched, and his draperies beautiful. He has etched several things from the antique; some of them, indeed, but indifferently. The best of his works, which I have seen, is the

Story

Story of NIOBE, (a long, narrow print) from POLIDORE.

MELLAN was a whimfical engraver. He fhadowed entirely with parallel lines; which he winds round the mufcles of his figures, and the folds of his draperies, with great variety and beauty. His manner is foft and delicate; but void of ftrength and effect. His compofitions of courfe make no *whole*, though his fingle figures are often elegant. His faints and ftatues are, in general, his beft pieces. There is great expreffion in many of the former; and his drapery is often incomparable. One of his beft prints is infcribed, *Per fe furgens:* and another very good one, with this ftrange paffage from St. AUSTIN; *Ego evangelio non crederem, nifi me catholicæ ecclefiæ commoveret auctoritas.*—His head of Chrift, effected by a fingle fpiral line, is a mafterly, but whimfical performance.

OSTADE's etchings, like his pictures, are admirable reprefentations of low life. They abound in humour and expreffion; in which

lies

lies their merit. They have little befides to recommend them. His compofition is generally very indifferent; and his execution no way remarkable. Sometimes, but feldom, you fee an effect of light.

CORNELIUS BEGA etches very much in the manner of OSTADE; but with more freedom.

VAN TULDEN has nothing of the Dutch mafter in his defign; which feems formed on the ftudy of the antique. It is chafte, elegant, and correct. His manner is rather firm, and diftinct; than free, and fpirited. His principal work is, *the voyage of* ULYSSES, *in fifty-eight plates;* in which we have a great variety of elegant attitudes, excellent characters of heads, good drawing; and though not much effect, yet often good grouping. His drapery is heavy.

JOSEPH PARROCELLE painted battles for LEWIS XIV. He etched alfo feveral of his own defigns. The beft of his works are eight
fmall

small battles, which are very scarce. Four of these are of a size larger than the rest; of which, the *Battle*, and *Stripping the Slain*, are very fine. Of the four smaller, that entitled *Vesper* is the best.—His manner is rough, free, and masterly; and his knowledge of the effect of light considerable.—His greatest undertaking was, the *Life of Christ*, in a series of plates: but it is a hasty, and incorrect work. Most of the prints are mere sketches: and many of them, even in that light, are bad; though the freedom of the manner is pleasing in the worst of them. The best plates are the 14th, 17th, 19th, 22d, 28th, 39th, 41st, 42d, and 43d.

V. LE FEBRE etched many designs from TITIAN and JULIO ROMANO, in a very miserable manner. His drawing is bad; his drapery frittered; his lights ill-preserved; and his execution disgusting: and yet we find his works in capital collections.

BELLANGE's prints are highly finished, and his execution is not amiss. His figures also have something in them, which looks like grace;

grace; and his light is tolerably well maffed. But his heads are ill fet on; his extremities incorrectly touched; his figures badly proportioned; and, in fhort, his drawing in general very bad.

Claude Gillot was a French painter: but finding himfelf rivalled, he laid afide his pencil, and employed himfelf entirely in etching. His common fubjects are *dances* and *revels;* adorned with fatyrs, nymphs, and fauns. By giving his fylvans a peculiar caft of eye, he has introduced a new kind of character. The invention, and fancy of this mafter are pleafing; and his compofition is often good. His manner is flight; which is the beft apology for his bad drawing.

Watteau has great defects; and, it muft be owned, great merit. He abounds in all that flutter, and affectation, which is fo difagreeable in the generality of French painters. But, at the fame time, we acknowledge, he draws well; gives grace and delicacy to his figures; and produces often a beautiful effect

of light. I speak, chiefly of such of his works, as have been engraved by others.—He etched a few slight plates himself, with great freedom and elegance. The best of them are contained in a small book of figures, in various dresses and attitudes.

Cornelius Schut excels chiefly in execution; sometimes in composition: but he knows nothing of grace; and has, upon the whole, but little merit.

William Baur etches with great spirit. His largest works are historical. He has given us many of the sieges and battles, which wasted Flanders in the sixteenth century. They *may* be exact, and probably they *are;* but they are rather plans than pictures; and have little to recommend them but historic truth, and the freedom of the execution. Baur's best prints are, characters of different nations· in which the peculiarities of each are well observed. His Ovid is a poor performance.

Coypel

COYPEL hath left a few prints of his own etching.; the principal of which is, an *Ecce Homo*, touched with great fpirit. Several of his own defigns he etched, and afterwards put into the hands of engravers to finifh. It is probable he overlooked the work: but we fhould certainly have had better prints, if we had received them pure from his own needle. What they had loft in force, would have been amply made up in fpirit.

PICART was one of the moft ingenious of the French engravers. His *imitations* are among the moft entertaining of his works. The tafte of *his day*, ran wholly in favour of antiquity: " No modern mafters were worth looking at." PICART, piqued at fuch prejudice, etched feveral pieces in imitation of ancient mafters; and fo happily, that he almoft out-did, in their own excellences, the artifts whom he copied. Thefe prints were much admired, as the works of GUIDO, REMBRANDT, and others. Having had his joke, he publifhed them under the title of *Impoftures inno-centes.*

centes.—PICART's own manner is highly finished; yet, at the same time, rich, bold, and spirited: his prints are generally small; and most of them from the designs of others. One of the best is from that beautiful composition of POUSSIN, in which *Truth is delivered by Time, from Envy.*

ARTHUR POND, our countryman, succeeded admirably in this method of imitation; in which he hath etched several valuable prints; particularly two oval landscapes after SALVATOR—a monkey in red chalk after CARRACHE—two or three ruins after PANINI, and some others equally excellent.

But this method of imitation hath been most successfully practised by *Count* CAYLUS, an ingenious French nobleman; whose works, in this way, are very voluminous. He hath ransacked the French king's cabinet; and hath scarce left a master of any note, from whose drawings he hath not given us an excellent specimen. Insomuch, that if we had nothing remaining of those masters, but *Count* CAYLUS's works,

works, we should not want a very sufficient idea of them. So versatile is his genius, that with the same ease he presents us with an elegant outline from RAPHAEL, a rough sketch from REMBRANDT, and a delicate portrait from VANDYKE.

LE CLERC was an excellent engraver; but chiefly in miniature. He immortalized ALEXANDER, and LEWIS XIV. in plates of four or five inches long. His genius seldom exceeds these dimensions; within which he can draw up twenty thousand men with great dexterity. No artist, except CALLOT and DELLA BELLA, could touch a small figure with so much spirit. He seems to have imitated CALLOT's manner; but his stroke is neither so firm, nor so masterly.

PETER BARTOLI etched with freedom; though his manner is not agreeable. His capital work is LANFRANK's gallery.

Jac. Freii is an admirable engraver. He unites, in a great degree, ftrength, and foftnefs; and comes as near the force of painting, as an engraver can well do. He has given us the ftrongeft ideas of the works of feveral of the moft eminent mafters. He preferves the drawing, and expreffion of his original; and often, perhaps, improves the effect. There is a richnefs too in his manner, which is very pleafing. You fee him in perfection, in a noble print from C. Maratti, intitled, *In confpectu angelorum pfallam tibi.*

R. V. Auden Aerd copied many things from C. Maratti, and other mafters, in a ftyle indeed very inferior to Jac. Freii, (whofe rich execution he could not reach,) but yet with fome elegance. His manner is fmooth, and finifhed; but without effect. His drawing is good, but his lights are frittered.

S. Gribelin is a careful, and laborious engraver; of no extenfive genius; but painfully

fully exact. His works are chiefly small; the principal of which are his copies from the Banqueting-Houfe at Whitehall; and from the Cartoons. His manner is formal; yet he has contrived to preferve the fpirit of his original. I know no copies of the Cartoons fo valuable as his. It is a pity he had not engraved them on a larger fcale.

LE BAS etches in a clear, diftinct, free manner; and has done great honour to the works of TENIERS, WOVERMAN, and BERGHEM; from whom he chiefly copied. The beft of his works are after BERGHEM.

BISCHOP's etching has fomething very pleafing in it. It is loofe, and free; and yet has ftrength, and richnefs. Many of his ftatues are good figures: the drawing is fometimes incorrect; but the execution is always beautiful. Many of the plates of his drawing-book are good. His greateft fingle work, is the reprefentation of JOSEPH *in Egypt;* in which there are many faults, both in the drawing and effect; fome of which are chargeable on himfelf, and others on the artift from
whom

whom he copied; but on the whole, it is a pleasing print.

FRANCIS PERRIER was the debauched son of a goldsmith in Franchecomté. His indiscretion forcing him from home, his inclination led him to Italy. His manner of travelling thither was whimsical. He joined himself to a blind beggar, whom he agreed to lead for half his alms. At Rome, he applied to painting; and made a much greater proficiency than could have been expected from his dissipated life. He published a large collection of statues and other antiquities; which are etched in a masterly manner. The drawing is often incorrect; but the attitudes are well chosen, and the execution spirited. Many of them seem to have been done hastily; but there are marks of genius in them all.

MAROT, architect to K. WILLIAM, hath etched some statues likewise, in a masterly manner. Indeed all his works are well executed; but they consist chiefly of ornaments in the way of his profession.

FRAN.

FRAN. ROETTIERS etches in a very bold manner, and with spirit; but there is a harshness in his outline, which is disagreeable; though the less so, as his drawing is generally good. Few artists manage a crowd better; or give it more effect by a proper distribution of light. Of this management we have some judicious instances in his two capital prints, the *Assumption of the cross*, and the *Crucifixion*.

NICHOLAS DORIGNY was bred a lawyer: but not succeeding at the bar, he studied painting; and afterwards applied to engraving. His capital work is, the *Transfiguration*; which Mr. ADDISON calls the noblest print in the world. It is unquestionably a noble work; but DORIGNY seems to have exhausted his genius upon it: for he did nothing afterwards worth preserving. His Cartoons are very poor. He engraved them in his old age; and was obliged to employ assistants, who did not answer his expectation.

Masters in Portrait.

Among the mafters in portrait, REMBRANDT takes the lead. His heads are admirable copies from nature; and perhaps the beft of his works. There is great expreffion in them, and character.

VAN ULIET followed REMBRANDT's manner; which he hath in many things excelled. Some of his heads are exceedingly beautiful. The force which he gives to every feature, the roundnefs of the mufcle, the fpirit of the execution, the ftrength of the character, and the effect of the whole, are admirable.

J. LIEVENS etches in the fame ftyle. His heads are executed with great fpirit; and deferve

ferve a place in any collection of prints; though they are certainly inferior to ULIET's.—ULIET, and LIEVENS etched some historical prints; particularly the latter, (whose *Lazarus*, after REMBRANDT, is a noble work), but their portraits are their best prints.

Among the imitators of REMBRANDT, we should not forget our countryman WORLIDGE; who has very ingeniously followed the manner of that master; and sometimes improved upon him. No man understood the drawing of a head better.—His small prints also, from antique gems, are neat, and masterly.

Many of VAN DYKE's etchings do him great credit. They are chiefly to be found in a collection of the portraits of eminent artists, which VAN DYKE was at the expence of getting engraved. They are done slightly; but bear the character of a master. LUKE VOSTERMAN is one of the best. It is probable VAN DYKE made the drawings for most of them: his manner is conspicuous in them all.

—A very

―――A very finished etching of an *Ecce homo*, paffes under the name of this mafter. It is a good print, but not equal to what we might have expected from VAN DYKE.

We have a few prints of Sir PETER LELY's etching likewife; but there is nothing in them that is very interefting.

R. WHITE was the principal engraver of portraits, in CHARLES the Second's reign; but his works are miferable performances. They are faid to be good likeneffes; and they may be fo; but they are wretched prints.

BECKET and SIMONS are names which fcarce deferve to be mentioned. They were in their time, mezzotinto-fcrapers of note, only becaufe there were no others.

WHITE, the mezzotinto-fcraper, fon of the engraver, was an artift of great merit. He
 copied

copied after Sir GODFREY KNELLER; whom he teafed fo much with his proofs, that it is faid Sir GODFREY forbad him his houfe. His mezzotintos are very beautiful. BAPTISTE, WING, STURGES, and HOOPER are all admirable prints. He himfelf ufed to fay, that old and young PARR were the beft portraits he ever fcraped. His manner was peculiar, at the time he ufed it: though it hath fince been adopted by other mafters. He firft etched his plate, and then fcraped it. Hence his prints preferve their fpirit longer than the generality of mezzotintos.

SMITH was the pupil of BECKET; but he foon excelled his mafter. He was efteemed the beft mezzotinto-fcraper of his time; though, perhaps, inferior to WHITE. He hath left a very numerous collection of portraits: fo numerous, that they are often bound in two large folios. He copied chiefly from Sir GODFREY · and is faid to have had an apartment in his houfe.—LORD SOMERS was fo fond of the works of this mafter; that he feldom travelled, without carrying them with him in the feat

of his coach.—Some of his beſt prints are two holy families, ANTHONY LEIGH, MARY MAGDALENE, SCALKEN, a half-length of Lady ELIZABETH CROMWELL, the duke of SCHOMBERG on horſe-back, the counteſs of SALISBURY, GIBBON the ſtatuary, and a very fine hawking piece from WYKE.—— After all, it muſt be owned, that the beſt of theſe mezzotintos are inferior to what we have ſeen executed by the maſters of the preſent age.

MELLAN's portraits are the moſt indifferent of his works. They want ſtrength, ſpirit, and effect.

PITTERI hath lately publiſhed a ſet of heads, from PIAZZETA, in the ſtyle of MEL-LAN; but in a much finer taſte, with regard both to compoſition, and manner. Though, like MELLAN, he never croſſes his ſtroke; yet he has contrived to give his heads more force and ſpirit.

J. MORIN's

J. Morin's heads are engraved in a very peculiar manner. They are stippled with a graver, after the manner of mezzotinto; and have a good effect. They have force; and, at the same time, softness. Few portraits, on the whole, are better. Guido Bentivolius from Van Dyke is one of the best.

J. Lutma's heads are executed in the same way: we are told, with a chisel and mallet. They are inferior to Morin's; but are not without merit.

Edm. Marmion etched a few portraits in the manner of Van Dyke, and probably from him; in which there is ease and freedom. He has put his name only to one of them.

Wolfang, a German engraver, managed his tools with softness, and delicacy; at the same time preserving a confiderable degree of spirit.

spirit. But his works are scarce. I make these remarks indeed, from a single head, that of HUET, bishop of Auranches; which is the only work of his, that I have seen.

DREVET's portraits are neat, and elegant; but laboured to the last degree. They are copied from RIGAUD, and other French masters; and abound in all that flutter, and licentious drapery, so opposite to the simple and chaste ideas of true taste. DREVET excels chiefly in copying RIGAUD's frippery; lace, silk, fur, velvet, and other ornamental parts of dress.

RICHARDSON hath left us several heads, which he etched for Mr. POPE, and others of his friends. They are slight, but shew the spirit of a master. Mr. POPE's profile is the best.

VERTUE was a good antiquarian, and a worthy man, but no artist. He copied with
painful

painful exactness; in a dry, disagreeable manner, without force, or freedom. In his whole collection of heads, we can scarce pick out half a dozen, which are good.

Such an artist in mezzotinto, was FABER. He has published nothing extremely bad; and yet nothing worth collecting. *Mrs.* COLLIER is one of his best prints; and has some merit. She is leaning against a pillar; on the base of which is engraved the story of the golden apple.

HOUBRAKEN is a genius; and has given us, in his collection of English portraits, some pieces of engraving at least equal to any thing of the kind. Such are his heads of HAMBDEN, SCHOMBERG, the earl of BEDFORD, the duke of RICHMOND particularly, and some others. At the same time we must own, that he has intermixed among his works, a great number of bad prints. In his best, there is a wonderful union of softness, and freedom. A more elegant and flowing line no artist ever employed.

Our

Our countryman FRY has left behind him a few very beautiful heads in mezzotinto. They are all copied from nature; have great foftnefs, and fpirit; but want ftrength. Mezzotinto is not adapted to works fo large, as the heads he has publifhed.

Masters in Animal Life.

BERGHEM has a genius truly paſtoral; and brings before us the moſt agreeable ſcenes of rural life. The ſimplicity of Arcadian manners is no where better deſcribed than in his works. We have a large collection of prints from his deſigns; many etched by himſelf, and many by other maſters. Thoſe by himſelf are ſlight, but maſterly. His execution is inimitable. His cattle, which are always the diſtinguiſhed part of his pieces, are well drawn, admirably characterized, and generally well grouped. Few painters excelled more in compoſition than BERGHEM; and yet we have more beautiful inſtances of it in the prints etched from him by others, than in thoſe by himſelf. Among his own etchings a few ſmall plates of ſheep and goats are exceedingly valued.

J. VISSCHER

J. Visscher never appears to more advantage than when he copies Berghem. His excellent drawing, and the freedom of his execution, give a great value to his prints; which have more the air of originals, than of copies. He is a mafter both in etching, and engraving. His flighteft etchings, though copies only, are the works of a mafter; and when he touches with a graver, he knows how to add ftrength and firmnefs, without deftroying freedom and fpirit. He might be faid to have done all things well, if he had not failed in the diftribution of light: it is more than probable, he has not attended to the effect of it, in many of the paintings which he has copied.

Danker Dankerts is another excellent copyift from Berghem. Every thing, that has been faid of Visscher, may be faid of him; and perhaps ftill in a ftronger manner: —Like Visscher too he fails in the management of his lights.

Hondius,

Hondius, a native of Rotterdam, paſſed the greater part of his life in England. He painted animals chiefly; was free in his manner; extravagant in his colouring; incorrect in his drawing; ignorant of the effect of light; but great in expreſſion. His prints therefore are better than his pictures. They poſſeſs his chief excellency, with fewer of his defects. They are executed in a neat ſtroke; but with great ſpirit; and afford ſtrong inſtances of animal fury. His *hunted wolf* is an admirable print.

Du Jardin underſtood the anatomy of domeſtic animals perhaps better than any other maſter. His drawing is correct; and yet the freedom of the maſter is preſerved. He copied nature ſtrictly, though not ſervilely: and has given us not only the form, but the characteriſtic peculiarities, of each animal. He never, indeed, like Hondius, animates his creation with the violence of ſavage fury. His genius takes a milder turn. All is quietneſs, and repoſe. His dogs, after their exerciſe,

are ſtretched at their eaſe; and the languor of a meridian ſun prevails commonly through all his pieces. His compoſition is beautiful; and his execution, though neat, is ſpirited.——His works, when bound together, make a volume of about fifty leaves; among which there is ſcarce one bad print.

RUBENS's huntings are undoubtedly ſuperior on the whole, to any thing of the kind we have. There is more invention in them, and a grander ſtyle of compoſition, than we find any where elſe. I claſs them under his name, becauſe they are engraved by *ſeveral* maſters. But all their engravings are poor. They repreſent the paintings they are copied from, as a ſhadow does the object which projects it. There is ſomething of the *ſhape*; but all the *finiſhing* is loſt. And there is no doubt, but the awkwardneſſes, the patch-work, and the grotesque characters, which every where appear in theſe prints, are in the originals bold fore-ſhortnings, grand effects of light, and noble inſtances of expreſſion.—But it is as difficult to copy the flights of RUBENS, as to tranſlate

tranflate thofe of PINDAR. The fpirit of each
mafter evaporates in the procefs.

WOVERMAN's compofition is generally
crouded with little ornaments. There is no
fimplicity in his works. He wanted a chafte
judgment to correct his exuberance.—VIS-
SCHER was the firft who engraved prints from
this artift. He chofe only a few good defigns;
and executed them mafterly.—MOYREAU un-
dertook him next, and hath publifhed a large
collection. He hath finifhed them highly;
but with more foftnefs than fpirit. His prints
however have a neat appearance, and exhibit
a variety of pleafing reprefentations; cavalcades,
marches, huntings, and encampments.

ROSA of TIVOLI etched in a very finifhed
manner. No one out-did him in compofition
and execution: he is very fkilful too in the
management of light. His defigns are all paf-
toral; and yet there is often a mixture of the
heroic ftyle in his compofition, which is very
pleafing. His prints are fcarce; and, were
they not fo, would be valuable.

H STEPHEN

Stephen de la Bella may be mentioned among the mafters in animal life; though few of his works in this way deferve any other praife, than what arifes from the elegance of the execution. In general, his animals are neither well drawn, nor juftly characterized. The beft of his works in animal life are fome heads of camels and dromedaries.

Anthony Tempesta hath etched feveral plates of fingle horfes, and of huntings. He hath given great expreffion to his animals; but his compofition is more than ordinarily bad in thefe prints: nor is there in any of them the leaft effect of light.

J. Fyt hath etched a few animals; in which we difcover the drawing, and fomething of that ftrength and fpirit, with which he painted. But I never faw more than two or three of his prints.

In

In curious collections we meet with a few of Cuyp's etchings. The *pictures* of this master excel in colouring, compofition, drawing, and the expreffion of character. His *prints* have all thefe excellences, except the firft.

Peter de Laer hath left us feveral fmall etchings of horfes, and other animals, well characterized, and executed in a bold and mafterly manner. Some of them are fingle figures; but when he compofes, his compofition is generally good, and his diftribution of light feldom much amifs; often pleafing: his drawing too is commonly good.

Peter Stoop came from Lifbon with queen Catharine; and was admired in England, till Wyck's fuperior excellence in painting eclipfed him. He hath etched a book of horfes, which are much valued; as there is in general, accuracy in the drawing, nature in the characters, and fpirit in the execution.

Rembrandt's lions, which are etched in his ufual ftyle, are worthy the notice of a connoiffeur.

Bloteling's lions are highly finifhed; but with more neatnefs than fpirit.

Paul Potter etched feveral plates of cows and horfes in a mafterly manner. His manner, indeed, is better than his drawing; which, in his fheep efpecially, is but very indifferent: neither does he characterize them with any accuracy.

Barlow's etchings are numerous. His illuftration of Æfop is his greateft work. There is fomething pleafing in the compofition and manner of this mafter, though neither is excellent. His drawing too is very indifferent; nor does he characterize any animal juftly. His birds in general are better than his beafts.

Flamen

FLAMEN has etched several plates of birds and fishes: the former are bad; the latter better than any thing of the kind we have.

I shall close this account with RIDINGER, who is one of the greatest masters in animal life. This artist has marked the characters of animals, especially of the more savage kind, with great expression. His works may be considered as natural history. He carries us into the forest among bears, and tygers; and, with the exactness of a naturalist, describes their forms, haunts, and manner of living ――His composition is generally beautiful; so that he commonly produces an agreeable whole. His landscape too is picturesque and romantic; and well adapted to the subject he treats.—On the other hand, his manner is laboured, and wants freedom. His human figures are seldom drawn with taste. His horses are ill-characterized, and worse drawn; and, indeed, his drawing, in general, is but slovenly.—The prints of this master are often real history; and represent the portraits

traits of particular animals, which had been taken in hunting. We have fometimes too, the ftory of the chace in High-Dutch, at the bottom of the print. The idea of hiftorical truth adds a relifh to the entertainment; and we furvey the animal with new pleafure, which has given diverfion to a German prince for nine hours together.——The productions of RIDINGER are very numerous; and the greater part of them good. His huntings in general, and different methods of catching animals, are the leaft picturefque of his works. But he meant them rather as didactic prints, than as pictures. Many of his fables are beautiful; particularly the 3d, the 7th, the 8th, and the 10th. I cannot forbear adding a particular encomium, on a book of the heads of wolves and foxes.—His moft capital prints are two large uprights; one reprefenting bears devouring a deer; the other, wild-boars repofing in a foreft.

MASTERS

Masters in Landscape.

Sadler's landscapes have some merit in composition: they are picturesque and romantic; but the manner is dry and disagreeable; the light ill-distributed; the distances ill-kept; and the figures bad.—There were three engravers of this name; but none of them eminent John engraved a set of plates for the Bible; and many other small prints in the historical way: in which we sometimes find a graceful figure, and tolerable drawing; but, on the whole, no great merit. Egidius was the engraver of landscape; and is the person here criticised. Ralph chiefly copied the designs of Bassan; and engraved in the dry disagreeable manner of his brother.

REMBRANDT's landscapes have very little to recommend them, besides their effect; which is often surprising. One of the most admired of them goes under the name of *The Three Trees.*

GASPER POUSSIN etched a few landscapes in a very loose, but masterly manner. It is a pity we have not more of his works.

ABRAHAM BLOEMART understood the beauty of composition, as well in landscape, as in history. But his prints have little force, through the want of a proper distribution of light. Neither is there much freedom in the execution.

HOLLAR was born at Prague; and brought into England by that great patron of arts, the earl of ARUNDEL, in CHARLES I's time. He was an artist of great merit, and in various ways: but I place him here, as his principal

works

works are views of particular places; which he copied with great truth, as he found them. If we are fatisfied with *exact reprefentation*, we have it no where better, than in HOLLAR's works. But we are not to expect pictures. His *large views* are generally bad: I might indeed fay, all his *large works*. His fhipping, his Ephefian matron, his Virgil, and his Juvenal, are among the worft. Many of thefe prints he wrought, and probably wrought haftily, for bookfellers. His fmaller works are often good. Among thefe are many views of caftles, which he took on the Rhine, and the Danube; and many views alfo in England. His diftances are generally pleafing. In his foregrounds, which he probably took exactly as he found them, he fails moft. Among his other views is a very beautiful one of London bridge, and the parts adjacent, taken fomewhere near Somerfet-houfe. HOLLAR has given us alfo feveral plates in animal life, which are good; particularly two or three fmall plates of domeftic fowls, wild ducks, woodcocks, and other game. Among his prints of game, there is particularly one very highly finifhed, in which a hare is reprefented hanging with a bafket of birds.

His

His fhells, muffs, and butterflies, are admirable. His loose etchings too are far from wanting spirit; and his imitations are excellent, particularly those after count GAUDE, CALLOT, and BARLOW. He has admirably expressed the manner of those masters—of CALLOT especially, whose *Beggars* have all the spirit of the originals, in a reduced size.— In general, however, HOLLAR is most admired as an antiquarian. We consider his works as a repository of curiosities; and records of antiquated dresses, abolished ceremonies, and edifices now in ruins. And yet many of his antiquities are elegantly touched. The Gothic ornaments of his cathedrals are often masterly. The sword of EDWARD VI. the cup of ANDREA MONTEGNA, and the vases from HOLBEIN, are all beautiful.—I have dwelt the longer on this artist, as he is in general much esteemed; and as I had an opportunity of examining two of the nobleft collections of his works, I believe, in England—one in the King's library, collected, as I have heard, by king WILLIAM; the other in the library of the late duchess dowager of PORTLAND. And yet though these collections are so very numerous (each, as I remember,

con-

contained in two large volumes in folio) neither of them is complete. There were some prints in each, which were not in the other.— Notwithstanding HOLLAR was so very indefatigable, and was patronized by many people of rank, he was so very poor, that he died with an execution in his house.

STEPHEN DE LA BELLA's landscapes have little to recommend them, besides their neatness, and keeping. His composition is seldom good; and the foliage of his trees resembles bits of spunge. I speak chiefly of his larger works; for which his manner is not calculated. His neatness qualifies him better for miniature.

BOLSWERT's landscapes after REUBENS are executed in a grand style. Such a painter, and such an engraver, could not fail of producing something great. There is little variety in them: nor any of the more minute beauties arising from contrast, catching lights, and such little elegances; but every thing is simple, and great. The print, which goes by

by the name of *The waggon*, is particularly, and defervedly admired. Of thefe prints we generally meet with good impreffions; as the plates are engraved with great ftrength.

Neulant hath etched a fmall book of the ruins of Rome; in which there is great fimplicity, and fome fkill in compofition, and the diftribution of light: but the execution is harfh and difagreeable.

We have a few landfcapes by an earl of *Sunderland*, in an elegant, loofe manner. One of them, in which a Spaniard is ftanding on the foreground, is marked *G. & J. fculpferunt* · another *J. G.*

Waterlo is a name beyond any other in landfcape. His fubjects are perfectly rural. Simplicity is their characteriftic. We find no great variety in them, nor ftretch of fancy. He felects a few humble objects. A coppice, a corner of a foreft, a winding road, or a ftraggling village is generally the extent of his
view:

view: nor does he always introduce an off-skip. His compofition is generally good, fo far as it goes, and his light often well diftributed; but his chief merit lies in execution; in which he is a confummate mafter. Every object that he touches, has the character of nature: but he particularly excels in the foliage of trees.—It is a difficult matter to meet with the larger works at leaft, of this mafter in perfection; the original plates are all retouched, and greatly injured.

SWANEVELT painted landfcape at Rome; where he obtained the name of *the hermit*, from his folitary walks among the ruins of TIVOLI, and FRESCATI; among the rocky vallies of the Sabine mountains; and the beautiful wooded lakes of the Latin hills. He etched in the manner of WATERLO; but with lefs freedom. His trees, in particular, will bear no comparifon with thofe of that mafter. But if he fell fhort of WATERLO in the freedom of execution, he went greatly beyond him in the dignity of defign. WATERLO faw nature with a Dutchman's eye. If we except two or three of his pieces, he never went
beyond

beyond the plain fimplicity of a Flemifh landfcape. Swanevelt's ideas were of a nobler caft. Swanevelt had trodden claffic ground; and had warmed his imagination with the grandeur and variety of Italian views; every where ornamented with the fplendid ruins of Roman architecture: but his favourite fubjects feem to have been the mountain-forefts, where a magnificent difpofition of ground, and rock is embellifhed with the nobleft growth of foreft-trees. His compofition is often good; and his lights judicioufly fpread. In his execution, we plainly difcover two manners: whether a number of his plates have been retouched by fome judicious hand; or whether he himfelf altered his manner in the different periods of his life.

James Rousseau, the difciple of Swanevelt, was a French proteftant; and fled into England from the perfecution of Lewis XIV. Here he was patronized by the duke of Montague; whofe palace, now the *Britifh Mufeum*, he contributed to adorn with his paintings; fome of which are good. The few etchings he hath left are beautiful. He underftood

derstood composition, and the distribution of light; and there is a fine taste in his landscapes; if we except perhaps only that his horizon is often taken too high. Neither can his perspective, at all times, bear a critical examination; and what is worse, it is often pedantically introduced. His figures are good in themselves, and generally well placed. —His manner is rather dry and formal.— Rousseau, it may be added, was an excellent man. Having escaped the rage of persecution himself, he made it his study to lessen the sufferings of his distressed brethren; by distributing among them great part of the produce of his genius. Such an anecdote, in the life of a painter, should not be omitted, even in so short a review as this.

We now and then meet with an etching by Ruysdale; but I never saw any, that was not exceedingly slight.

J. Lutma hath etched a few small landscapes in a masterly manner; which discover

some

some skill in composition, and the management of light.

- Israel Sylvestre has given us a great variety of small views (some indeed of a larger size) of ruins, churches, bridges and castles, in France and Italy. They are exceedingly neat, and touched with great spirit. This master can give beauty even to the outlines of a modern building; and what is more, he gives it without injuring the truth: insomuch that I have seen a gentleman just come from his travels, pick out many of Sylvestre's views, one by one, (though he had never seen them before,) merely from his acquaintance with the buildings. To the praise of this master it may be farther added, that in general he forms his view into an agreeable whole; and if his light is not always well distributed, there are so many beauties in his execution, that the eye cannot find fault. His works are very numerous, and few of them are bad. In trees he excels least.

The

The etchings of CLAUDE LORRAIN are below his character. His execution is bad; and there is a dirtinefs in it, which difpleafes: his trees are heavy; his lights feldom well-maffed; and his diftances only fometimes obferved.——The truth is, CLAUDE's talents lay upon his pallet; and he could do little without it.——His *Via facra* is one of his beft prints. The trees and ruins on the left, are beautifully touched; and the whole (though rather formal) would have been pleafing, if the foreground had been in fhadow.——After all, it is probable, I may not have feen fome of his beft prints. I have heard a fea-port much praifed for the effect of a fetting fun; and another print, in which a large group of trees fill the centre, with water, and cattle on the foreground; and a diftance, on each fide of the trees. But I do not recollect feeing either of thefe prints.

PERELLE has great merit. His fancy is fruitful; and fupplies him with a richnefs, and variety in his views, which nature feldom exhibits.

hibits. It is indeed too exuberant; for he often confounds the eye with too great a luxuriancy. His manner is his own; and it is difficult to fay, whether it excels moſt in richneſs, ſtrength, elegance, or freedom. His trees are particularly beautiful; the foliage is looſe, and the ramification eaſy. And yet it muſt be confeſſed, that PERELLE is rather a manneriſt, than a copier of nature. His views are all ideal; his trees are of one family; and his light, though generally well diſtributed, is ſometimes affected: it is introduced as a ſpot; and is not properly melted into the neighbouring ſhade by a middle tint. Catching lights, uſed ſparingly, are beautiful: PERELLE affects them.—Theſe remarks are made principally on the works of *Old* PERELLE: For there were three engravers of this name; the grandfather, the father, and the ſon. They all engraved in the ſame ſtyle; but the juniors, inſtead of improving the family taſte, degenerated. The grandfather is the beſt, and the grandſon the worſt.

VANDER CABEL ſeems to have been a careleſs artiſt; and diſcovers great ſlovenlineſs

in

in many of his works: but in thofe which he has ftudied, and carefully executed, there is great beauty. His manner is loofe and mafterly. It wants effect; but abounds in freedom. His trees are often particularly well managed; and his fmall pieces, in general, are the beft of his works.

In WEIROTTER we fee great neatnefs, and high finifhing; but often at the expence of fpirit and effect. He feems to have underftood beft the management of trees; to which he always gives a beautiful loofenefs.——There is great effect in a fmall moon-light by this mafter: the whole is in dark fhade, except three figures on the foreground.

OVERBECK etched a book of Roman ruins: which are in general good. They are pretty large, and highly finifhed. His manner is free, his light often well diftributed, and his compofition agreeable.

GENOEL's landscapes are rather free sketches, than finished prints. In that light they are beautiful. No effect is aimed at: but the free manner in which they are touched, is pleasing; and the composition is in general good, though often crowded.

BOTH's taste in landscape is elegant. His ideas are grand; his composition beautiful; and his execution rich and masterly in a high degree. His light is not always well distributed. His figures are excellent. We regret that we have not more of his works; for they are certainly, on the whole, among the best landscapes we have.

MARCO RICCI's works, which are numerous, have little merit. His human figures indeed are good, and his trees tolerable; but he produces no effect, his manner is disgusting, his cattle ill-drawn, and his distances ill-preserved.

Le Veau's landscapes are highly finished: they are engraved with great softness, elegance, and spirit. The keeping of this master is particularly well observed. His subjects too are well chosen; and his prints indeed, in general, make beautiful furniture.

Zuingg engraves in a manner very like Le Veau; but not quite so elegantly.

Zeeman was a Dutch painter; and excelled in sea-coasts, beaches, and distant land; which he commonly adorned with skiffs, and fishing-boats. His prints are copies from his pictures. His execution is neat, and his distances well kept: but he knows nothing of the distribution of light. His figures too are good, and his skiffs admirable. In his *sea-pieces* he introduces larger vessels; but his prints in this style are commonly awkward, and disagreeable.

VANDIEST left behind him a few rough sketches, which are executed with great freedom.

GOUPY very happily caught the manner of SALVATOR; and in some things excelled him. There is a richness in his execution, and a spirit in his trees, which SALVATOR wants. But his figures are bad. Very gross instances, not only of indelicacy of outline, but even of bad drawing, may be found in his print of PORSENNA, and in that of DIANA. Landscape is his fort; and his best prints are those which go under the titles of the *Latrones*, the *Augurs*, *Tobit*, *Hagar*, and its companion.

PIRANESI has given us a larger collection of Roman antiquities, than any other master; and has added to his ruins a great variety of modern buildings. The critics say, he has trusted too much to his eye; and that his proportions and perspective are often faulty. He seems to be a rapid genius; and we are told,

told, the drawings, which he takes on the spot, are as slight and rough as possible: the rest he makes out by memory and invention. His invention indeed is wonderful; and I know not whether such of his works as are entirely of his own invention are not the best. From so rapid, and voluminous an artist, indeed we cannot expect much correctness: his works complete, sell at least for fifty pounds.——But the great excellence of this artist lies in execution; of which he is a consummate master. His stroke is firm, free, and bold, in the greatest degree; and his manner admirably calculated to produce a grand, and rich effect. But the effects he produces are rarely seen, except in single objects. A defaced capital, a ruined wall, or broken fluting, he touches with great spirit. He expresses even the stains of weather-beaten marble: and those of his prints, in which he has an opportunity of displaying expression in this way, are generally the best. His stroke has much the appearance of etching; but I have been informed that it is chiefly engraved, and that he makes great use of the dry needle.—His faults are many. His horizon is often taken too high; his views are frequently ill-chosen; his objects crowded; his forms ill-shaped. Of the distribution of light he

has little knowledge. Now and then we meet with an effect of it; which makes us only lament, that in such masterly performances it is found so seldom. His figures are bad: they are ill-drawn, and the drapery hangs in tatters. It is the more unhappy, as his prints are populous. His trees are in a paltry style; and his skies hard, and frittered.

Our celebrated countryman HOGARTH cannot properly be omitted in a catalogue of engravers; and yet he ranks in none of the foregoing classes. With this apology I shall introduce him here.

The works of this master abound in true humour; and satire, which is generally well directed. They are admirable moral lessons, and afford a fund of entertainment suited to every taste: a circumstance, which shews them to be just copies of nature. We may consider them too as valuable repositories of the manners, customs, and dresses of the present age. What amusement would a collection of this kind afford, drawn from every period of the history of Britain?—How far the works of HOGARTH will bear a *critical examination*, may be the subject of a little more inquiry

In

In *defign* HOGARTH was feldom at a lofs. His invention was fertile; and his judgment accurate. An improper incident is rarely introduced; a proper one rarely omitted. No one could tell a ftory better; or make it, in all its circumftances, more intelligible. His genius, however, it muft be owned, was fuited only to *low*, or *familiar* fubjects. It never foared above *common* life: to fubjects naturally fublime; or, which from antiquity, or other accidents borrowed dignity, he could not rife.

In *compofition* we fee little in him to admire. In many of his prints, the deficiency is fo great, as plainly to imply a want of all principle; which makes us ready to believe, that when we do meet with a beautiful group, it is the effect of chance. In one of his minor works, the *idle 'prentice*, we feldom fee a crowd more beautifully managed, than in the laft print. If the fheriff's officers had not been placed in a line, and had been brought a little lower in the picture, fo as to have formed a pyramid with the cart; the compofition had been unexceptionable; and yet the firft print of this work is fo ftriking an inftance of difagreeable compofition, that it is amazing, how an artift, who had any idea of beautiful

forms,

forms, could suffer so unmasterly a performance to leave his hands.

Of the *distribution of light* HOGARTH had as little knowledge as of *composition*. In some of his pieces we see a good effect; as in the *execution* just mentioned: in which, if the figures at the right and left corners, had been *kept down* a little, the light would have been beautifully distributed on the foreground, and a fine secondary light spread over part of the crowd: but at the same time there is so obvious a deficiency in point of effect, in most of his prints, that it is very evident he had no principles.

Neither was HOGARTH a master of *drawing*. Of the muscles and anatomy of the head and hands he had perfect knowledge; but his trunks are often badly moulded, and his limbs ill set on. I tax him with plain bad drawing; I speak not of the niceties of anatomy, and elegance of out-line: of these indeed he knew nothing; nor were they of use in that mode of design which he cultivated: and yet his figures, on the whole, are inspired with so much life, and meaning; that the eye is kept in good humour, in spite of its inclination to find fault.

The

The author of the *Analysis of Beauty*, it might be supposed, would have given us more instances of *grace*, than we find in the works of HOGARTH; which shews strongly that theory and practice are not always united. Many opportunities his subjects naturally afford of introducing graceful attitudes; and yet we have very few examples of them. With instances of *picturesque grace* his works abound.

Of his *expression*, in which the force of his genius lay, we cannot speak in terms too high. In every mode of it he was truly excellent. The passions he thoroughly understood; and all the effects which they produce in every part of the human frame: he had the happy art also of conveying his ideas with the same precision, with which he conceived them.— He was excellent too in expressing any humorous oddity, which we often see stamped upon the human face. All his heads are cast in the very mould of nature. Hence that endless variety, which is displayed through his works; and hence it is, that the difference arises between *his* heads, and the affected caricatures of *those* masters, who have sometimes amused themselves with patching together an assemblage of features from their own ideas. Such

Such are SPANIOLET's; which, though admirably executed, appear plainly to have no archetypes in nature. HOGARTH's, on the other hand, are collections of natural curiosities. The *Oxford-heads,* the *physician's-arms,* and some of his other pieces, are expresly of this humorous kind. They are truly comic - though ill-natured effusions of mirth : more entertaining than SPANIOLET's, as they are pure nature ; but less innocent, as they contain ill-directed ridicule.—But the species of expression, in which this master perhaps most excels, is that happy art of catching those peculiarities of air, and gesture, which the ridiculous part of every profession contract ; and which, for that reason, become characteristic of the whole. His counsellors, his undertakers, his lawyers, his usurers, are all conspicuous at sight. In a word, almost every profession may see in his works, that particular species of affectation, which they should most endeavour to avoid.

The execution of this master is well suited to his subjects, and manner of treating them. He etches with great spirit ; and never gives one unnecessary stroke. For myself, I greatly more value the works of his own needle, than

thofe

thofe high-finifhed prints, on which he employed other engravers. For as the production of an effect is not his talent; and as this is the chief excellence of high-finifhing; his own rough manner is certainly preferable; in which we have moft of the force, and fpirit of his expreffion. The *manner* in none of his works pleafes me fo well, as in a fmall print of a corner of a play-houfe. There is more fpirit in a work of this kind, ftruck off at once, warm from the imagination, than in all the cold correctnefs of an elaborate engraving. If all his works had been executed in this ftyle, with a few improvements in the compofition, and the management of light, they would certainly have been a more valuable collection of prints than they are. The *Rake's Progrefs*, and fome of his other works, are both etched and engraved by himfelf: they are well done; but it is plain he meant them as furniture. As works defigned for a critic's eye, they would have been better without the engraving; except a *few* touches in a *very few* places. The want of effect too would have been lefs confpicuous, which in his higheft finifhed prints is difagreeably ftriking.

those high-finished prints, on which he employed other engravers. For as the production of an effect is not the talent; and as this is the chief excellence of high-finishing, his own rough manner is certainly preferable; in which we have most of the force, and spirit of his expression. The manner in none of his works pleases me so well, as in a small print of a corner of a play-house. There is more spirit in a work of this kind, struck off at once, warm from the imagination, than in all the cold correctness of an elaborate engraving. If all his works had been executed in this style, with a few improvements in the composition, and the management of light, they would certainly have been a more valuable collection of prints than they are. The Rake's Progress, and some of his other works, are both etched and engraved by himself: they are well done; but it is plain he meant them as finished. As works designed for a critic's eye, they would have been better without the engraving, except a few touches in a very few places. The want of effect too would have been less conspicuous, which in his highest finished prints is displeasably striking.

CHAP. IV

Remarks on particular Prints.

HAVING thus examined the characters of several masters, I shall now make a few remarks on some particular prints, by way of illustrating the observations that have been made. The first print I shall criticize, is

THE RESURRECTION OF LAZARUS, BY
BLOEMART.

Wih regard to design, this print has great merit. The point of time is very judiciously chosen. It is a point between the first command, *Lazarus, come forth;* and the second, *Loose him, and let him go.* The astonishment of the two sisters is now over. The predominant passion is gratitude; which is discovering itself in praise. One of the attendants is telling

the ftupified man, " That is your fifter." Himself, collecting his fcattered ideas, directs his gratitude to Chrift. Jefus directs it to heaven. So far the defign is good. But what are thofe idle figures on the right hand, and on the left? Some of them feem no way concerned in the action. Two of the principal are introduced as grave-diggers; but even in that capacity they were unwanted; for *the place,* we are told, *was a cave, and a ftone lay upon it.* When a painter is employed on a barren fubject, he muft make up his groups as he is able; but there was no barrennefs here: the artift might, with propriety, have introduced, in the room of the grave-diggers, fome of the Pharifaical party maligning the action. Such, we are told, were on the fpot; and, as they are figures of confequence in the ftory, they ought not to have been fhoved back, as they are, among the appendages of the piece.

The *compofition* is almoft faultlefs. The principal group is finely difpofed. It opens in a beautiful manner, and difcovers every part. It is equally beautiful, when confidered in combination with the figures on the left hand.

The *light* is but ill-diftributed, though the figures are difpofed to receive the moft beauitful effect

effect of it. The whole is one glare. It had been better, if all the figures on the elevated ground, on the right, had been in strong shadow. The extended arm, the head and shoulder of the grave-digger, might have received catching lights. A little more light might have been thrown on the principal figure; and a little less on the figure kneeling. The remaining figures, on the left, should have been *kept down*. Thus the light would have centered strongly on the capital group, and would have faded gradually away.

The single figures are in general good. The principal one indeed is not so capital as might be wished. The character is not quite pleasing; the right arm is awkwardly introduced, if not ill-drawn; and the whole disagreeably incumbered with drapery.—Lazarus is very fine: the drawing, the expression, and grace of the figure are all good.—The figure kneeling contrasts with the group.—The grave-diggers are both admirable. It is a pity, they should be incumbrances only.

The *drawing* is in general good: yet there seems to be something amiss in the pectoral muscles of the grave-digger on the right. The hands too of almost all the figures are constrained

strained and awkward. Few of them are in natural action.

The *manner*, which is mere engraving, without any etching, is strong, distinct, and expressive.

THE DEATH OF POLYCRATES; BY SALVATOR ROSA.

The *story* is well told: every part is fully engaged in the subject, and properly subordinate to it.

The *disposition* is agreeable. The contrivance of the groups, falling one into another, is pleasing: and yet the form would have been more beautiful, if a ladder with a figure upon it, a piece of loose drapery, a standard, or some other object, had been placed on the left side of the crofs, to have filled up that formal vacancy, in the shape of a right-angle, and to have made the pyramid more complete. The groups themselves are simple and elegant. The three figures on horse-back indeed are bad. A line of heads is always unpleasing.

There is little idea of *keeping*. The whole is too much one surface; which might have been prevented by more force on the fore-ground, and a slighter sky.

The *light* is diftributed without any judgment. It might perhaps have been improved, if the group of the foldier refting on his fhield, had been in fhadow; with a few catching lights This fhadow, paffing through the label, might have extended over great part of the foreground above it; by which we fhould have had a body of fhadow to balance the light of the centre-group. The lower figures of the equeftrian-group might have received a middle tint, with a few ftrong touches; the upper figures might have caught the light, to detach them from the ground.—There are fome lights too in the fky, which would be better removed.

With regard to the figures taken feparately, they are almoft unexceptionably good. We feldom indeed fee fo many good figures in any collection of fuch a number. The young foldier leaning over his fhield; the other figures of that group; the foldier pointing, in the middle of the picture; and the figure behind him fpreading his hands, are all in the higheft degree elegant, and graceful. The diftant figures too, are beautiful. The expreffion, in the whole body of the fpectators, is ftriking. Some are more, and fome lefs affected; but every

every one in a degree.----All the figures, however, are not faultlefs. POLYCRATES hangs ungracefully on his crofs : his body is compofed of parallel lines, and right angles. His face is ftrongly marked with agony : but his legs are difproportioned to his body.—The three lower figures of the equeftrian-group have little beauty.----One of the equeftrian figures alfo, that neareft the crofs, is formal and difpleafing : and as to a horfe, SALVATOR feems to have had very little idea of the proportion and anatomy of that animal.—Indeed the *whole* of this corner of the print is bad; and I know not whether the compofition would not be improved by the removal of it.

The fcenery is beautiful. The rock broken, and covered with fhrubs at the top; and afterwards fpreading into one grand, and fimple fhade, is in itfelf a pleafing object; and affords an excellent back-ground to the figures.

The *execution* of this print is equal to that of any of SALVATOR's works.

THE TRIUMPH OF SILENUS; BY PETER TESTA.

P. TESTA seems, in this elegant and masterly performance, as far as his sublime ideas can be comprehended, to have intended a satire on the indulgence of inordinate desires.

The *design* is perfect. Silenus, representing drunkenness, is introduced in the middle of the piece, holding an ivy-crown, and supported by his train, in all the pomp of unwieldy majesty. Before him dance a band of bacchanalian rioters; some of them, as described by the poets,

―――― inter pocula læti,
Mollibus in pratis, *unctos saliere per utres.*

Intemperance, Debauchery, and unnatural Lusts complete the immoral festival. In the offskip rises the temple of Priapus; and hard-by a mountain, dedicated to lewdness, nymphs, and satyrs.—In the heavens are represented the

Moon and *Stars* pufhing back the *Sun*. This group is introduced in various attitudes of furprize, and fear. The Moon is hiding her face; and one of her companions, extinguifhing a torch—all implying, that fuch revels, as are here defcribed, dreaded the approach of day.

The *difpofition* has lefs merit; yet is not unpleafing. The group, on the left, and the *feveral parts* of it, are happily difpofed. The group of dancers, on the other fide, is crowded, and ill-fhaped. The difpofition might, perhaps, have had a better effect, if an elegant canopy had been held over SILENUS; which would have been no improper appendage; and, by forming the apex of a pyramid over the principal figure, would have given more variety and beauty to the whole.

The *light*, with regard to *particular figures*, is juft, and beautiful. But fuch a light, at beft, gives us only the idea of a picture examined by a candle. Every figure, as you hold the candle to it, appears well lighted; but inftead of an *effect* of light, you have only a fucceffion of *fpots*. Indeed the light is not only ill, but abfurdly diftributed. The upper part is enlightened by one fun, and the lower part by another; the direction of the light

being different in each.—Should we endeavour to amend it, it might be better perhaps to leave out the Sun; and to reprefent him, by his fymbols, as *approaching* only. The fky-figures would of courfe receive catching lights, and might be left nearly as they are. The figure of *Rain* under the *Moon* fhould be in fhadow. The bear too, and the lion's head fhould be *kept down*. Thus there would be nothing glaring in the celeftial figures. Silenus, and his train, might be enlightened by a ftrong torch-light, carried by the dancing figures. The light would then fall nearly as it does, on the principal group. The other figures fhould be *brought down* to a middle tint. This kind of light would naturally produce a gloom in the background, which would have a good effect.

With regard to the figures taken feparately, they are conceived with fuch claffical purity, and fimplicity of tafte; fo elegant in the drawing, and fo graceful in every attitude; that if I were obliged to fix upon any print, as an example of all the beauties which fingle figures are capable of receiving, I fhould almoft be tempted to give the preference to this.

The moft ftriking inftances of fine *drawing* are feen in the principal figure; in the legs of the figure that fupports him; and in thofe of the figure dancing with the pipes; in the man and woman behind the centaur; in the figure in the clouds, with his right hand over his knee; and particularly in that bold fore-fhortened figure on the right of the Sun.

Inftances of *expreffion* we have in the unwieldinefs of Silenus. He appears fo dead a weight, fo totally unelaftic, that every part of him, which is not fupported, finks with its own gravity. The fenfibility too with which his bloated body, like a quagmire, feels every touch, is ftrongly expreffed in his countenance. The figure, which fupports him, expreffes ftrongly the labour of the action. The dancing figures are all well characterized. The pufhing figures alfo in the fky are marked with great expreffion; and above all the threatening figure, reprefented in the act of drawing a bow.

With regard to *grace*, every figure, at leaft every capital one, is agreeable; if we except only that figure, which lies kicking its legs upon the ground. But we have the ftrongeft inftances of grace in the figure dancing with

the pipes; in the man and woman behind the centaur, (who, it is not improbable, might be defigned for BACCHUS and ARIADNE;) and in the boy lying on the ground.

With regard to *execution*, we rarely fee an inftance of it in greater perfection. Every head, every mufcle, and every extremity is touched with infinite fpirit. The very appendages are fine; and the ftone-pines, which adorn the background, are marked with fuch tafte and precifion, as if landfcape had been this artift's only ftudy.

SMITH'S PORTRAIT OF THE DUKE OF
SCHOMBERG; FROM KNELLER.

KNELLER, even when he laid himfelf out to excel, was often but a tawdry painter. His equeftrian portrait of king WILLIAM, at Hampton-court, is a very unmafterly performance: the compofition is bad; the colouring gaudy; the whole is void of effect, and there is fcarce a good figure in the piece.—The compofition before us is more pleafing, though the effect is little better. An equeftrian figure, at beft, is an awkward fubject. The legs of a horfe are great incumbrances in grouping. VANDYKE, indeed, has managed king CHARLES the Firft, on horfeback, with great judgment: and RUBENS too, at Hampton-court, has made a noble picture of the duke of ALVA; though his horfe is ill drawn.——In the print before us the figure fits with grace and dignity; but the horfe is no Bucephalus: his character is only

that

that of a managed pad. The bush, growing by the duke's truncheon, is a trifling circumstance; and helps to break, into more parts, a composition already too much broken.——The *execution* is throughout excellent; and though the parts are rather too small for mezzotinto, yet SMITH has given them all their force.

Pether's Mezzotinto of Rembrandt's Jewish Rabbi.

The character is that of a stern, haughty man, big with the idea of his own importance. The *rabbi* is probably fictitious; but the *character* was certainly taken from nature. There is great dignity in it; which in a work of Rembrandt's is the more extraordinary.—— The full expression of it is given us in the print. The unelastic heaviness of age, which is so well described in the original, is as well preserved in the copy. The three equidistant lights on the head, on the ornament, and on the hands, are disagreeable: in the print they could not be removed; but it might have been judicious to have *kept down* the two latter a little more.——With regard to the execution, every part is scraped with the utmost softness, and delicacy. The muscles are round and plump; and the insertions of them, which in an old face are very apparent, are well expressed.

preſſed. Such a variety of middle tints, and melting lights, were difficult to manage; and yet they are managed with great tenderneſs. The looſeneſs of the beard is maſterly. The hands are exactly thoſe of a fat old man. The ſtern eyes are full of life; and the noſe and mouth are admirably touched. The ſeparation of the lips in ſome parts, and the adheſion of them in others, are characteriſtic ſtrokes; and happily preſerved. The folds and lightneſs of the turban are very elegant. The robe, about the ſhoulder, is unintelligible, and ill managed: but this was the painter's fault.———In a word, when we examine this very beautiful mezzotinto, we muſt acknowledge, that no engraving can equal it in ſoftneſs, and delicacy.

HONDIUS'S HUNTED WOLF.

The compofition, in this little print, is good; and yet there is too much fimilitude, in the direction of the bodies of the feveral animals. The group alfo is too much broken, and wants folidity. The horizon is taken too high; unlefs the dimenfions of the print had been higher. The rifing ground, above the wolf's head, had been offskip enough: and yet the rock, which rifes higher, is fo beautifully touched; that it would be a pity to remove it.——The *light* is diftributed without any judgment. It might have been improved, if all the interftices among the legs, and heads of the animals, had been *kept down;* and the fhadow made very ftrong under the fawn, and the wounded dog. This would have given a bold relief to the figures; and might, without any other alteration, have produced a good effect.—The *drawing* is not faultlefs. The legs and body of the wounded dog are inaccurate: nor does the attacking dog

ftand

ſtand firm upon his right leg.—With regard to *expreſſion*, HONDIUS has exerted his full force. The expreſſion, both of the wounded dog, and of the wolf, is admirable: but the expreſſion of the attacking dog is a moſt bold and maſterly copy from nature. His attitude ſhews every nerve convulſed; and his head is a maſterpiece of animal fury.—We ſhould add, that the ſlaughtered animal is ſo ill characterized, that we ſcarce know what it is.—The *execution* is equal to the expreſſion. It is neat, and highly finiſhed; but diſcovers in every touch the ſpirit of a maſter.

THE FIFTH PLATE OF DU JARDIN'S ANIMALS.

The *defign*, though humble, is beautiful. The two dogs repofing at noon, after the labour of the morning, the implements of fowling, the fictitious hedge, and the loop-holes through it, all correfpond; and agreeably tell the little hiftory of the day.——The *compofition* alfo is good: though it might have been better, if another dog, or fomething equivalent, had been introduced in the vacancy at the left corner. This would have given the group of dogs a better form. The nets, and fowling-pieces are judicioufly added; and make an agreeable fhape with the dogs. The hedge alfo adds another pyramidal form; which would have been more pleafing if the left corner of the reeds had been a little higher.—The *light* is well diftributed; only there is too much of it. The farther dog might have been *taken down* a little;

a little; and the hinder parts of the nearer. ———The *drawing* and *expreſſion* are pure nature; and the *execution* elegant and maſterly.

WATERLO'S TOBIAS.

The landscape I mean, is an upright near twelve inches, by ten. On the near ground stands an oak, which forms a diagonal through the print. The second distance is composed of a rising ground, connected with a rock, which is covered with shrubs. The oak, and the shrubs make a vista, through which appears an extensive view into the country. The figures, which consist of an angel, Tobias, and a dog, are descending a hill, which forms the second distance. The print, with this description, cannot be mistaken.—The *composition* is very pleasing. The trees, on the foreground, spreading over the top of the print, and sloping to a point at the bottom, give the beautiful form of an inverted pyramid; which, in trees especially, has often a fine effect. To this form the inclined plane, on which the figures stand, and which is beautifully broken, is a good contrast. The rock approaches to a

per-

perpendicular, and the diſtance to an horizontal line. All together make ſuch a combination of beautiful and contraſting lines, that the whole is pleaſing. If I ſhould find fault with any thing, it is the regularity of the rocks. There is no variety in parallels; and it had been very eaſy to have broken them.—The *keeping* is well preſerved. The ſecond and third diſtances are both judiciouſly managed. The *light* is well difpoſed. To prevent heavineſs, it is introduced upon the tree, both at the top, and at the bottom; but it is properly *kept down*. A maſs of ſhade ſucceeds over the ſecond diſtance; and the water. The light breaks in a blaze, on the bottom of the rock, and maſſes the *whole*. The trees, ſhrubs, and upper part of the rock are happily thrown into a middle tint. Perhaps the effect of the diſtant country might have been better, if the light had been *kept down*; leaving only one eaſy catching light upon the town, and the riſing ground on which it ſtands;—The *execution* is exceedingly beautiful. No artiſt had a happier manner of expreſſing trees than WATERLO; and the tree before us is one of his capital works. The ſhape of it we have already criticized. The bole

bole and ramification are as beautiful as the shape. The foliage is a masterpiece. Such a union of strength, and lightness is rarely found. The extremities are touched with great tenderness; the strong masses of light are relieved with shadows equally strong; and yet ease, and softness are preserved. The foreground is highly enriched; and indeed the whole print, and every part of it, is full of art, and full of nature.

THE DELUGE AT COEVERDEN, BY ROMAN LE HOOGHE.

This is an historical landscape, a style very different from that of the last. WATERLO had nothing in view, but to form an agreeable picture. The figures, which he introduced, unconnected with his subject, serve only to embellish it. But LE HOOGHE was confined within narrower lines. He had a *country* to describe, and a *story* to tell. The *country* is the environs of Coeverden, a Dutch town, with a view of an immense bank, thrown up against the sea. The *story*, is the ruin of that bank; which was broken through in three p'aces, by the violence of a storm. The subject was great and difficult; and yet the artist has acquitted himself in a masterly manner. The town of Coeverden fills the distant view. The country is spread with a deluge; the sky with a tempest; and the breaches in the bank appear in all their horror.—The *compofi-
tion,*

tions in the distant and middle parts, is as pleasing, as such an extensive subject can be. An elevated horizon, which is always displeasing, was necessary here to give a distinct view of the whole.—The *light* too is thrown over the distant parts in good masses.—The *expression* of the figures, of the horses especially, is very strong: those, which the driver is turning, to avoid the horrid chasm before him, are impressed with the wildest character of terror: and, indeed, the whole scene of distress, and the horrible confusion in every part of it, are admirably described.—The *execution* is good, though not equal to that of many of LE HOOGHE's works. It may be added, that the shape of the print is bad. A little more length would have enlarged the idea; and the town would have stood better, not quite in the middle.——But what is most faulty, is the disproportion, and littleness of the foreground on the right. The spirit, which the artist had maintained through the whole description, seems here to flag. Whereas *here* he should have closed the whole with some noble confusion; which would have set off the distant parts, and struck the spectator with the strongest images of horror. Instead of this,

we are presented with a few pigs, and calves floundering in the water. The thought seems borrowed from OVID. In the midst of a world in ruins, *Nat lupus inter oves.*

HOGARTH'S RAKE'S PROGRESS.

The first print of this capital work is an excellent representation of a young heir, taking possession of a miser's effects. The passion of avarice, which hoards every thing, without distinction, what is and what is not valuable, is admirably described.—The *composition*, though not excellent, is not unpleasing. The principal group, consisting of the young gentleman, the taylor, the appraiser, the papers, and chest, is well shaped: but the eye is hurt with the disagreeable regularity of three heads nearly in a line, and at equal distances.——The *light* is not ill disposed. It falls on the principal figures: but the effect might have been improved. If the extreme parts of the mass (the white apron on one side, and the memorandum-book on the other) had been in shade, the *repose* had been less injured. The detached parts of a group should rarely catch a strong body of light.—We have no

striking

striking inſtances of *expreſſion* in this print.
The principal figure is unmeaning. There are
ſeveral modes of expreſſion, very ſuitable to the
character, under which he is repreſented. He
might have entertained himſelf with an old
wig, or ſome other object of his father's atten-
tion—or he might have been grinning over
a bag of money—or, as he is introduced diſ-
miſſing a girl he had debauched, he might have
returned the old woman's threatening with a
ſneer. The only figure, which diſplays the true
vis comica of HOGARTH, is the appraiſer finger-
ing the gold. We enter at once into his cha-
racter.—The young woman might have fur-
niſhed the artiſt with an opportunity of preſent-
ing a graceful figure; which would have been
more pleaſing. The figure he has introduced,
is by no means an object of allurement.——
The *perſpective* is accurate, but affected. So
many windows, and open doors, may ſhew
the author's legerity; but they break the back-
ground, and injure the ſimplicity of

The ſecond print introduces our hero into
all the diſſipation of modiſh life. We became
firſt acquainted with him, when a boy of
eighteen.

eighteen. He is now of age; has entirely thrown off the clownish school-boy; and assumes the man of fashion. Instead of the country-taylor, who took measure of him for his father's mourning, he is now attended by French-barbers, French-taylors, poets, milliners, jockies, bullies, and the whole retinue of a fine gentleman.—The *expression*, in this print, is wonderfully great. The dauntless front of the bully; the keen eye, and elasticity of the fencing-master; and the simpering importance of the dancing-master are admirably expressed. The last is perhaps rather a little *outré*. The architect is a strong copy from nature.—The *composition* seems to be entirely subservient to the expression.—It appears, as if Hogarth had sketched, in his memorandum-book, all the characters which he has here introduced, but was at a loss how to group them: and chose rather to introduce them in detached figures, as he had sketched them, than to lose any part of the expression by combining them.—The *light* is ill distributed. It is spread indiscriminately over the print, and destroys the *whole*.—The *execution* is good. It is elaborate, but free.—The satire on operas, though it may be well directed, is forced and unnatural.

The

The third plate carries us still deeper into the history. We meet our hero engaged in one of his evening amusements. This print, on the whole, is no very extraordinary effort of genius.—The *design* is good; and may be a very exact description of the humours of a brothel.—The *composition* too is not amiss. But we have few of those masterly strokes which distinguish the works of HOGARTH. The whole is plain history. The lady setting the world on fire, is the best thought: and there is some humour in furnishing the room with a set of Cæsars; and not placing them in order.——The *light* is ill managed. By a few alterations, which are obvious, particularly by throwing the lady dressing, into the shade, the disposition of it might have been tolerable. But still we should have had an absurdity to answer, whence comes it? Here is light in abundance; but no visible source.——*Expression* we have very little through the whole print. That of the principal figure is the best. The ladies have all the air of their profession; but no variety of character. HOGARTH's women are, in general, very

inferior

inferior to his men. For which reason I prefer the *rake*'s *progress* to the *harlot*'s. The female face indeed has seldom strength of feature enough to admit the strong markings of expression.

Very disagreeable accidents often befal gentlemen of pleasure. An event of this kind is recorded in the fourth print; which is now before us. Our hero going, in full dress, to pay his compliments at court, on St. David's day, was accosted in the rude manner which is here represented.——The *composition* is good. The form of the group, made up of the figures in action, the chair, and the lamp-lighter, is pleasing. Only, here we have an opportunity of remarking, that a group is disgusting when the extremities of it are heavy. A group in some respect should resemble a tree. The heavier part of the foliage (the *cup*, as the landscape-painter calls it) is always near the middle: the outside branches, which are relieved by the sky, are light and airy. An inattention to this rule has given a heaviness to the group before us. The two bailiffs, the woman, and the chairman, are all huddled together

together in that part of the group which should have been the lighteſt; while the middle part, where the hand holds the door, wants ſtrength and conſiſtence. It may be added too, that the four heads, in the form of a diamond, make an unpleaſing ſhape. All regular figures ſhould be ſtudiouſly avoided.——The *light* had been well diſtributed, if the bailiff holding the arreſt, and the chairman, had been a little lighter, and the woman darker. The glare of the white apron is diſagreeable.——We have, in this print, ſome beautiful inſtances of *expreſſion*. The ſurprize and terror of the poor gentleman is apparent in every limb, as far as is conſiſtent with the fear of diſcompoſing his dreſs. The inſolence of power in one of the bailiffs, and the unfeeling heart, which can jeſt with miſery, in the other, are ſtrongly marked. The ſelf importance too of the Welſhman is not ill portrayed; who is chiefly introduced to ſettle the chronology of the ſtory.—In point of *grace*, we have nothing ſtriking. HOGARTH might have introduced a degree of it in the female figure; at leaſt he might have contrived to vary the heavy and unpleaſing form of her drapery.—The *perſpective* is good, and makes

an

an agreeable shape.—I cannot leave this print without remarking the *falling band-box.* Such representations of quick motion are absurd; and every moment, the absurdity grows stronger. Objects of this kind are beyond the power of representation.

Difficulties crowd so fast upon our hero, that at the age of twenty-five, which he seems to have attained in the fifth plate, we find him driven to the necessity of marrying a woman, whom he detests, for her fortune. The *composition* here is good; and yet we have a disagreeable regularity in the climax of the three figures, the maid, the bride, and the bridegroom.—The *light* is not ill distributed. The principal figure too is *graceful*; and there is strong *expression* in the seeming tranquillity of his features. He hides his contempt of the object before him as well as he can; and yet he cannot do it. She too has as much meaning as can appear through the deformity of her features. The clergyman's face we are well acquainted with, and also his wig; though we cannot pretend to say, where we have seen either. The clerk too is an admirable fellow.

———The

―――The *perspective* is well understood; but the church is too small; and the wooden post, which seems to have no use, divides the picture disagreeably.――――The creed loft, the commandments broken, and the poor's-box obstructed by a cobweb, are all excellent strokes of humour.

The fortune, which our adventurer has just received, enables him to make one push more at the gaming table. He is exhibited, in the sixth print, venting curses on his folly for having lost his last stake.――――This is on the whole, perhaps, the best print of the set. The horrid scene it describes, was never more inimitably drawn. The *composition* is artful, and natural. If the shape of the whole be not quite pleasing, the figures are so well grouped, and with so much ease and variety, that you cannot take offence.—In point of light, it is more culpable. There is not shade enough among the figures to balance the glare. If the neck-cloth, and weepers of the gentleman in mourning had been removed, and his hands thrown into shade, even that alone would have improved the effect.――――The *expression*, in

almost

almoſt every figure, is admirable; and the whole is a ſtrong repreſentation of the human mind in a ſtorm. Three ſtages of that ſpecies of madneſs, which attends gaming, are here deſcribed. On the firſt ſhock, all is inward diſmay. The ruined gameſter is repreſented leaning againſt a wall, with his arms acroſs, loſt in an agony of horror. Perhaps never paſſion was deſcribed with ſo much force. In a ſhort time this horrible gloom burſts into a ſtorm of fury: he tears in pieces what comes next him; and kneeling down, imprecates curſes on himſelf. He next attacks others; every one in his turn whom he imagines to have been inſtrumental in his ruin.—The eager joy of the winning gameſters, the attention of the uſurer, the vehemence of the watchman, and the profound revery of the highwayman, are all admirably marked. There is great coolneſs too expreſſed in the little we ſee of the fat gentleman at the end of the table. The figure oppoſing the mad-man is bad: it has a drunken appearance; and drunkenneſs is not the vice of a gaming table.——The principal figure is *ill drawn.* The *perſpective* is formal; and the *execution* but indifferent: in heightening his expreſſion HOGARTH has loſt his ſpirit.

M

The

The seventh plate, which gives us the view of a jail, has very little in it. Many of the circumſtances, which may well be ſuppoſed to increaſe the miſery of a confined debtor, are well contrived; but the fruitful genius of Hogarth, I ſhould think, might have treated the ſubject in a more copious manner. The epiſode of the fainting woman might have given way to many circumſtances more proper to the occaſion. This is the ſame woman, whom the rake diſcards in the firſt print; by whom he is reſcued in the fourth; who is preſent at his marriage; who follows him into jail; and, laſtly, to Bedlam. The thought is rather unnatural, and the moral certainly culpable.—The *compoſition* is bad. The group of the woman fainting, is a round heavy maſs: and the other group is ill ſhaped.. The *light* could not be worſe managed; and, as the groups are contrived, could hardly be improved.—In the principal figure there is great *expreſſion*; and the fainting ſcene is well deſcribed.——A ſcheme to pay off the national debt, by a man who cannot pay his own; and the attempt of a ſilly rake, to retrieve his affairs

fairs by a work of genius, are admirable ſtrokes of humour.

The eighth plate brings the fortunes of the rake to a concluſion. It is a very expreſſive repreſentation of the moſt horrid ſcene which human nature can exhibit.——The *compoſition* is not bad. The group, in which the lunatic is chained, is well managed; and if it had been carried a little farther towards the middle of the picture, and the two women (who ſeem very oddly introduced) had been removed, both the compoſition, and the diſtribution of light had been good.——The *drawing* of the principal figure is a more accurate piece of anatomy than we commonly find in the works of this maſter. The *expreſſion* of the figure is rather unmeaning; and very inferior to the ſtrong characters of all the other lunatics. The fertile genius of the artiſt has introduced as many of the cauſes of madneſs, as he could well have collected; but there is ſome tautology. There are two religioniſts, and two aſtronomers. Yet there is variety in each; and ſtrong *expreſſion* in all the characters. The ſelf-ſatisfaction, and conviction, of him who has

has difcovered the longitude; the mock majefty of the monarch; the moody melancholy of the lover; and the fuperftitious horror of the popifh devotée, are all admirable.—The *perfpective* is fimple and proper.

I fhould add, that thefe remarks are made upon the firft edition of this work. When the plates were much worn, they were altered in many parts. They have gained by the alterations, in point of *defign*; but have loft in point of *expreffion*.

CHAP. V.

CAUTIONS IN COLLECTING PRINTS.

THE collector of prints may be firſt cautioned againſt indulging a deſire of becoming poſſeſſed of *all* the works of any maſter. There are no maſters whoſe works in the *groſs* deſerve notice. No man is equal to himſelf in all his compoſitions. I have known a collector of REMBRANDT ready to give any price for two or three prints which he wanted to complete his collection; though it had been to REMBRANDT's credit, if thoſe prints had been ſuppreſſed. There is no doubt, but if one third of the works of this maſter ſhould be tried by the rules of juſt criticiſm, they would appear

appear of little value. The great prince *Eugene*, it is said, was a collector of this kind; and piqued himself upon having in his possession, *all the works of all the masters*. His collection was bulky, and cost fourscore thousand pounds; but when sifted, could not, at that time of day, be worth so many hundreds.

The collector of prints may secondly be cautioned against a superstitious veneration for names. A true judge leaves the *master* out of the question, and examines only the *work*. But, with a little genius, nothing sways like a name. It carries a wonderful force; covers glaring faults, and creates imaginary beauties. That species of criticism is certainly just, which examines the different manners of different masters, with a view to discover in how many ways a good effect may be produced, and which produces the best. But to be curious in finding out a master, in order *there* to rest the judgment, is a kind of criticism very paltry, and illiberal. It is judging of the work by the master, instead of judging of the master by the work. Hence it is, that such vile prints as the

the *Woman in the cauldron*, and *Mount Parnaſſus*, obtain credit among connoiſſeurs. If you aſk wherein their beauty conſiſts? you are informed, they are engraved by MARK ANTONIO: and if that do not ſatisfy you, you are farther aſſured, they are after RAPHAEL. This abſurd taſte raiſed an honeſt indignation in that ingenious artiſt PICART: who having ſhewn the world, by his excellent imitations, how ridiculous it is to pay a blind veneration to *names;* tells us, that he had compared ſome of the engravings of the ancient maſters with the original pictures; and found them very bad copies. He ſpeaks of the ſtiffneſs, which in general runs through them——of the hair of children, which reſembles pot-hooks—and of the ignorance of thoſe engravers in anatomy, drawing, and the diſtribution of light.

Nearly allied to this folly, is that of making the public taſte our ſtandard. It is a moſt uncertain criterion. Faſhion prevails in every thing. While it is confined to dreſs, or the idle ceremonies of a viſit, the affair is trivial: but when faſhion becomes a dictator in arts,

the matter is more serious. Yet so it is; we seldom permit ourselves to judge of beauty by the rules of art: but follow the catch-word of fashion; and applaud, and censure from the voice of others. Hence it happens, that sometimes the works of one master, and sometimes of another, have the prevailing run. REMBRANDT has long been the fashionable master. Little distinction is made: if the prints are REMBRANDT's, they must be good. In two or three years, perhaps, the date of REMBRANDT may be over: you may buy his works at easy rates; and the public will have acquired some other favourite. For the truth of these observations, I might appeal to the dealers in old prints; all of whom know the uncertain value of the commodity they vend. Hence it is, that such noble productions, as the works of P. TESTA, are in such little esteem, that the whole collection of this master, though it consists of near twenty capital prints, beside many small ones, may be bought for less than is sometimes given for a single print of REMBRANDT. The true connoisseur leaves the voice of fashion entirely out of the question; he has a better standard of beauty—the merit

of

of each master, which he will find frequently at variance with common opinion.

A fourth caution, which may be of use in collecting prints, is, not to rate their value by their *scarceness*. Scarceness will make a *valuable* print *more* valuable: but to make scarceness the standard of a print's value, is to mistake an accident for merit. This folly is founded in vanity; and arises from a desire of possessing what nobody else can possess. The want of *real* merit is made up by *imaginary*; and the object is intended to be *kept*, not *looked at*. Yet, absurd as this false taste is, nothing is more common; and a trifling genius may be found, who will give ten guineas for HOLLAR's shells, which, valued according to their merit (and much merit they certainly have), are not worth more than twice as many shillings.—Instances in abundance might be collected of the prevalence of this folly. LE CLERC, in his print of *Alexander's triumph*, had given a profile of that prince. The print was shewn to the duke of Orleans; who was pleased with it on the whole, but justly enough objected to

the

the side-face. The obsequious artist erased it, and engraved a full one. A few impressions had been taken from the plate in its first state; which sell among the curious for ten times the price of the impressions taken after the face was altered.——Callot, once pleased with a little plate of his own etching, made a hole in it; through which he drew a ribbon, and wore it at his button. The impressions after the hole was made, are very scarce, and amazingly valuable.—In a print of the holy family, from Vandyke; St. John was represented laying his hand upon the virgin's shoulder. Before the print was published, the artist shewed it among his critical friends, some of whom thought the action of St. John too familiar. The painter was convinced, and removed the hand. But he was mistaken, when he thought he added value to his print by the alteration. The few impressions, which got abroad, with the hand upon the shoulder, would buy up all the rest, three times over, in any auction in London.—Many of Rembrandt's prints receive infinite value from little accidental alterations of this kind. A few impressions were taken from one plate, before

a dog

a dog was introduced; from another, before a white-horse tail was turned into a black one; from a third, before a sign-post was inserted at an ale-house door: and all the scarce prints from these plates, though altered for the better, are the prints of value: the rest are common and cheap.—I shall conclude these instances with a story of a late celebrated collector of pictures. He was shewing his collection with great satisfaction; and after expatiating on many noble works by Guido, Marratti, and other masters, he turned suddenly to the gentleman, whom he attended, and, "Now, Sir, said he, I'll shew you a real curiosity: there is a Woverman, without a horse in it."—The circumstance, it is true, was uncommon; but was unluckily that very circumstance, which made the picture of little value.

Let the collector of prints be cautioned, fifthly, to beware of buying copies for originals. Most of the works of the capital masters have been copied; and many of them so well, that if a person be not versed in prints, he may easily be deceived. Were the copies really as good

good as the originals, the name would signify nothing: but, like tranflations, they neceffarily fall fhort of the fpirit of the original: and contract a ftiffnefs from the fear of erring. When feen apart, they look well; but when compared with the originals, the difference eafily appears. Thus CALLOT's *beggars* have been fo well copied, that the difference between the originals and the copies would not immediately ftrike you; but when you compare them, it is obvious. There is a plain want of freedom; the characters are lefs ftrongly marked; and the extremities are lefs accurately touched.———It is a difficult matter to give rules to affift in diftinguifhing the copy from the original. In moft cafes the engraver's name, or his mark (which fhould be well known), will be a fufficient direction. Thefe the copyift is feldom hardy enough to forge. But in anonymous prints it is matter of more difficulty. All that can be done, is to attend carefully to the *freedom* of the *manner*, in the *extremities* efpecially, in which the copyift is more liable to fail. When you are pretty well acquainted with the *manner* of a mafter, you cannot well be deceived. When you are not; your beft way is to be directed by thofe who are.

The

The laſt caution I ſhall give the collector of prints, is, to take care he purchaſe not bad impreſſions.—There are three things which make an impreſſion bad.—The firſt is, its being *ill taken off.* Some prints ſeem to have received the force of the roller at intervals. The impreſſion is double; and gives that glimmering appearance, which illudes the eye. —A ſecond thing, which makes an impreſſion bad, is *a worn plate.* There is great difference between the firſt and the laſt impreſſion of the ſame plate. The *effect* is wholly loſt in a faint impreſſion; and you have nothing left but a vapid deſign without ſpirit, and without force. In mezzotinto eſpecially a ſtrong impreſſion is deſirable. For the ſpirit of a mezzotinto quickly evaporates; without which it is the moſt inſipid of all prints. In engraving and etching there will be always here and there a dark touch, which long preſerves an appearance of ſpirit: but mezzotinto is a flat ſurface; and when it begins to wear, it wears *all over.* Very many of the works of all the great maſters, which are commonly hawked about at auctions, or ſold in ſhops, are in this wretched
ſtate.

ſtate. It is difficult to meet with a good impreſſion. The Salvators, Rembrandts, and Waterlos, which we meet with now, except here and there, in ſome choice collection, are ſeldom better than mere reverſes. You ſee the form of the print; but the elegant, and maſterly touches are gone; backgrounds and foregrounds are jumbled together by the confuſion of all diſtance; and you have rather the ſhadow of a print left, than the print itſelf.—The laſt thing which makes a bad impreſſion, is *retouching a worn plate*. Sometimes this is performed by the maſter himſelf; and then the ſpirit of the impreſſion may be ſtill preſerved. But moſt commonly the retouching part is done by ſome bungler, into whoſe hands the plate has fallen; and then it is very bad. In a *worn* plate, at leaſt what you have is good: you have the remains of ſomething excellent; and if you are verſed in the works of the maſter, your imagination may be agreeably exerciſed in making out what is loſt. But when the plate has gone through the hands of a bungler, who has worked it over with his harſh ſcratches, the idea of the maſter is loſt; and you have nothing left, but ſtrong, unmeaning lines on a faint ground; which is a moſt diſagreeable contraſt. Such

prints,

prints, and many fuch there are, though offered us under the name of Rembrandt, or Waterlo, are of little value. Thofe mafters would not have owned fuch works.——Yet, as we are often obliged to take up with fuch impreffions, as we can get; it is better to chufe a *faint* impreffion, than a *retouched* one.

THE END.

(175)

prints, and many fuch there are, though offered us under the name of REMBRANDT, or WATERLO, are of little value. Thofe mafters would not have owned fuch works.——Yet, as we are often obliged to take up with fuch impreffions, as we can get; it is better to chufe a faint impreffion, than a retouched one.

THE END.

INDEX.

Appendages, what — Page 4
Ananias; cartoon of, criticized — 9, 10
Aqua-fortis, its manner of biting the copper 32
Aldgrave — — — 45
Andreani, Andrea — — 49
Antonio, Mark — — 50
Augustin of Venice — — 50
Anthony, St. temptation of — 55
Austin, St. a motto from him — 72
Alexander, triumph of: by Le Clerc 79
Auden Aerd — — — 80
Augurs, by Goupy — — 118
Alva, duke of: by Rubens — 139

Baffan criticized — — 4, 103
Beautiful gate; cartoon of, criticized 7, 27
Baptism of John: by Muller — 46
Bloemart, Abraham — 46, 104, 127
Barrochi, Frederic — — 51
Beggars, Callot's — — 55
Bartholomew, St. by Spaniolet — 63
Bella, Stephen de la — 64, 98
Bolswert — — 66, 107
Bible,

Bible, history of: by Luiken, 67. By Sadler, *Page* 103
Bega, Cornelius — — 73
Bellange — — — 74
Baur, William — — 76
Bartoli, Peter — — 79
Bas, Le — — — 81
Bischop — — — 81
Becket — — — 86
Baptiste's head, by White — 87
Bentivolius, Guido: his head by Morin 89
Bedford, earl of: his head by Houbraken 91
Berghem — — — 93
Bloteling — — — 100
Barlow — — — 100
Bears devouring a deer: by Ridinger 102
Boars, a print of: by Ridinger — 102
Both — — — 116

Contrast: its effect — — 7
Claude — — — 26
Circumcision, by Goltzius — 46
Cæsar, triumph of, at Hampton Court 47
Carracci, Augustin — — 53
Cantarini — — — 54
Callot — — — 54
Chiswick: a picture there of Salvator's, criticized, 56
Cross, descent from: by Villamena — 64
Castiglione — — — 69

Christ,

Chrift, life of: by Parrocelle — Page 74
Coypel — — — 77
Caylus, Count — — 78
Clerc, Le — — 79
Cromwell, Elizabeth: her head by Smith 88
Collier, Mrs.: her portrait by Faber 91
Cuyp — — 99
Charles I. by Vandyke — 139
Coeverden, deluge of: by R. le Hooghe 150
Cobies, cautioned againſt — 171

Deſign defined, and illuſtrated — 2
Diſpoſition defined, and illuſtrated — 5
Drawing defined, and illuſtrated — 15
Diſtant magnitude expreſſed better in a painting than in a print — 26
Durer, Albert — — 43
Dorigny, Michael — — 65
Dorigny, Nicholas — — 83
Dyke, Van — — 85
Drevet — — — 90
Dankerts — — 94
Diana hunting : by Goupy — 118

Expreſſion explained, and illuſtrated 16
Execution explained, and illuſtrated 21
Engraving conſidered — 32, &c.

N 2 *Etching*

Etching considered — Page	32, &c.
Elſhamer, Adam — —	55
Egypt, flight into: by Count Gaude	56
Ertinger — —	66
Ecce Homo: by Coypel, 77. By Van Dyke,	86
Eſop: by Barlow — —	99
Eugene, prince: his collection of prints	165

Flemiſh ſchool: its character —	48
Fair: Callot's — —	54
Fage, La — —	65
Febre, V. le — —	74
Freii, Jac. — —	80
Faber — —	91
Fry — —	92
Fyt, J. — —	98
Flamen — —	101
Fables: by Ridinger —	102

Grace defined, and illustrated —	16
Ground in mezzotinto —	38
Goltzius — —	45
Guido — —	53
Gaude, count — —	55
Galeſtruzzi — —	71
Gillot, Claude — —	75
Gribelin, Sim. — —	80
	Gibbon:

Gibbon: his head by Smith — *Page* 88
Genoel — — 116
Goupy — — 118
Group: the form of one criticized 6

Harmony in painting illuſtrated — 11
Hell-ſcene: by A. Durer — 43
Hiſben — — 45
Hundred-guildres-print — 60
Hooghe, Roman le — 67
Hooper: his head by White — 87
Houbraken — — 91
Hamden: his head by Houbraken 91
Hondius, 95. His hunted wolf — 95
Hollar, 104. His works 105, 106, 107
Huntings: by Rubens, 96. By Ridinger 102
Hagar: by Goupy — 118
Hogarth, 116. His rake's progreſs criticized, 125

Journeyings, patriarchal: by C. Macee 69
Impoſtures innocentes: by Picart — 77
Joſeph in Egypt: by Biſchop — 81
Jardin, Du, 95. One of his etchings criticized, 145
John, St. a print of, by Van Dyke 170
Impreſſions — — 172

Keeping defined, and illuſtrated — 10

Lyſtra,

Lyſtra, ſacrifice at, cartoon of, criticized, *Page* 8, 17
Light, diſtribution of, criticized — 22
Lucas Van Leiden — 45
Lot: by Aldgrave — 45
Lazarus: by Bloemart — 47
Luiken — — 67
Laireſſe, Gerard — 68
Lanfrank: his gallery — 79
Lievens, J. — — 84
Lely, Peter — — 86
Leigh, Anthony: his head by Smith 88
Lutma, J. — — 89, 111
Laer, Peter de — — 99
Lorraine, Claude — 113
Latrones: by Goupy — 118

Michael Angelo: his idea of form in grouping 9
Manneriſt: what is meant by the word 21
Mezzotinto conſidered — 36
Muller — — 46
Mantegna, Andrea — 48
Miſeries of War: Callot's — 54
Moyſe, Vocation de: by La Fage — 66
Macee — — 69
Muilen, Vander — 70
Mellan — — 72

Marot

Marot — —	Page 82
Magdalene, Mary: her head by Smith	88
Mellan — —	88
Morin, J. — —	89
Marmion, Edm. —	89
Moyreau — —	97
Montague, duke of —	110

Neulant — —	108
Names: their influence —	168

Oſtade — —	72
Ovid: illuſtrated by W. Baur —	76
Overbeck - — —	115
Oxford-heads: by Hogarth —	124

Paul preaching at Athens, the cartoon of, criticized — —	5, 7
Perſpective defined, and illuſtrated	23
Poliſhed bodies expreſſed better in a picture than in a print —	29
Pewter: engraving on —	36
Pens — —	45
Parmigiano — —	48
Palma — —	49
Paria, Francis — —	49
Picart: his character of M. Antonio	51

Pont

Pont-Neuf: by de la Bella	*Page* 64
Pontius — —	66
Parrocelle, Joseph —	73
Picart — —	77
Pond, Arthur — —	78
Perrier, Francis — —	82
Parr's head by White —	87
Piazetta — —	88
Pope, Mr. his head by Richardson	90
Potter, Paul — —	100
Pouffin, Gasper —	104
Perelle — —	113
Porsenna: by Goupy —	118
Piranesi — — —	118
Prentice, idle: by Hogarth —	121
Physicians-arms: by Hogarth —	124
Playhouse, corner of —	125
Polycrates, death of: by Salvator Rosa	131
Pether: his print of a Jewish rabbi	141
Parnassus, Mount: by M. Antonio	166

Rupert, prince: character of his mezzotintos	37
Roman-school: its character —	47
Rosa, Salvator —	56, 131
Robbers, Salvator Rosa's —	58
Rembrandt — 58, 79, 100, 104,	165
Rosary, mysteries of: by Sciaminossi	66
Roettiers, Fr. —	83

Rigaud

Rigaud	*Page* 90
Richardson	90
Richmond, duke of: his head by Houbraken	91
Reubens	96
Rosa of Tivoli	97
Ridinger	101
Rousseau, James	110
Ricci, Marco	116
Rake's progress	125

Salutation: by Barrochi	51
Spaniolet	63, 124
Silenus and Bacchus: by Spaniolet	63
Sciaminossi	66
Schut, Cornelius	76
Simons	86
Sturges: his head by White	87
Smith	87
Scalken: his head by Smith	88
Salisbury, countess of: her head by Smith	91
Schomberg: his head by Houbraken	91
by Smith	139
Stoop, Peter	99
Sadler	103
Sunderland, earl of	108
Swanevelt	109
Sylvestre, Israel	112
Silenus, triumph of: by Peter Testa	134
Scarceness, no test of merit	169

Titian:

Titian: his illustration of massing light, *Page* 14
Transparency expressed better in a painting,
 than in a print — 28
Tempesta, Anthony — 52, 98
Testa, Peter — — 60, 134
Tiepolo — — 70
Tulden, Van — — 73
Truth delivered by Time from Envy: by Poussin, 78
Tobit: by Goupy — 118

Virgil: a passage of his criticized — 27
Vasari: his opinion of A. Durer — 44
Vouet, Simon — — 63
Villamena — — 64
Venius, Otho — — 71
Ulysses, voyage of: by Tulden — 73
Vesper, by Parrocelle — 74
Uliet, Van — — 84
Vertue — — 90
Visscher, J. — — 94, 97
Veau, Le — — 117
Vandiest — — 118

Whole in painting: how constituted 1
Watteau — — 75
Worlidge — — 85

White, the engraver	—	*Page* 86
White, the mezzotinto-fcraper	—	86
Wing: his head by White	—	87
Wyke: a mezzotinto from him by Smith		88
Wolfang	—	89
Woverman, 142. Story of	—	171
Wolves-heads: by Ridinger	—	102
Waggon: a print from Rubens	—	108
Waterlo, 108. His Tobias	—	147
Woman in the cauldron: by M. Antonio		166

Zuingg	—	—	117
Zeeman	—	—	117

A CATALOGUE of Mr. GILPIN's WORKS, fold by Meffrs. CADELL and DAVIES, in the Strand.

An EXPOSITION of the NEW TESTAMENT; intended as an Introduction to the Study of the Holy Scriptures, by pointing out the leading Senfe and Connexion of the facred Writers. Third Edition, 8vo. 2 vols. price 12s.

LECTURES on the CATECHISM of the CHURCH of ENGLAND. Fifth Edition, 12mo. price 3s. 6d.

MORAL CONTRASTS; or the POWER of RELIGION exemplified under different Characters. Second Edition, price 3s. 6d.

LIVES of Several REFORMERS; of different Editions, and Prices: The whole together, 12s. 6d.

PICTURESQUE REMARKS on the RIVER WYE. Fourth Edition, price 17s.

——————— on the LAKES of CUMBERLAND and WESTMORELAND. Third Edition, 2 vols. price 1l. 11s. 6d.

——————— on the HIGHLANDS of SCOTLAND, 2 vols. Second Edition, price 1l. 16s.

——————— on FOREST SCENERY. 2 vols. Second Edition, price 1l. 16s.

——————— on the WESTERN PARTS of ENGLAND. Price 1l. 5s.

THREE ESSAYS—On Picturefque Beauty—On Picturefque Travel —and The Art of fketching Landfcape. Second Edition, price 10s. 6d.

Printed by A. Strahan,
Printers-Street, London.